SAMURAI

Also by John Man

Gobi
Atlas of the Year 1000
Alpha Beta
The Gutenberg Revolution
Genghis Khan
Attila the Hun
Kublai Khan
The Terracotta Army
The Great Wall
The Leadership Secrets of Genghis Khan
Xanadu
Ninja

SAMURAI

WITHDRAWN
— THE —
LAST WARRIOR

A HISTORY

JOHN MAN

WM
WILLIAM MORROW
An Imprint of HarperCollins*Publishers*

Excerpt from NINJA copyright 2012, 2013 by John Man.

HarperCollins books may be purchased for educational, business,
or sales promotional use. For information please e-mail the
Special Markets Department at SPsales@harpercollins.com.

Originally published in slightly different form in the
United Kingdom in 2011 by Transworld Publishers.

FIRST U.S. EDITION

Library of Congress Cataloging-in-Publication Data has been applied for.

ISBN 978-0-06-220267-3

14 15 16 17 18 DIX/RRD 10 9 8 7 6 5 4 3 2 1

CONTENTS

CONTENTS

LIST OF MAPS

PREFACE

This is three stories intertwined.

One tells of the fast-flowing and dramatic events by which Japan, for 250 years a feudal patchwork almost entirely isolated from the rest of the world, became a unified, outward-looking and fast-developing nation. In 1850 the country was much as it had been in 1600: a self-contained world of thirty million serfs dominated by three hundred lords who owed their authority to the nation's military dictator, the shogun, yet locally were absolute rulers. At the top of this pyramid was the emperor, a semidivinity, pampered as a lapdog, remote from everyday affairs.

The second story is that of the samurai, a military élite of some two million who underpinned the whole system with attitudes, behavior and equipment that all reached as far back into the past as the history of their local lords and the shogun they served.

By 1880 the lords and the samurai were gone, and with them the whole edifice of feudalism. Japan had leaped from the Middle Ages into the modern world. It was not a popular revolution, because the peasants had no say in it, but it

produced a society familiar to Europeans: a sovereign at the top, a governing élite, an emerging middle class, and a restless but subdued mass of peasants.

The third story is that of the man who helped drive this revolution, and at the same time became its victim.

A NOTE ON TRANSLITERATION AND DATING

Except for Japanese names and words common in English (e.g., Tokyo), Japanese has been romanized according to the "revised Hepburn" system, with a macron to indicate long vowels, mainly the ō. I have removed the macron from Saigo's own name to reflect his growing fame.

Traditionally, Japan used the lunar calendar, which divided the year into twelve months, each with 29 or 30 days. This gave 354 days in each year, so a thirteenth month had to be added every three years (approximately, because one year is about, 365.25 days, not an exact number of whole days). On January 1, 1873, the Japanese government adopted the Gregorian calendar. Some sources use both systems, but to avoid confusion I use only the Gregorian.

PROLOGUE
OUT OF THE VOLCANO

LONG AGO IN A GALAXY FAR, FAR AWAY, AND ALSO NOT LONG ago right here on earth, two warriors prepare for action. Though inhabiting separate worlds, Digital and Reality, the two have much in common. They are expert in the use of swords, despite the fact that they can call on the most fearsome and destructive of long-distance weapons. The real warrior carries a supremely strong yet flexible steel sword known as a *katana*, with edges that make flesh and bone seem as soft as new bread; the digital one wields a "light saber," a blade of energy that emits a rather annoying hum when switched on and deflects other light sabers and almost anything else with a sharp crackle. Both say they are willing to fight to the death, though only one means it. Both could wear armor that would make them look like rather exotic insects, but prefer loose tunics.

Yes, the samurai, though long gone, are with us still in the Jedi knights of *Star Wars*, exemplified by the young hero, Luke Skywalker. Luke is not only the son of Darth Vader; he is also the spiritual heir of our real-life hero, Saigo Takamori, "the last samurai." They are linked by more than their equipment.

Both have an epic task ahead of them: to restore to power a vanished but virtuous world. Both adhere to austere chivalric rules supposedly based on ancient principles. Both have their spiritual masters, whose voices echo down through the ages. Yamamoto Tsunetomo, in his early eighteenth-century classic *Hagakure* [*Hidden Leaves*]: *The Book of the Samurai*, dispenses wisdom "that has been passed down by the elders," like "Stamp quickly and pass through a wall of iron," for the wisest counsel is often obscure. Yoda expounds precepts in Hollywoodese: "Named must your fear be before banish it you can," he tells Luke. Wise he is, so backward he talks.

An inspiration for *Star Wars*: that's just one example among many of the ways Japan's warrior class lives on in the present. Novels, cartoons, DVDs, games, TV series without number and followers of martial arts the world over all show the enduring popularity of the subject. In Japan, samurai movies have been so popular—twenty-six films have been made about one character alone, the blind swordsman Zatoichi, who fights by hearing—that their influence on the West was virtually inevitable. They come down to us indirectly through the films of Kurosawa Akira (Akira being his given name, which comes second in Japanese). Without *Seven Samurai*—seven *ronin* (masterless samurai) hired by villagers to protect them from bandits—there would be no *Magnificent Seven* (1960), its Wild West remake; without *Yojimbo*, no *Fistful of Dollars* (1964) or *Last Man Standing* (1996).

You would think from most portrayals of samurai that they were solely a medieval phenomenon. They should have been. The Middle Ages were their heyday. Yet they survived not only as anachronisms but as a vital part of Japanese society until their destruction in the rebellion of 1877, as anyone who has seen Tom Cruise in *The Last Samurai* knows. That's

about the only historical fact you should take from the film, which is hardly more about samurai than *Star Wars* is. It is a beautifully made, well-acted hall of mirrors, splicing together bits of fact and fiction to make a story appealing to Western tastes. There were a few Westerners—Cruise-like figures—who fought in the Japanese ranks down through the years, and a couple who fought as samurai, but none on either side in this war. The samurai in the film are portrayed as a tribe apart, living like America's Amish in noble isolation; in fact, they were interfused with the rest of society, many playing crucial roles as administrators. In the film, their leader Katsumoto (Ken Watanabe) is a traditionalist—one who, wonderful to relate, speaks English—steeped in the Way of the Warrior; in fact, the real-life samurai leader, Saigo Takamori, was a complex and contradictory mixture of past and future, revolutionary and reactionary, top government minister and rebel; a man who despised foreigners yet reluctantly accepted the need for change, a warrior who never actually fought, a man of action who loved to compose Chinese poetry, a man with a zest for life who spent much of it determined to die well, a leader who did not choose to lead the rebellion that ended in his death.

This is Saigo's story. It is also the story of the formation of modern Japan. To understand him and his crucial role you have to start with the region from which he sprang.

The southern tip of Japan's most southerly island has one particularly famous feature. I knew it was there, of course, yet missed seeing it for hours. From the airport expressway it was hidden by steep green hills. If you come by bullet train, you will miss it too, for you glide into Kagoshima's heart through tunnels and cuttings. Away from the coast, views are blocked by new buildings. There are clues: the coarse, gray dust that

gathers on footpaths, roads, parked cars and collars; perhaps a column of smoke darkening a blue sky. Soon, though, you will glance down an avenue leading to the sea, and stare astonished at the thing that defines the city, and the whole region: the great, gray, fuming volcano.

After that first revelation, Sakurajima was never out of mind, and hardly ever out of sight. From the eighty kilometers of curving coast, from the bulky green hill at the city's heart; from hotel rooms and balconies and trams—you see it at every turn, half hidden by its own smoke or pale in dissipating mist or in crystal clarity under a blue sky. No wonder they sell Kagoshima to Europe as the Naples of the Orient. Sakurajima looms as large as Vesuvius over a bay that is as glorious as the Gulf of Naples, and safer for shipping too: Kinko Bay, protected by a fifty-kilometer inlet, is an inland lake, almost totally enclosed. The volcano is as erratic as Vesuvius, though less destructive, because Sakura is a *jima*, an island, with a handy three-kilometer stretch of water between volcano and city. Actually, it's not quite an island anymore, because an eruption in 1914 pumped out enough lava to make a causeway to the mainland, but that is on the far side of the bay, and no one has suggested changing the name.

Sakurajima defines this place: its history, the city and the character of its people. Its explosive outbursts thousands of years ago cut this part of Kyūshū, formerly known as Satsuma, from the rest of Japan (by pumping out ejecta that makes wonderful soil for the oranges named after the province—and cherries: Sakurajima means "Cherry Island"). Historically, Satsuma was hard to get to from the north, and hard to leave. But southward lay the open sea, and the outside world. It was this interplay of accessibility and isolation that made Satsuma what it was—and today's Kyūshū what it is: a province that

was in effect its own miniature nation-state, part of Japan, yet apart from it. The city of Kagoshima also owes its character to the volcano, for the hills have stopped it spreading outward; most provincial capitals are circles centered on their castles, but Kagoshima is long and thin, squeezed between hills and sea. Saigo Takamori, the last samurai, owed his character to this proud region, and both were products of Sakurajima.

Once upon a geological time, southern Kyūshū was very different. There were no hills—well, not today's hills—nor was there a bay. But there was the volcano, one of eleven in Kyūshū, all part of the system of volcanoes that encircles the Pacific. This one had been active on and off for a million years when, about 22,000 years ago, it blew up in one of the largest explosions in world history. Equal to a hundred Saint Helens, or ten Krakatoas, it blasted over one hundred cubic kilometers of the earth skyward, leaving a flooded crater almost twenty kilometers across and covering all southern Kyūshū with a spongy plateau of rock and dust one hundred meters thick. Over the next ten thousand years rain eroded the soft rock into steep hills, leaving a forested battlement that cut off the Japanese mainland to the north. One of these hills is the tree-covered lump in the middle of Kagoshima where Saigo started his doomed rebellion and met his death.

Then, in another upheaval thirteen thousand years ago, the volcanic vent below the new bay burst again, spewing out enough lava to build the island of Sakurajima. The huge weight of rock, 10 kilometers across and just over 1,100 meters high, plugged the subterranean furnace, but not completely. This is one of the world's most active volcanoes. Every day, often several times a day, it puffs out a cloud: sometimes a mere filigree, sometimes a thunderhead of ash and lightning. When in September 2009 I went to the research station that keeps

a wary eye on the volcano's beating heart, a hand-painted sign, changed daily, proclaimed that Sakurajima had erupted 365 times that year already. And occasionally the daily cough turns nasty. In well-recorded crises—twenty-five in the last five hundred years—side vents open, new craters form, villages vanish under lava. Yes, people live here, because the ash and lava turn into good, rich soil, which grows not only oranges but also radishes as big as watermelons, the world's largest. Nothing more than daily smoke signals punctuated Saigo's life, but sometime—tomorrow, next year, a century hence—villages, people, oranges and radishes will vanish beneath a new skin of ash and lava.

Thanks to the volcano, Saigo had somewhere to hide in his final, useless battle. It was September 23, 1877. His rebellion, ill-conceived from the start, was coming to an end. His band of six hundred warriors were armed with swords, and below him was an army of thirty-five thousand with field guns. His hiding place was a cave dug into a cliff halfway up Kagoshima's central ash-and-pumice hill, Shiroyama. There was no escape. If he were to be captured, he would be executed. Even if he escaped, he was done for. At the age of fifty, he was exhausted and sick, with a heart too weak for his huge frame. There would be only one way to end it. As a samurai, he planned a glorious death in battle. He would fight; and then, when all was lost, he would choose the samurai's ritual end, disemboweling himself with his own knife before an aide cut off his head with one swing of a sword.

Climbing through the forest on Shiroyama's steep slopes, staring at the shallow cave, hardly wide enough for a man of Saigo's bulk to lie down, I wondered at the nature of his heroism. The West likes its heroes to risk all and then live, or if they die to give up their lives in a noble cause. Think of Luke in *Star*

Wars; or Horatius, who (in Macaulay's poem) was prepared to die, facing fearful odds, for the ashes of his fathers and the temples of his gods, and survived gloriously; or Scott of the Antarctic, who didn't. Saigo is a hero to the Japanese for exactly the opposite reasons: not only did he die, he did so in an utterly hopeless, even foolish cause, achieving nothing. That is precisely why the Japanese revere him, and several others like him in their history. This type of hero is admired and loved because "he is the man whose single-minded sincerity will not allow him to make the maneuvers and compromises that are so often needed for mundane success."[1]

Saigo was a man trapped into a useless death by paradox: the troops below were the emperor's, he loved the emperor, yet he had rebelled against him. How could he, a poet, a charismatic leader, a former minister, have gotten himself into such a fix? How could a man so rooted in the past be so admired today?

[1] Morris, *The Nobility of Failure*.

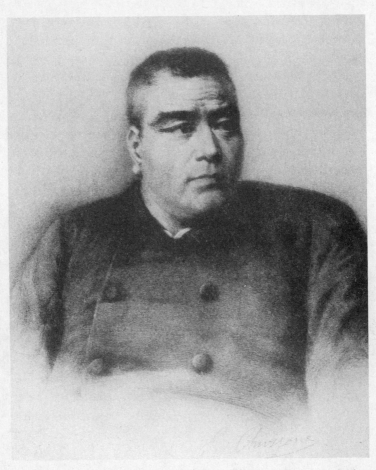

Saigo, in charcoal, by the Italian Edoardo Chiossone, who worked in Japan from 1875 until his death in 1898. The portrait was done in 1883, six years after Saigo's death. Chiossone combined the features of Saigo's younger brother (upper half) and a cousin (lower half). This, the standard portrait, has been much copied. The original has vanished.

1

THE WAY OF THE
WARRIOR: BEGINNINGS

AT LEAST THE VOLCANO HAD NOT ERUPTED RECENTLY. THERE
was only a dusting of dark gray ash on the paving stones, not
enough to cake car windshields. Mr. Fukuda, head of the Mu-
seum of the Meiji Restoration, led the way out of his museum
into the September heat, down from the embankment over-
looking Kagoshima's river. He was taking me to the birthplace
of Saigo Takamori.

Not that there was much to see—a small square hemmed in
by newish glass-and-concrete buildings, a grove of trees, a pile
of rocks, a plaque. The house itself, the simple wooden house
he was born in, was long gone.

"The government put this here in 1880," said Mr. Fukuda.
"The year of the new constitution."

The government? But Saigo had died a rebel, fighting
imperial troops.

"That was three years earlier. They couldn't go on denying that he was a patriot at heart, and a hero, so he was pardoned."

And instantly became a role model, as the plaque confirmed: "We want the young people of Kagoshima to follow in the footsteps of men like Saigo."

This was a hero with humble origins, as Mr. Fukuda was eager to reveal, leading me on to the nearby reconstruction of Saigo's house: a thatched roof and just four rooms, five if you included the area where the futons were stored during the day. Mr. Fukuda took off his shoes and stepped up into the shadowy kitchen, where a pot hung from a beam over the fire pit.

"He lived with his grandparents and his parents, and six younger brothers and sisters, and a servant—that's twelve people in such a little house."

The design was beautiful in its simplicity, with high ceilings to soak up the summer heat and the fire smoke, and tatami mats to sit on, and neat sliding partitions of wood and semi-transparent paper. But it would have been crowded, with little privacy. Was this how all samurai used to live?

"Not all. His father was of low rank. But samurai are samurai! Even a low-ranking samurai was better off than a peasant."

Not much, though. For one thing, other family members sometimes came to stay, swelling the household to sixteen. For another, his father's pay for his job in the local tax office was not enough, even when added to the small stipend of rice that all samurai received. They might have had just about enough rice, but they still needed soy sauce, salt, bean paste, fish, vegetables, sake, oil for the lamps, charcoal, cotton cloth. The house was always in need of repair, the kids always in need of food and clothes. Saigo and his brothers

were big boys, crowding onto a single futon with the girls. To get by, his father borrowed money and farmed part-time.

As a child, then, Saigo lived with contradiction: samurai status offset by poverty. His young life was one of hard work for the sake of the family. The struggle might have left him embittered; in fact, he was proud of both his roots, which made him stoical in adversity, and his poverty, which hardened his determination to help those in need. His strength came from his sense of identity—as a samurai, as a citizen of a proudly independent province, and as the product of an ancient culture.

To be born a samurai, even in 1827, was to win a top prize in the lottery of life. It really should not have been so. The violent, proud, prickly and thoroughly medieval samurai should have been swept into history's trash basket after Japan was unified in 1600. But they weren't. Quite the opposite. They survived, living on the rice stipends wrung as tax from farmers, merchants and artisans, and would remain a vital force for another three hundred relatively peaceful years. To outsiders, their peculiar attitudes and practices seem as exotic as peacocks' tails; to themselves, and to most of their compatriots then and since, they were the very essence of Japanese society.

The key to their survival was the way they renewed their sense of identity, not by abandoning the past but by cherry-picking aspects of it to suit new circumstances. Luckily for them, they had many rich centuries and much folklore from which to pick their cherries.

Emerging from a thousand years rich in legend and poor in historical record, Japan first came together under an emperor in the seventh century. All emperors thereafter were related, making Japan's the oldest hereditary ruling house in the world.

Imperial unity lasted for some five hundred years, the seedbed of the earliest samurai traditions.

When you hear the word "samurai," you probably think "sword." But samurai swords—the proper curved ones, not the heavy-duty, straight iron type that was imported from China—came later, because it took a while to create a tradition of sword making. The first heyday of the samurai was the age of the bow: so the first samurai were mounted bowmen, not swordsmen. Their bow was something very different from the short semicircle of wood and bone used all across mainland Eurasia. By comparison, the Japanese bow (*yumi*), made of laminated bamboo, looks lanky and unwieldy, an unlikely weapon for mounted archers.

There had been similar bows on the mainland. They were used by the Xiongnu, who had ruled an empire centered on Mongolia and today's northern China from the third century BC to about AD 200. The Huns (perhaps descendants of the Xiongnu) had had something similar when they invaded Europe in the fourth and fifth centuries AD. These bows—Xiongnu, Hun and early Japanese—had one thing in common: they were all "asymmetrical," the grip being placed about one-third of the way along the shaft, the shorter section being the bottom bit. Why? It's a mystery. Some claim it allowed a horseman to lift the bow across the horse's neck (surely not: when you shoot from horseback you do so on one side only, the left if you are right-handed; you can't shoot to the *right* if you are holding the bow in your *left* hand). Or perhaps hunters liked their bows to have a short lower limb so they could shoot while kneeling. A third theory claims that asymmetry originally derived from the nature of bamboo: it tapers, which meant that for a bow to draw evenly, it *had* to be asymmetrical, thicker and shorter at the bottom, thinner and longer at

the top (but any good bowyer can get over that). A leading member of Britain's *kyudo* community—those who practice Japanese archery—shook his head when I asked about this: "Personally, I think they liked their bows to have a long upper limb because it made them look taller. It's good to have something tall to threaten opponents with." As I said, a mystery. No one has a clue. If there was a reason for the asymmetry, it had vanished from consciousness before the gangly bamboo bow became traditional. In Japan, that was the way you made a bow. End of story.

There's nothing very samurai about Japanese archery today. *Kyudo* practitioners are the very opposite of samurai, being dedicated to archery as a ritual art rather than a war-fighting skill. Since all things martial were banned by the Americans after the Second World War, *kyudo* is a post-1945 invention, with dress and actions that proclaim its purely cultural significance. You wear a sort of white kimono top, with a sweeping black skirt and white slipper-socks. You take your turn; you approach your mark with reverence; you stand edge on, legs akimbo; you set the shoulders just so; you nock the arrow with the correct gestures, the arrow resting to the *right* of the bow on thumb and forefinger (which looks wrong to me, because with the English longbow, the arrow is on the left, resting on the knuckle); you hold the bow lightly; you raise it and the nocked arrow above your head; you solemnly lower the bow and at the same time draw the string right back beyond the ear; you hold, straining Zen-like not to struggle to attain the proper level of calm; you feel the balance between the forces—the drawn bow, your quivering muscles, your attention on the little circles of black and white fifty paces away—and you release, allowing your arm to swing back so that your two arms make the right aesthetic balance. It's like a cross between Noh

theater and ballet, and almost as demanding. Beauty and inner peace: those are the aims. Hitting the target is incidental. Not exactly the sort of activity for a warrior in single combat.

In two ways, though, modern *kyudo* archers connect with their samurai forebears. The bow is the traditional design, asymmetrical, with many laminations of bamboo. Also, it is built ever so slightly out of true, so that the two limbs lean a little to the right to place the string off center. Why? With an English longbow—with most types of bow, actually—the arrow is nocked centrally but is directed minutely off course by the width of the bow. In the Japanese bow, it flies straight and true. And second, in Japan itself, there are once more horseback archers, riding and shooting with the skills developed by their ancestors over one thousand years ago. Hun-style mounted archery is a growing sport internationally, but no one outside Japan does it Japanese style. Not yet.

By the early twelfth century, horseback archery had developed a complex set of fighting rituals. Opposing sides would line up and fire whistling arrows to call upon the gods as witnesses. Then top warriors, boxed into their leather-and-iron armor, would call out challenges to single combat, each boasting his achievements, virtues and pedigree. They would then discharge arrows, either at a distance or galloping past each other. Then, if there was no winner, came a rather unseemly grapple, like sumo wrestling on horseback (or in my mind's eye more like a tussle between two rather old-fashioned sci-fi robots), with each trying to unseat the other. And then came a final bout with daggers. Since both warriors were totally enclosed in armor, the rounds of horseback archery were usually more show than substance, designed to give the individual samurai a chance to display himself and his skills. In one sea battle (Yashima, 1184) between the two great rival families of

the day, the Taira and the Minamoto, the Taira hung a fan on the mast of one of their ships and, to induce their opponents to waste arrows, challenged them to shoot it down. A bowman named Nasu nu Yoichi, on horseback in shallow water, hit it with his first shot, guaranteeing himself immortality for doing what the samurai admired most: winning glory for oneself in battle.

At this time, in the late twelfth century, the Taira and the Minamoto were vying for dominance, each seeking to sideline the cloistered emperor. Their war ended in 1185, when the Minamoto, under their great general Yoshitsune, crushed their rivals in a monumental sea battle. Yoshitsune—a brilliant military leader, but headstrong—was then hounded to death by his equally brilliant and far more devious elder brother, Yoritomo. It was Yoritomo who took a step that would define Japanese administration for the next seven hundred years. With the approval of the emperor (who was in no position to disapprove), he appointed his own officials in every province and estate so that he could wield power across the land. Had this been China, he would have seized absolute power, made himself emperor and established a new dynasty. But that was not the Japanese way. For centuries the emperor had been sacrosanct. Instead, Yoritomo had himself awarded the highest military rank, *sei i tai shōgun*, "barbarian-quelling great general." This ancient title had once referred to the general empowered to wage war against the wild indigenous tribe of northern Honshu, the Ainu. Now its holder, known simply as the shogun, ruled the whole country as top samurai—in effect, military dictator—in the name of the revered but impotent emperor, basing his military government, the *bakufu*, at his HQ in Kamakura.

Under the remote and ineffectual emperor and his no-

tional servant the shogun, Japan became a patchwork of sixty provinces and six hundred estates, all scrapping with their neighbors. Warlord battled warlord, temples raised their own militias, armed bands plagued the countryside.

Warfare was an expensive business even then. No lord or commander could survive without an investment in armor, horses, bows, swords, daggers and fighting men. There arose an élite of landowning warriors—*bushi*—fighting for their masters, to whom they were bound by mutual need, the lord providing land, war booty and protection in exchange for the skills of the specialist warriors, the samurai (originally *saburai*, meaning "one who serves," in particular one who provides military service for the nobility). That was the deal, the Japanese version of the system that scholars call feudalism.

But there was an inherent instability in this relationship. If a samurai prospered, he would win status, power and wealth enough to claim his freedom. Why, as a boastful, independent warrior, would he continue to devote himself to a lord? How could a master ensure his loyalty? How, in brief, could the feudal system be made stable?

The answer was to invest loyalty—to one's lord, not to the far-off emperor—with ever greater significance and mystique, turning it into an ideal more loved than life itself, guaranteeing status and glory in both life and death. An eleventh-century history tells of the Minamoto, future military overlords, and in particular of a warrior called Minamoto no Yoriyoshi and his loyal vassal Tsunenori. In one battle,

> though Tsunenori had broken through the victorious enemies around him, he had barely managed to escape, and knew nothing about what had happened to Yoriyoshi. He

questioned a soldier, who said, "The general is surrounded by rebels. Only five or six men are with him; it is hard to see how he can get away."

"For thirty years now I have been in Yoriyoshi's service," said Tsunenori. "I am sixty and he is almost seventy. If he must die, I intend to share his fate and go with him to the underworld."

He wheeled and entered the enemy cordon.

Two or three of Tsunenori's retainers were present. "Now that our lord is about to die honorably by sharing Yoriyoshi's fate," they said, "how can we stay alive? Although we are merely subvassals, we are honorable men too." They penetrated the enemy ranks together and fought savagely. They killed a dozen rebels—and all fell in front of the enemy.

Holding themselves apart from the aristocrats, intellectuals, peasants and brigands, the samurai became fiercely proud of their toughness and valor, quick to perceive an insult and as quick to avenge it. In war, a warrior equated his very being with extreme acts of bravery and self-sacrifice, especially in the face of overwhelming odds, for this was the way to gain reputation and rewards. In peace, quickness to see an insult was a virtue. At the lowest level, samurai were like the "foot soldiers" of inner-city street gangs; at the highest, like paramilitaries in the government of an old-style South American dictatorship or the well-off enforcers of top Mafia "families," with estates and armies of their own. To survive in this anarchic world, in which power and life could be snatched away in an instant, self-image was vital. Every man had to strut and preen like a cockerel, or seem a loser. The samurai's whole way of life was dominated by their extreme sensitivity to any threat

or insult to their honor, and their near-instantaneous readiness to take violent action in its defense. Only in this way could "honor" be asserted, protected or restored.

Honor cultures are popular subjects with sociologists, who discern certain features in common. Most, for instance, are outside the mainstream of ordinary life: their members do not produce anything, but rather fight each other to control some crucial resource—usually territory—which cannot be created, only seized or defended. Ordinary foot soldiers—young, sexually mature males who dream of power and wealth but have neither—fight for their boss, their territory and their "name," because that, in the end, is all they have. Honor systems involve young men on the lookout for anything that appears to demean them and are eager to make a violent, often fatal response.

But all honor systems also have unique features of their own. To take two examples:

In rural Greece, even as recently as the late 1960s, a man was dishonored if a female relative had sex outside an acceptable relationship. The woman, too, was dishonored. Honor was partly restored by the woman committing suicide, but only fully restored by the man killing either the lover or the woman or both. "Dishonor could be 'washed away' only with blood, and only the men in the family carry the responsibility for the restoration of family name and honor."[1] This was not considered a crime, but was expected and approved behavior. (Similar attitudes still govern "honor killings" in Islamic communities today.)

American street gangs have been subjects of particular in-

[1] Safilios-Rothschild, "'Honor' Crimes in Contemporary Greece."

terest. Though often now identified by their ethnic origins, they are first and foremost defenders of territory, usually naming themselves after streets, blocks or neighborhoods. Gang members are young men who perceive each other as equals, for whom any small breach of etiquette can be interpreted as an insult to the gang, which has to respond with physical violence. Sometimes the rules are so arcane that gang members themselves cannot tell the difference between interest, sympathy and an intended slight. In London these days, best beware of staring at hoodies, in case your gaze sparks a belligerent, "Are you dissing [disrespecting] me?" In ganglands, many a stare has precipitated a drive-by shooting. Yet gang members can operate in—and often graduate into—the real world of jobs and marriage, and "quite often follow the spirit as well as the letter of the laws of proper decorum." Only within the tight little world of gang culture do they feel compelled to defend their honor. As a central figure of one Chicago gang, the Lions, put it: "You got your pride, don't you. You can't let anyone step on you. We know when we do wrong, we really do, but . . . there's some things we have to do." Several researchers have compared the gangs of Chicago, New York, St. Louis and Cleveland to warrior societies. "Just as feudal barons sized up each other's armies, adolescents in street-corner gangs collected information on the heights, weights, fighting skills and weaponry of their rivals."[2]

In the first of these two examples, male honor was defined by women's behavior; in the second, by relationships between equal males as gang members. But samurai honor was not dependent on the actions of women or on territory or on a need to defend others of their kind. It was defined by respect *for* su-

[2] Adamson, "Tribute, Turf, Honor and the American Street Gang."

periors and *from* inferiors. They were at heart prickly dealers in death on behalf of their masters, from whom they received status, power and wealth. This was the original Way of the Warrior: that of the street fighter, the enforcer, the racketeer, the hired gun, with no moral code but to respond to insults, fight for his master and gain glory on the field of battle.

A fine example of the way a samurai would "lift his name" with displays of death-defying valor occurred during the two Mongol invasions of 1274 and 1281—two events that seared the Japanese soul like no others, for several reasons. The Mongols fought dirty, deploying explosive shells delivered by catapult and taking no notice of samurai who expected proper enemies to engage in single combat. These dreadful opponents would have swept away the samurai, but for two strokes of luck, two storms that the Japanese quickly came to see as divine intervention.

Opposing both landings by the vast Mongol-Chinese fleet on Hakata Bay in southwest Japan was a young warrior from Higo province (today's Kumamoto prefecture, immediately north of Satsuma, and not far from Hakata Bay). Later in life he used some of the wealth he had amassed to commission a series of paintings recording his heroic exploits. These were then pasted together, along with a collection of letters, prayers, edicts and battle reports that act as a commentary on the pictures, to make up what have become known as the "Invasion Scrolls." [3] Both fleets were scattered by storms, the second attempt being perhaps the worst naval disaster ever, but in both cases not before this resourceful warrior threw himself into the

[3] Translated and analyzed by Thomas Conlan: see Conlan, *In Little Need of Divine Intervention*.

fray. His name was Takezaki Suenaga, and this is his boastful story.

Age twenty-nine at the time of the 1274 invasion, Suenaga survived several skirmishes when the Mongols managed to break away from the beachhead and advance a few miles inland before the approaching storm forced them to retreat to their ships. Seven years later he's back, and can't wait to prove himself again. This time the Japanese are better prepared, having built a wall the length of Hakata Bay that might just be enough to pin the Mongols to the beaches. Suenaga arrives at the beach on his horse in full regalia—but the enemy are still all out at sea. He's desperate to get at them. With absolutely no interest in acting as a team member and a sublime disregard for orders, he focuses totally on self-serving acts of derring-do.

"I cannot fight them during this crisis without a ship!" he yells.

His commander, Gota Goro, appears indifferent to his frustration. "If you don't have a ship there's nothing to be done."

However, Suenaga isn't the only one chafing at the bit, and another equally gung-ho warrior says: "Let's find a good ship among the damaged craft in the harbor and drive off the pirates!"

"That's right," Suenaga replies. "Those troops would be infantry and their boats would be seaworthy craft. I want to cut down at least one of the enemy!"

So Suenaga, with two companions, searches for a boat to take them out to the invaders. But they can't find one, and are on the point of giving up the search when a Japanese war boat comes by. It's not very big, only about eight meters long, and with ten or eleven people already aboard it's riding low in the water; so while it's handy for getting around the bay, it

won't be much good on the open sea. Gota Goro recognizes it as belonging to Adachi Yasumori, a senior official, and sends Suenaga and his friends off as messengers. They row out in a skiff, and when they get within earshot Suenaga, standing precariously at the bow, yells that he has orders to get on board the next boat and fight. Then, without waiting for permission, he jumps onto the war boat, to the outrage of the captain, Kotabe, who orders him off again:

"This is [Adachi's] boat! Only members of his forces can board it! Stay off this boat!"

Suenaga is in no mood to be docile. "In this vital matter I want to aid my lord. Since I just got on the boat, I am not going to get off and wait for another that may never arrive."

But the captain is adamant. "It is an outrage for you not to leave a boat when you have been ordered to disembark."

No doubt muttering furiously, Suenaga gives way, climbs back into his skiff, and rows on with his two companions. After a while they come across another war boat, this one belonging to an official called Takamasa. Again Suenaga brings his skiff alongside, losing his helmet in the muddle. This time Suenaga doesn't waste time arguing but simply lies:

"I am acting on secret orders. Let me on the boat."

Shouts come from Takamasa's boat: "You have no orders! Get out of here! There's no room for all of you!"

Shamelessly, Suenaga refines his demand. "Since I am a warrior of considerable stature," he boasts, "let me alone get on your boat."

That does the trick. "We are heading off for battle," comes the exasperated reply. "Why must you make such a fuss? Get on!"

He doesn't need to be asked twice. Not only does he leave his two companions behind, as he abandons them he grabs the

shin guards of one of them as a makeshift helmet. He ignores their shouts of indignation. "The Way of the Bow and Arrow is to do what is worthy of reward," he says in his commentary. Not the Way of the Sword, please note. His attitude was still governed by the bow and the *tantō*, the dagger. "Without even a single follower I set off to engage the enemy."

Now he starts to offer advice to Takamasa, urging him to use grappling hooks to get to close grips with the enemy. They won't give up until we board them, he argues. "Once we have them hooked, stab them by impaling them where there is a joint in their armor." Takamasa's crew are not properly armed. Nor is Suenaga, in his makeshift headgear; but this doesn't stop him for a second. With five new companions he finds another puntlike skiff and attacks one of the smaller Mongol ships, about ten meters long, carrying seven Mongol crew and a couple of Chinese officers. A picture shows Suenaga first onboard, in the bow, as his companions storm over the stern. One officer lies dead, his throat cut. Our hero is dealing with the other, about to cut his head off, gripping him by his pigtail and wielding his *tantō*.

Clearly they took the boat, because a later illustration shows Suenaga with his two heads. Returning to shore somehow bearing his gruesome trophies, he reports his deeds to his commander, Gota Goro, who (in Suenaga's account, at least) admires his subordinate's enterprise more than he censures Suenaga's willfulness. "Without your own boat, you repeatedly lied in order to join the fray. You really are the baddest man around!"

Suenaga didn't need to do anything else, because the rest was very effectively achieved by nature, in the form of the first typhoon of the season, which churned the whole fleet to mush—some 4,400 vessels, a number unequaled until the Al-

lied invasion of Europe in 1944—and buried it in mud on the seabed. Suenaga came out of his part of the fray arrogantly convinced of his own bravery, while the Japanese saw the typhoon as the Divine Wind, the *kamikaze*, proving that Japan was under the protection of heaven and would never, ever fall to a barbarian power (hence the name given to the suicide pilots of the Second World War, who would deal with the Americans as the original had dealt with the Mongols). In fact, it is quite possible that the samurai's improved collaboration, their fighting spirit and the wall would have been enough to halt even this massive invasion, as the title of Thomas Conlan's book suggests. Quite possibly the samurai were, after all, *In Little Need of Divine Intervention*.

But after 1281 the Mongols were not enough of a threat to unite the Japanese against a common foe. The country remained a patchwork of squabbling warlords and samurai eager to display their bravery, kill their enemies and die a glorious death in battle. Emperors and shoguns jockeyed for power, top families fought top families, shoguns retained authority only by empowering rival warlords (*daimyos*, "great names" as they were called). It got worse. The century from 1470 is known as the "Period of the Country at War." An eleven-year civil war in and around the capital Kyoto reduced the city to ruins and the imperial court to poverty. The emperors had to abandon ceremonies they could not afford, selling their own calligraphy to make money. With no central authority, local *daimyos* fended for themselves, wringing taxes from their rice farmers, building castles and setting up their own armies with their samurai retainers and their peasant soldiers, developing ever more exotic ways of fighting. Major battles would end with dozens, sometimes hundreds of severed heads being collected for inspection, skin cleaned, hair combed and

often teeth reblackened as fashion dictated: the better the head of the fallen, the greater the victor's glory.

All of which suited the samurai just fine, since their whole ethos centered on loyalty to their lords, their *daimyos*. For four hundred years, the samurai and their descendants—for sons succeeded fathers as vassals—were well served by the system. They became Asia's most successful warrior class, some rich in land, power and wealth, some poor, but all proudly independent, their role accepted by and admired by their society, until 1600, when the final victory of the new top family, the Tokugawa, at last brought the heyday of the real fighting samurai to an end.

2

A YOUNG LIFE
TRANSFORMED

AS A SAMURAI'S SON AND AS THE ELDEST, SAIGO'S FIRST DUTY
was to be educated, and a pretty grim prospect it was for an
eight-year-old.

Once, in the old days of war and anarchy, schooling had
been for the few who could afford Buddhist temple schools. In
the eyes of a medieval samurai, book learning was for wimps.
But after 1600 well-educated scholars and officials were
needed to help with administration, drafting laws and writ-
ing official histories. Shogun and daimyos wanted people with
knowledge of precedents, and established schools to produce
them. They found their sources not at home but abroad, in
China and in the ideals of Confucianism. Students flocked to
great teachers who argued about the best forms of Confucian-
ism and whether its purpose was moral improvement or an aid
to practical government, or both. Learning was fashionable,

literacy the norm for everyone who was not a peasant and increasingly common even among the peasantry, many of whose children learned to read in one of the fifteen thousand village schools. "There is nothing more shameful than being illiterate," wrote Ihara Saikaku, one of the most prolific and influential writers of the period, indeed the first to make a living from his profession. By 1710 there were six hundred publishers and booksellers in Japan, dealing increasingly with Confucian classics in translation.

The new breed of samurai, with the old ways of war barred to them, seized on education as one of the main purposes in life, the real purpose of education in turn being to teach morality (which was after all the justification of many educationalists, from Aristotle in ancient Greece to Dr. Thomas Arnold, headmaster of Rugby School). Through learning one could build a sort of great chain of virtue linking the individual to the body politic and the true purposes of existence: study—knowledge—sincerity—purity—civilized behavior—harmonious families—right government—universal tranquillity. According to Confucian theory, a triumph of hope over experience, human beings were essentially good, and once everyone understood the nature of virtue, everyone would behave well and society would be stable and people would live happily ever after.

What happened to the girls, we may ask, with all the benefits of our twenty-first-century viewpoint? Not much. Few women engaged in the hard business of reading Chinese classics. "Girls were not expected to master a large number of Chinese characters," recalled one woman of her childhood around 1870.[1] "It was regarded as sufficient if they could read the Japanese

[1] Yamakawa Kikue, *Women of the Mito Domain*.

syllabary, and when they reached the age of twelve or thirteen the main focus of their education became learning how to sew." About one in four girls learned to read Japanese poetry and novels, mostly at home, the main purpose of this limited education being to strengthen their acceptance of self-denying obedience to parents, husband and (in widowhood) eldest son. It would be a long, long time before women won economic, social or political power. "When women are learned and clever in their speech," said the late nineteenth-century chief minister and regent Matsudaira Sadanobu, "it is a sign that civil disturbance is not far off."

For boys, it was a hard struggle. One had to go back to those with true understanding who lived in the golden age of ancient China: the sages, including Confucius and Mencius, authors of the Four Books and the Five Classics, as defined and expounded by the Song philosopher Zhu Xi (Chu Hsi). Rulers and teachers agreed that if only everyone, in particular the samurai, would study these books and Zhu Xi's commentaries properly, all disputes would vanish. Sadanobu complained of "scholars who argue and abuse one another . . . like the bubbling of boiling water or the twisting of strands of thread." The answer, he said, was "to put one's trust in the Song teachings." What was good for ancient China was good for modern Japan.

All this meant that no one in Japan knew much of what was going on in the rest of the world. It was only around the time of Saigo's birth that educated Japanese heard about the French Revolution and the American War of Independence over forty years before. Of the wars unleashed by Napoleon's campaigns—not a hint. Few knew of the rise of the British empire, of the colonization of Australia, of British rule in India, of the all-conquering wealth produced by the industrial revolu-

tion. Even when European powers started to push their way into China, few hints of any threat filtered through. When they did, it was a shock, as we shall see.

For scholars and teachers, it was China's past that defined Japan's present. The Chinese and Japanese languages are not related, yet the Japanese (like several other Asian cultures) had adopted thousands of Chinese signs to write their own language. They still use them, in a system known as *kanji*, alongside two other semialphabetical scripts. It seems terribly inefficient to outsiders, but it has worked perfectly well in Japan for centuries. The signs have their own pronunciation in the two languages, which is less odd than it may seem: think of how signs for numbers are rendered in words. For example, the sign "5" is pronounced "five," *cinq*, *fünf*, *wǔ*, *go* and in as many other ways as there are languages. So the Chinese sign for "mountain" (山) is the same in Japanese; but in Chinese it is *shān*, in Japanese *yama*.

However, Japanese reverence for all things Chinese had a peculiar consequence. Children had to read the Chinese aloud as a weird bastardized form of Japanese, having learned many rules about changing the word order and adding particles.[2] So there was Saigo, at the age of ten, parroting *Filial Piety* and *Greater Learning* (the two shortest of the Four Books) without understanding a word. Everything had to be repeated ad nauseam, learned at the rate of half a dozen characters a day, and only after years of study—possibly, with luck, if you were bright—would you understand any of the text well enough to have a conversation about it. This

[2] There have been equivalent systems. In the third millennium BC the Akkadians adopted Sumerian cuneiform signs, though there was no relationship between the two languages.

was tough, earnest, serious, hard work. "When reading, sit squarely upright, maintain an expression of gravity and concentrate," wrote one eighteenth-century educationalist, Kaibara Ekken. "Never glance around or fiddle with your fingers." No one argued that children should have fun, or that curiosity was to be encouraged. For most kids, it was tedious beyond belief. Tsurumine Shigenobu, a nineteenth-century scholar, remembered what it had been like when he started:

> I hated it. My father taught me reading himself and at the mere sound of his summons, "Bring me your *Greater Learning*," I would scuttle off to hide in the storehouse or spend the whole day in the guards' quarters. When I was forced into it I would sometimes get the idea that if I memorized the passage quickly it would be over that much sooner and tried as hard as I could. Then my father would say, "Yes, you've learned it very well. Let's go on to another bit." At which I would burst into tears ... and my father would dismiss me saying I was a hopeless child.

For the young Saigo, education involved a lot more than the Chinese classics, for Kagoshima's system had traits of its own. Over two hundred years previously, all the adult men had gone off on an abortive invasion of Korea, leaving the boys unsupervised, so the town had set up a system by which older boys supervised the younger ones. Eighteen districts, called *goju*, were set up, each one with its own school, in which older boys taught and often terrorized their juniors. School hours were from 6:00 A.M. to 6:00 P.M., with the other twelve hours spent under curfew at home. The regime was strict and highly competitive. *Goju* education emphasized honor, courage, honesty, solidarity and pride in your own school as the

best of the best. It sounds like the British private school system from the days of Dr. Arnold in the mid-nineteenth century up to, say, 1960, based on the classics, sport, the monitoring and ritual humiliation of younger boys, military training, a uniform, homosexuality and physical punishment. It was a system designed to break down and then rebuild, injecting self-sufficiency, stiff-upper-lip endurance and a firm awareness of right and wrong, without asking too many questions about which was which and why. The comparison works only up to a point, as you will see, because the *goju* system prepared boys for a world in which violent death was rather closer than it was on the playing fields of Eton.

After morning classes, there was drill and sports, which often exposed some unfortunate to a mock assault by the class. ("Come on, boy, pull yourself together. It's only a bit of fun.") In the early afternoon the younger kids were taught local "history," in the form of odes and epics praising the feats of Kyūshū's lords, the Shimazu family, back to their twelfth-century origins, and presenting Kyūshū more as an independent nation than as part of Japan ("Remember, lads, this is the finest school in the land and these are the happiest days of your life.")

In the midafternoon came martial arts training, which sometimes meant going to the martial arts school, where the boys could witness men practicing their archery by shooting dogs (I heard several references to shooting dogs as part of martial arts training, but have not found any further details). The key skill was swordsmanship, of a particularly aggressive style known as Jigen-ryū. Most sword schools used bamboo staves, but Jigen-ryū fighters used real swords sheathed in cloth or bamboo to practice their defining skill, which emphasized the need to kill with a single stroke.

In Saigo's day, the closest young samurai got to the feel of steel on flesh involved the bloodthirsty practice described by Katsu Kokichi, an impoverished young samurai struggling to survive in Kyoto at about the time of Saigo's birth. Boys would be assembled in the local jail to witness an execution. When the head of the condemned man fell, they rushed forward to seize the head and the corpse, and competed to bite off a body part. The first to show a chewed-off ear or finger was allowed to make the first practice sword stroke into the body. It is at this point that the *goju*–private school comparison breaks down. My school rugby coach was all for killing the opponents, but he never advocated chewing off bits of them.

They still take Jigen-ryū fighting seriously. The man in charge of it for the Education Board in Kagoshima is Mr. Ebera, a small, intense fast talker who was happy to explain that Jigen-ryū involves two techniques, both intended to kill with one stroke. The first is when you draw your sword, with a deft one-handed upward slice. Then, if that fails, you grab the sword with two hands, raise it high, and go into the two-handed downward chop, which cuts your opponent diagonally from neck to rib cage. He was playacting this in his office, with hands for a sword.

There was something about Jigen-ryū I could not really take seriously. For one thing, it sounded like two strokes. And what happened if you did not kill with either stroke? And how, in today's world, do you practice? Indeed, what had it to do with death at all?

"When was the last time someone was actually killed?"

"Oh, that was . . . sometime perhaps in early Meiji times," which sounded to me like well over a century ago.

"So . . . do they fight each other?"

"No, it's not like Kendo ["The Way of the Sword," still supposedly training for real sword fighting], it's just training."

"And the purpose?"

"It develops physical and mental strength. And patience. It's a preparation for life."

"Do any of the kids have their own swords?"

"Oh, no. No one has used real swords since early Meiji. This is just a piece of wood. But it's part of their training that they have to go into the mountains to cut their own."

How could you train without fighting? This and other questions, he said, could be answered if I saw the boys at practice the following Sunday morning. So my guide, Michiko, and I found ourselves on a square of dark volcanic gravel right by the cemetery devoted to the samurai who died with Saigo. It was an idyllic setting, overlooking the bay, with the volcano, Sakurajima, wearing a cap of cloud. A score of barefoot boys, from seven upward, loosened up under the gaze of two teachers, all of them in black floppy trousers and loose white shirts. Along one side of the square were four supports like sawhorses, each pair bearing a bundle of canes, and along another side staves lying on mats. Warm-up over, the boys seized their staves with two hands and in turn attacked the bundles of canes with tremendous zest, one foot forward with knees bent, each delivering twenty or thirty whacks to the springy bundle while yelling an extended, bloodcurdling "a-a-a-a-ah!" It didn't at all fit the image of the ice-cool samurai warrior killing with a single blow. What it fit best was my very westernized image of an extreme form of anger therapy.

What was the purpose? I asked Mr. Higashi, the senior

instructor—not the master, he hastened to say, because the master was away touring with pupils in the U.S.

"We try to educate young people so they can be responsible for the future of Japan."

I did not see how beating bundles of canes with mock swords would help, but clearly, given the energy and commitment of these kids, that was my problem. It was certainly an aim with which Saigo would have been in sympathy.

As it happened, Saigo's ambitions to become a master swordsman came to nothing, rather suddenly, at the age of twelve.[3] One day, on his way to school, his path crossed that of a boy from another *goju*. Saigo was already noted for his size, which made him the target of a challenge. The two got into a fight, which ended with Saigo knocking his opponent into the ditch. That afternoon, on Saigo's return, the boy was waiting with friends, and carrying his sword. It was sheathed, of course, and the boy's intention was to deliver a revenge beating with it, not to kill. The blow, made in the Jigen-ryū style, double handed, from above the head, struck Saigo hard on the lower part of his right arm. The sheath broke, and the blade made a nasty wound, cutting him right to the bone. At home, being patched up by his mother, Saigo burst into tears, and felt humiliated by his own weakness. Men should be strong and not cry! But the incident had its benefits. Short term, it gave him great "street cred," with other kids being told by their parents: "Be a man, like Saigo!" Longer term, the wound, which never healed properly and left him with a scarred arm for the rest of his life, turned him from sport to scholarship, especially

[3] These details are from Mr. Fukuda, director of the Museum of the Meiji Restoration.

when he moved on from the *goju* to the upper school, the domain's academy, where he mixed with several hundred of Kyūshū's brightest and best.

Here the early work in Chinese classics paid off. For those who got this far, the curriculum was inspiring as well as conservative. Many scholars were unhappy with Zhu Xi as the sole arbiter of Confucianism. They had turned to an early sixteenth-century philosopher named Wang Yangming, founder of a school of Neo-Confucianism, who taught that people did not have to learn good from evil because that knowledge was innate. In Wang's words, "The light of wisdom is in every man's possession." Intuition was fundamental, learning less important than individual enlightenment. Wang had quite a following in Japan, known as the Ōyōmei school, this being the way his name is transliterated into Japanese. His metaphysics was extremely obscure and theoretical, but it had practical consequences, because Wang asserted that enlightenment acquired meaning only through action. The emphasis on the individual (rather than the teacher) and on action had revolutionary implications, inspiring several outbreaks of violence that worried the authorities, who tried to ban Ōyōmei teaching without much success.

Saigo was no revolutionary, and would later seek to combine the philosophies of Zhu Xi and Wang Yangming by turning every act into an expression of virtue. This, he came to believe, was the way to become a sage and be at peace with death. You simply knew what was right if you were true to yourself and could dispense with selfishness.

The child was the father of the man: from Saigo's education sprang the convictions that underpinned three crucial aspects of his character—his passionate sincerity, his determination

SAIGO'S JAPAN

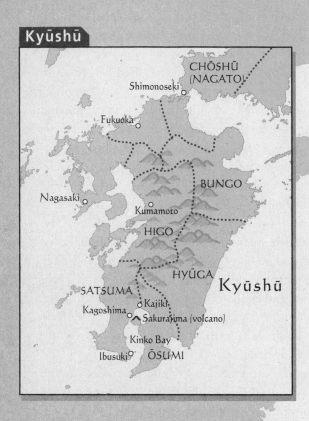

Kyūshū

CHŌSHŪ
(NAGATO)

Shimonoseki

Fukuoka

BUNGO

Nagasaki

Kumamoto

HIGO

HYŪGA

Kyūshū

SATSUMA

Kagoshima ○ Kajiki

Sakurajima (volcano)

Kinko Bay

Ibusuki ○ ŌSUMI

CHINA

East China
Sea

Ryūkyū

Okinoerabu

Okinawa

0 200 km

0 200 miles

TAIWAN

to follow his conscience and his utter disregard for his own survival. As he wrote in a late poem:

> Those things that common men all shun
> Are not feared by the hero, but held most precious.
> When confronted with difficulties, never escape them;
> When faced with worldly gain, never pursue it.

Bright kids came through the upper school strengthened by having mastered a hugely complex discipline. Saigo and his fellow students would have agreed with Kaibara: "There is no pleasure in the world to compare with reading. One has a sense of personal colloquy with the Sages." For those who emerged successfully from their years of education, the samurai agenda conferred huge benefits. There was no religious baggage, because the education was secular, with no priests in control; it gave scholars an optimistic sense that the world was an organized place, ruled by accessible laws; and it injected an awareness of a culture outside Japan. Above all, like many an old-fashioned British private-school education, it gave those who could absorb it a strong sense of identity.

All in all, *goju* education and the domain schools produced some remarkable leaders. One was a friend of Saigo's from childhood, Ōkubo Toshimichi, one of the principal architects of modern Japan, who would remain close to Saigo as both friend and adversary. We will hear much of him later. A statue of him, clad in the frock coat of a Victorian gentleman flapping in the wind, stands near Saigo's birthplace, and a plaque copies the sentiments on Saigo's own: this man is a model for the young today. He and Saigo used to go to meditate with a monk named Musan, head of the Shimazu family temple. Their meeting place is now a tourist site (of course), marked by the Medi-

tation Stone on which they sat, a reminder that Saigo, even as a student, sought to balance his fiery temperament with Zen. Not that it seemed to make much difference.

Satsuma, in Japan's top four provinces in terms of population, size and rice harvest, always felt itself to be special. Cut off from the north by mountains, by Saigo's day it had been self-assertively independent under the Shimazu family for seven hundred years, which made them Japan's oldest ruling house. In the years leading up to 1600 they had opposed the Tokugawa shogun and lost, but were still formidable enough to retain their independence locally in exchange for acknowledging the shogun's supremacy nationally.

Another aspect of Satsuma's uniqueness was Kagoshima's rather unimpressive seventeenth-century castle. At first glance its masonry walls and simple structure—with none of the complex redoubts and high towers of typical domain castles—suggest that the Shimazu were so secure they had no need of defenses. In fact, Tsurumaru, the province's political and administrative heart, relied for protection on a halo of smaller castles that were technically illegal—not that the shogun was going to make an issue of it. "The people are the stronghold," claimed the Shimazus. The town had other unique features. Of its seventy thousand residents, some fifty thousand were samurai and their families, a much higher proportion than elsewhere, the rich ones resplendent in their stone-walled compounds lining the main avenue in front of the castle, the poorer ones huddling in thatched houses like Saigo's toward the sea. Satsuma's people were proud, a little overburdened by their samurai and a mite arrogant.

In addition, the province had a sense that, because it looked south, it was Japan's gateway to the outside world, and vice

versa. In the 1540s the musket-carrying Portuguese made their approach northward from Okinawa, hopping along the Ryukyu Islands as if they were stepping-stones across a river. Along the way, some of them seized a Chinese ship, which was then wrecked in a storm on the coast of Satsuma. Locals rescued them, and as a thank-you the adventurers gave them some muskets. That was the first Japanese had seen of Europeans and their weapons.

Six years later, the first European missionary, St. Francis Xavier, from Spain's Basque country, landed on Satsuma's coast, guided by a local man who had become his disciple in Malaya. So he first preached in Kagoshima, with considerable success. Later the ground on which he cast his seed turned stonier. The shogun did not like the idea of what might follow a mass conversion to Christianity. Oppression followed—twenty-six Franciscans crucified in Nagasaki, among other atrocities. Kagoshima's Christian church, rebuilt after being bombed in the Second World War, has a scanty following nowadays—a forlorn reminder of Francis's disappointed hopes. He is honored in Kagoshima not as a missionary, but as a foreigner who followed the islands northward in the footsteps of the Portuguese traders.

The Chinese were there as well. They considered the Ryukyu Islands their own, without ever forcing the point. Even after Satsuma took them over in 1609, the Chinese went on believing them to be Chinese, mainly because the local king in Okinawa ordered all Japanese into hiding whenever an official arrived from China, while at the same time sending numerous embassies to Kagoshima. Depending on your point of view, the Ryukyu Islands were vassals of the shogun, Chinese vassals, an independent kingdom or vassals of Satsuma, which was itself independent when it felt like it. No shogun could expect to be

taken seriously 1,700 kilometers from his home in Kamakura, in the face of such long-established eminence and free-spirited self-importance.

There are still hints of Shimazu power and prestige in Kagoshima today. The thirty-second lord—by tradition, they always number their generations—is president of the family corporation, which focuses on tourism. Among other things, it manages what used to be its own palatial villa and estate, Sengan'en, with a garden as exquisite today as it was when first laid out by the nineteenth lord, Mitsuhisa, in 1658. To the north is a steep mountain covered with five-needle pines (for this is the northern limit of these tropical trees), with a grove of bamboo introduced from China in the mid-eighteenth century, and an eleven-meter rock face displaying three enormous *kanji* signs one above the other—Sen Jin Gan ("1,000-fathom crag"). A stream wanders in gentle bends through a grassy glade. Here, at summer garden parties in the eighteenth century, gentlemen composed lines of verse, which they floated downstream to be completed by other aspiring poets, their refined literary skills being rewarded with sake offered by kimono-clad women of porcelain delicacy (actually, this part of the garden was later covered by a landslide, but it has now been remade, and locals reenact these garden parties every year). To the south the garden was, and is still, bordered by a hedge trimmed into wavelike shapes, images of the waves of Kinko Bay beyond, all set against a backdrop formed by the decapitated and gently smoking cone of Sakurajima. A restored summerhouse, open on all sides to cooling breezes, recalls the original, a gift from the Ryukyu islanders as a place to receive their embassies. On the lower slopes of the mountain there is a reminder of the Shimazus' attempted conquest of Korea in the 1690s—a shrine to seven cats that the daimyo

brought back with him and turned into cat deities; now you can buy a ready-made prayer to bring your own cat good luck and a long life.

For Japan's culture, China was the epitome, the fount, the origin. So what happened to China in 1840–2—the disaster known as the First Opium War—was almost as much of a shock to Japan as to China. It proved exactly what so many in Japan feared: that foreigners, particularly Europeans, were the bringers of catastrophe, and that Japan had better be ready to repel them.

Europeans—French, Portuguese, Dutch and British—and Americans had been trading with China for three hundred years, through small coastal bases where they made little impact on the mainland and were a welcome addition to the imperial coffers. For the British, trade had grown throughout the eighteenth century, all of it in the hands of the East India Company, which ruled India and many places farther east until the mid-nineteenth century. Britain imported tea in astonishing quantities: over four thousand tons a year in 1800, a figure that would quadruple during the next century. Though privately owned, the East India Company was the right hand of government, and the tax on tea—contributing 10 percent of the government's revenue—was crucial to the British economy. And those were just the official sums. Private adventurers were in on the business as well, buying in China, importing into the Netherlands and smuggling into Britain. To buy the tea, traders used silver, which drained company coffers. They had nothing else that the Chinese wanted—until 1773, when the East India Company took control of poppy growing in Bengal, and found itself with a monopoly on the opium trade.

Demand for opium grew, and so did attempts by China

to suppress the destructive habit. The trade went offshore—basing itself in Singapore, acquired by the British in 1819—and underground. By 1836 commerce in opium was "the world's most valuable single commodity trade in the 19th century." [4] In the main port of entry, Guangzhou, traders paid the East India Company protection money, which the company used to buy tea. No one needed to pay in silver anymore, and European governments breathed sighs of relief. But in China, a shortage of silver caused an economic meltdown. The Chinese government debated how best to control the destructive trade.

In these increasingly chaotic circumstances, the British government moved to impose its own control, sending a commissioner, Lord Napier, to talk to China's top mandarins. They refused to have anything to do with him; he refused to leave, sent for backup in the form of troops from India and retreated to the Portuguese enclave of Macao, where he died of dysentery. London cried for redress; Beijing cheered and became more determined than ever to stem the flow of opium.

A top official and scholar, Lin Zexu, came to Guangzhou as commissioner, rounded up dealers and demanded the surrender of all the available opium. The new British superintendent, Captain Charles Elliot, backed down, and handed over twenty thousand chests of opium, some one thousand tons, which were destroyed in lime pits. Lin then wrote to Queen Victoria, lecturing her on the evils of opium. Though she was surely ignorant of the fact, she should know that "a poisonous article is manufactured by certain devilish people subject to your rule... Our Heavenly Court's resounding might could at any moment control [the opium traders'] fate, but in its compassion and generosity it gives due warning be-

[4] Fairbank, *Cambridge History of China*, vol. 10.

fore it strikes . . . I now give my assurance that we mean to cut off this harmful drug forever." This was tough talk, in Chinese of course, its effect exacerbated by the British inability to understand the language, the tone or the context.

Lin demanded an agreement by the British never again to carry opium. The British refused, and the dispute escalated. Lin pressed the Portuguese to expel the British from Macao, which they did. Elliot led the now rootless British across the Pearl River to a lump of rock named Hong Kong, where they set up a new base. Provisions were ordered, troops requested. In early 1840 a large force left India, approached the river leading to Beijing and delivered a letter from the prime minister, Lord Palmerston, demanding redress for injuries and insults. Lin having been fired in disgrace for allowing events to lead to such a showdown, his successor negotiated a treaty that was at once repudiated by both governments—by China because of its severity, by Britain because of its leniency.

The British task force, which included an iron-clad paddle steamer, went on the offensive. In a few days, British guns sank seventy-one junks and shattered Guangzhou's waterfront. On land, a minor conflict inspired an upsurge of Chinese irregulars, as angry with their own government as with the foreigners: a sign that China was seething with discontent which would eventually explode in rebellion. More British ships arrived with more troops and more demands. Ships advanced up the Yangzi, bombarding and raiding their way to Shanghai and seizing a vital city on the Grand Canal.

The emperor had no choice but to capitulate. By the Treaty of Nanjing, the British got $21 million in silver as compensation, Hong Kong as a colony and the right to trade in five treaty ports. Opium remained illegal, but the smuggling trade continued. To balance this "unequal treaty" the Chinese

government signed many other similar ones, in effect opening China to foreign traders and missionaries. Fourteen years later, a Second Opium War would wring more concessions from a totally discredited Qing government. Foreigners, it seemed, were free to tear at the flesh of a nation and a culture which only a few decades before had seemed utterly impregnable.

When Saigo was sixteen he left school, and for ten years thereafter we hear little of him. He got a job as a low-level clerk, which brought him for the first time into contact with the reality of life in the countryside.

Satsuma had more samurai families—some 40 percent of its 650,000 people—than most other domains, which meant that its peasant farmers had to provide enough rice to feed over 200,000 extra mouths. Its peasants were overtaxed, its samurai underpaid and underfed. At the age of twenty-two, Saigo saw the consequences. Bad weather reduced harvests, but the government allowed no tax relief. The tax director resigned in disgust, a moral stand that seems to have impressed Saigo, who would always be ruled more by morality than practicality. The hardships he saw left him with a lifelong admiration for the frugality and stoicism of rural samurai. He married, in response to family pressure, but soon divorced, apparently without recriminations, and when both his parents died in quick succession in 1852 he was left as head of the family at age twenty-five, looking after his six younger siblings, relying mainly on the pathetic rice stipend inherited from his father. They were as poor as ever, and would apparently remain so. He seemed all set for a life of poverty, hard work and utter insignificance.

But his life was about to be transformed. The man who would work the transformation on both Saigo and Satsuma

was Satsuma's daimyo, Nariakira, who had taken over four years previously in shocking and gruesome circumstances.

Once, everything had seemed set fair for Nariakira. He had been designated heir by his father at the age of three, and gone on to become one of the best and brightest: talented, well-read in both Chinese and Japanese, a brilliant archer, rider and fencer, and all in all a fine product of the shogunal system. Indeed, he owed more to his father's house in Edo, the shogun's capital, where daimyos were required to spend much of their time, than the castle in Satsuma. Like many of his peers from other parts of the country, he never saw his own domain when he was growing up, visiting Kagoshima for the first time only in his midtwenties. So it was in Edo that he became one of the minority who were able to indulge a fascination with western culture.

This unusual interest he owed to his great-grandfather, a collector of Dutch instruments both musical and scientific, who introduced him to a German scientist, Philipp von Siebold, a leading member of the Dutch colony clinging to its base on the tiny island of Dejima off Nagasaki. Von Siebold, one of a family of brilliant scientists, was a doctor, which was what won him the favor of the Japanese. But he was much more than that: he was a polymath who trained Japanese researchers and gathered encyclopedic amounts of information about Japan's flowers, animals, people, language and literature, writing volumes still regarded as prime sources. No wonder he was an inspiration to Nariakira when they met in 1826, the prince being just seventeen at the time. (Von Siebold's legendary zeal ran away with him shortly afterward when he obtained a Japanese map of the country and was thrown into jail, then out of Japan altogether. He would return twenty years later, to be welcomed by the emperor and become for three years the main contact between Japan and Europeans.)

Nariakira, the brilliant and open-minded heir apparent, had enemies. One was his father's mistress, who was determined that her child, Nariakira's half-brother, would inherit. Another was a senior minister, Zusho Hirosato, who had turned around Satsuma's finances and was suspicious of Nariakira's interest in foreign things and people. He supported the ambitions of concubine and half-brother. In the hothouse atmosphere of Edo, rivalry and mistrust turned to mutual antagonism, mainly because Nariakira's five children—all his heirs—died. He suspected witchcraft. An aide reported the casting of spells. Nariakira responded by leaking secrets about illegal trade through the Ryukyu Islands to undermine both the minister and his father. Zusho suddenly died, probably either committing seppuku (ritual suicide by "cutting the belly," on which more later) or taking poison to shield his master. The father, Narioki, sought to preempt a suspected coup by accusing his son's supporters of treachery. Six committed seppuku that same day. In a fury that they had escaped their due punishment, Narioki had two of the corpses displayed on crosses and a third cut up with a saw. According to an undocumented story, one of the victims was a friend of Saigo's father, who witnessed the seppuku and brought home the bloodstained shirt, intensifying Saigo's sympathy for Nariakira. Over the next eighteen months, another fifty were fired, eight more committed seppuku, seventeen were exiled and twenty more were jailed, several of whom died.

This purge turned out to be counterproductive. Other lords, including a senior shogunal official, turned against Narioki in support of his son. In 1850 he accepted the inevitable, and retired. Nariakira became Satsuma's new lord.

At once, he moved to prepare his backward estate for the changes he had seen coming from his childhood visit to Na-

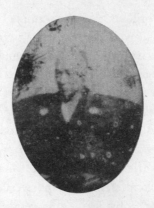

Top: Satsuma's lord, Shimazu Nariakira, in a much-degraded daguerreotype. *Bottom*: Nariakira's industrial area, Shuseikan.

gasaki, and from the humiliation inflicted on China by the First Opium War (Kagoshima's Museum of the Meiji Restoration displays an entry in Nariakira's diary written after news came of the war, with its conclusion that Japan should not follow China, but be prepared to resist). He had seen the foreigners' ships and weapons. He was determined to have both, to fend off the economic and military threat to both Satsuma and Japan, for he believed that wealth could be created to the benefit of all and that strength could come only from unification. A fine oceangoing three-master would replace the little coastal vessels that locals had used for centuries. And industry would thrust province and nation into the modern world, with results that today's tourist board proudly shows to visitors.

Alan Booth, a British travel writer who in 1986 followed Saigo's footsteps on his last journey, quotes a villager who praised Nariakira as the reason why Kagoshima produced so much and so many great men:

> My goodness, there was a lord all right! Talk about work, he didn't know how to stop! He built the steam-powered warships in Japan, the biggest glass factory, a munitions foundry, and the first textile mill to use Western-style looms. He was the first man to set up gas lights in Japanese streets and the first to send messages in Morse code. He spoke Dutch and developed his own photographs. And on top of all that he found time to design the national flag. No wonder they were all workaholics down there, with a lord like Nariakira to kick their asses.

The remains of Nariakira's industrial complex—blast furnace, glassware factory, research institute—lie just beside his

very un-industrial Sengan'en gardens, backed by the same forested hills. Saigo would have seen some one thousand two hundred men at work here, struggling to reproduce forging techniques of which no one had any experience. There were no foreign advisers. Everything had to be done from scratch, on the basis of Dutch manuals. It took over five years to produce the impressive cannon that guards the complex—not in time for Nariakira, whose days were numbered, but (as we shall see in due course) in time to contribute to a significant exchange with British warships.

The local people hero-worship him, literally. In a broad open space at the bottom of Shiroyama, a statue of him stands on a high plinth. It is as if he is a star performer at center stage, the wave of green rearing up behind him like a backcloth. A few meters to the left stands a Shinto temple dedicated to him, its entrance protected by a tree encouraged over decades to grow ten-meter wings and a beak: a crane, a bird that mates for life and is a traditional symbol of loyalty. Behind is the shrine, up four broad steps to three doors.

Under a rope hung with twists of paper to ensure the protection of the spirits was a banner displaying the Shimazu sign, a cross in a circle. Inside, the altar bore a mirror, a sword and beads, traditional symbols of holiness.

"But is it in use, this temple?" I asked Michiko.

"Oh, yes. If we want to get a blessing, the priest will come. And Shinto maidens assist." She pointed into the shadows to two girls in white kimono tops and orange skirts.

This was intriguing. What did they do? How long did they stay? Why?

The Shinto maidens were fairy-tale creatures, hardly more than teenagers, demure, perfect as works of art, hair held by

intricate cloth clasps, and happy to talk. Their answers run together in my memory, as if they spoke as one. "There are five of us, serving eleven priests. When there is a blessing, we play the drum and dance and handle amulets. There is also clerical work. It's full time for us, until we get married." They glanced up. "He will tell you more."

We turned, to see a small man in a similar big-sleeved kimono, with a dark, patterned skirt. He was a priest, one of the eleven. This was his third shrine in forty years of service. He had been here twenty years, happy ones, "because it is for Nariakira, and everyone admires him. It is the most popular shrine in Kagoshima. People bring their new-born children to be blessed here, and bring them back when they turn three, and five, and seven, and when they come of age. At certain times, this place is packed with hundreds of thousands."

I wondered about the status of Shintoism, which was, after all, an ancient animistic religion, and should have declined in competition with Buddhism and today's agnostic tendencies. Not at all.

"Under the Meiji in the late nineteenth century, there was an edict to abolish Buddhism and favor Shintoism. I myself am a graduate of Kokugakuin [set up in the late nineteenth century as the only university which trains Shinto priests]. At the time there was a Buddhist temple right here, so it's a powerful place in religious terms. When Nariakira died, they wanted to make a shrine to him and decided this would be the place. So the Buddhist temple was abolished, and the Shinto shrine took its place."

Shinto would always be with us, because in Shinto everything in nature is sacred, is spiritual, is *kami*.

"While there is nature," he finished, "there is Shinto."

And this shrine. And the memory of Nariakira.

After his father's purge, Nariakira needed to move fast to fill his decimated ranks with loyal, bright, well-educated officials, preferably local, and not senior enough to be connected with the terrible events surrounding his succession. These were still dangerous times. Indeed, Nariakira followed his great-grandfather in keeping a diary in Roman script, so no spy would understand his thinking. He needed eyes and ears, honest ones, discreet ones; men he could brief without formality, who would speak truth to power.

How Nariakira heard of Saigo we have no idea. Perhaps it was his size. He was literally outstanding, a giant when compared to his contemporaries, 1.8 meters tall and 110 kilos, with slablike shoulders and a vast belly, yet athletic enough to wrestle and hunt and walk long distances. In any event, he was right for the job. Mr. Fukuda at the Museum of the Meiji Restoration explained why, putting words into Nariakira's mouth:

"Saigo does not fear authority, nor does he fear evil. He is honest, never telling anything but the truth. He is trustworthy. Therefore he is the kind of man who cannot be manipulated. He is a treasure of Satsuma. No one else can use him. But perhaps I can."

What position could such a low-ranking samurai be given so that he would have immediate access to his lord without arousing the suspicions and jealousy of long-established officials wedded to the old ways? Nariakira had the answer. Saigo was given the job of looking after his lord's magnificent gardens. As Mr. Fukuda explained, being "allowed to be inside the garden, that meant close to his lord." Suddenly there he was, at twenty-six, plucked from obscurity to become part of Nariakira's entourage. It's one of the many ironies about Saigo's life that he acquired a reputation as a conservative,

eager to turn the clock back, yet here he was being given the job of turning it forward, helping to make the industries and political contacts that would build a new Japan.

As Nariakira planned, Saigo came aboard just in time to join his first 1,700-kilometer trek back to Edo.

3

THE WAY OF THE WARRIOR: A SHORT HISTORY OF SWORDS

SEVERAL WEAPONS HAVE MADE HISTORY—THE ENGLISH LONG-bow, the Zulu assegai, the Colt .45, the Kalashnikov—but for artistry, effectiveness, length of service and symbolic significance there's nothing to touch the gorgeous curved samurai sword, the *katana*. By Saigo's time it had been around in much the same form for some six hundred years, and today it is with us still, made in much the same way, and granted an equivalent degree of reverence.

The samurai's sword was his greatest treasure, one that occupied—occupies still—a multidimensional world of magic, spirituality, chemistry, artistry and skill, each aspect with its own arcane vocabulary and traditions, and all focused by the mind and body of the swordsman, ideally at least, into one

or two or three lightning blows. Armor, however exotic and all-encompassing, was no guarantee of protection—and anyway, it slowed you down. The true samurai swordsman wore nothing but his kimono. There was no shield but the sword itself, which was strong enough to deflect a blade that was its equal in resilience and suppleness.

No one man could invent such a weapon. It evolved over centuries, starting with ordinary straight iron swords imported from China in the eighth century. Some of these had one edge, some two; they were good for thrusting and stabbing, Roman style, by infantry, but not so good for slashing, especially with one hand, which was what a horseman needed to do. In the early days, too, the samurai found that their own swords tended to chip when they struck armor. Much harder blades were needed. Horsemen preferred a curved, single-edged, one-handed sword, for the same reasons that the saber found favor in the Muslim and western worlds in the early nineteenth century—effectiveness and fashion. Japanese smiths, many of a renown reserved in the West for the greatest artists, were inspired to innovate. They created several major schools or traditions, each with several subgroups, all of which developed their own variations of the basic sword styles. Lengths varied: some were not much more than half a meter, for quick use on horseback; others, used by infantry against cavalry, were almost two meters long (though not many of these survive because they were cut shorter by later owners). The result, honed over four hundred years, was the unique combination of practicality and beauty so admired by warrior monks, warlords and their samurai enforcers.

If you take the bullet train through the steep green hills north of Kagoshima, you come to Kumamoto, which we shall be

doing in due course, because it was Kumamoto's great castle that halted Saigo in his tracks in 1877. Thirty-five kilometers farther up the coast lies the little town of Arao, once famous for its coal mine, now struggling for a place in the sun with a theme park famous for roller coasters. In a back street, where the modern world falls away, is a workshop that could, in most respects, be medieval. This is where Matsunaga Genrokuro makes swords on which any medieval samurai, and Saigo himself, would have gazed with awe, as modern collectors do. He is one of the 210 smiths who form the All-Japan Swordsmith Association, each of whom has a "smith's name" as well as his own (Matsunaga's is Kiyotsugu), rather as Chinese emperors had reign names, and all of whom submit to regulations that limit their production to twenty-four swords a year each, to guarantee the high quality that has defined the samurai sword for centuries.

Matsunaga is a latter-day alchemist, collecting his own raw iron—he harvests it from the beach, dragging a heavy magnet through the iron-rich sand—and then turning it into steel by heating it in his oven, then hammering, folding and quenching it with water, many times, until the impurities and air pockets and carbon molecules—all the microscopic elements that weaken iron—have been beaten out. This is the process that smiths have been following since the thirteenth century, the only difference being that Matsunaga uses a mechanical hammer to avoid having to employ two assistants.

Steel comes in a range of varieties, from relatively soft and malleable to hard and brittle, depending on the number of times it has been heated, folded, hammered and quenched. This variability allowed smiths to solve the fundamental contradiction of sword making: if it is sharp, it is brittle; if it is resilient and flexible, it can't be sharp. The answer was to combine

in each sword two different types of steel, hard for the cutting edge, softer, more resilient and more pliable for the body. A good sword, folded and hammered and tempered many times, may have tens or hundreds of thousands of laminations (2 to the power of 10 is 1,024; 2 to the power of 20 is over a million) or layers. The cutting edge is targeted for focused treatment by protecting the body with a mixture of clay and ashes, leaving the edge exposed. This creates a transition zone marked by a *hamon* or temper line of crystals, which smiths modify into wavy patterns by varying the application of the clay and ash. The different ways in which the blade and body are treated also create the curve that is so much a part of the sword's beauty, a curve that also confers a practical advantage: a curved blade is not only better for slashing, but also easier to draw, since the drawing arm sweeps in a curve across the body.

The result, when finally sharpened and polished—polishing being a subspecialty of its own—was a thing of both technical wizardry and glittering beauty, simultaneously a tool and a work of abstract art. Experts obsess about points, ridges, temper lines, notches, edges and grooves, with results that are a fog of swordspeak: "The *hamon* is overall *notare*, with *gunome midare* and some *choji*," runs one description of a blade by the fourteenth-century smith Masamune, "and contains bright varied lines of *kinsuji*, *sunagashi* and deep *ashi*." For nonspecialists, truth is better served by poetry and simile. Each blade's grain is like that of wood, the flow depending on whether the smith folds the metal vertically across the width of the blade, or horizontally along its length, or both, making a grain of sea-surface complexity known as "pear skin." Large irregular bands of bright and dark steel are known as "pine bark." The blade is heated until its color becomes "that of the moon in February." The fine frost of crystals that forms the

wave-shaped temper line is compared to smoke, or the Milky Way, or flowing sand, or distant cherry-tree blossoms as seen in the morning sun.

The best blades—sharp as razors, heavy as hand axes, fast as a whip in the right hands—could sever iron helmets, and cut through skin and bone like a kitchen knife through asparagus. In the early seventeenth century there were specialists who tested for cutting efficiency, the results being inscribed on the swords. Tests were made using condemned criminals—a practice known as *tameshigiri*—or their corpses, on which young swordsmen also built up their experience. Tests specified ten different cuts across the body between hips and shoulders, and a particularly demanding diagonal cut, known as *kesagiri*, in which the sword enters at the left shoulder, slices down through the chest and exits at the right hip; some museums have skeletons that have been almost cut in two. There's a story of a criminal condemned to death with this cut who joked with his executioner: "If I had known I would have swallowed a couple of big stones to spoil your sword!" Cuts of comparable length were performed on piled-up corpses. There are swords engraved with an attestation reading "cut three bodies through the trunk," which added greatly to their value. A sword tester named Yamano Kauemon once (it was said) used a sword made by the master smith Yamato no Kami Yasusada to sever five bodies at once, and a blade by the sixteenth-century smith Kanefusa was supposedly used to cut through seven bodies.

What of today's swords? One of Britain's leading *katana* exponents is Colin Young, who studied and trained with Matsunaga sensei (master). Surely, I wondered, a steel blade is a steel blade. Why worry so much about handmade ones? It was a question of shocking naiveté. Without the folding of the steel, there is no grain; without the grain, no real beauty.

And each sword is different, each is chosen to suit—is often *made* to suit—the owner's height, weight, strength and fitness. Some swords may be lightened by the removal of a gram or two of metal along the blade, making a so-called "blood line." Machine made versus handmade? "It's the difference," Colin said, "between a Ford Mondeo and the latest Ferrari." You can pick up a so-called samurai sword on the Internet for a few hundred dollars or pounds. But you should know that one of Matsunaga's takes him six months to make, and will set you back something like 3 million yen (about $30,000). For historic ones, collectors and museums will pay several hundred thousand.

Can modern swords cut as well as old ones? Colin has no doubt he could cut off a limb, "maybe even through a pig, which is what some people practice on." But cutting flesh is passé: these days swords are tested on plastic hoses or rolled-up tatami mats soaked in water. Matsunaga the smith is also a master of Shodai Ryu, a technique derived from samurai swordplay that involves drawing the sword, approaching the plastic or tatami-mat target, cutting through it, resheathing the sword and retreating, all with the correct attitude, formalities and actions.

The best swords had genealogies as detailed as their owners'. One of Masamune's swords is named after the late sixteenth-century general Ishida Mitsunari, whose famous defeat at the battle of Sekigahara in 1600 ushered in the 250 years of peaceful rule under the Tokugawas. Once, a few years before this battle, Ishida was escorted safely to his estate by a son of the man who would later defeat him. As if foreseeing his fate, Ishida gave the sword to his protector, thus ensuring that when he died the sword—the Ishida Masamune, as it is known today—would be safe in the

hands of the ruling shoguns. In Japan's first autobiography, *Told around a Brushwood Fire*, the scholar Arai Hakuseki, writing in the early eighteenth century, recalled his father's words:

> "My own sword originally belonged to a man called Gotō, a native of Kōzuke Province. His elder brother had cut an enemy's head clean in two with a horizontal blow of this sword. Gotō said he used that skull for a plaything when he was a child. After I heard the story, I begged the sword from him for many years, until finally he gave it to me. You must never let it leave your side and must hand it on."

He was referring to the long sword: a samurai had two, long for duels and short for hand-to-hand combat and for committing suicide by "slicing the belly."

Swords also had their own names, a common feature in sword cultures (like King Arthur's Excalibur, Charlemagne's Joyeuse and Roland's Durendal). Arai's sword in the quotation above "is the narrow decorated one called 'Lion.'" One story from the days of the bow, when swords were still in their infancy, tells of how Minamoto Yorimatsu (944–1021), the first of the Minamotos to become famous for his military exploits, used a sword named Dojigiri—the Monster Cutter—to quell the giant fiend Shuten-dōji ("Drunkard Boy"), who lived on human blood. The tale is legendary, but the sword is real: the Monster Cutter was made by the ninth-century master smith Yasutsuna of Hoki, whose work, in the words of one sword history,[1] "possesses a wild beauty that seems beyond mere human contrivance." This sword was one of the "Five

[1] Harris and Ogasawara, *Swords of the Samurai*.

Best Swords under Heaven," the others being the Demon, the Quarter Moon, the Rosary and Great Tenta, all of which survive in museums.[2]

It took high-level alchemy to turn a rough lump of iron into a work of art and a killing device. Nature herself provided the three elements—iron from the earth, fire and water—each of which, in Japan's ancient animistic religion, Shintoism, had its own spirit, lending the sword itself spiritual properties. Making the sword was a spiritual act, for which smiths often underwent purification ceremonies, and the swords themselves were often thought to have personalities of their own. According to one legend, two great smiths, the fourteenth-century master Masamune and his supposed pupil Murumasa (who in fact lived a generation later), decided to compete to see who could make the best sword. They suspended their blades in a river, with the cutting edges facing upstream. Murumasa's sword, named Ten Thousand Cold Nights, cut every fish and leaf that drifted into it. Masamune's sword, Tender Hands, cut nothing but water, because everything floated to one side or another. A watching monk explained the meaning of what had happened: Murumasa's sword was bloodthirsty and evil, with no powers of discrimination; Masamune's was finer, because it "does not needlessly cut that which is innocent and undeserving." Again, fiction and fact are forged together: several signed Masamune blades survive in museums today.

Of course, there is no dueling anymore, no need for *real* samurai. But the traditions live on, in men like Matsunaga. He may not douse himself with cold water to purify himself in preparation for his work, but he still surrounds his forge with

[2] There are dozens of others dating back over a thousand years in Japanese museums, many of them listed online at wiki.samurai-archives.com.

string from which dangle countless twists of paper to encourage the *kami*—the spirits—to give the process the right spiritual aura. And they survive in other rather more dubious ways. Criminal gangs (*yakuza*) punish an errant member by ordering him to cut off bits of his fingers, starting with the little finger of the left hand, the rationale being that this weakens the sword grip and makes an individual more reliant on the boss, thus guaranteeing obedience. In the age of the handgun, the myth of the sword lives on.

And the *katana* blade was just a beginning. Samurai also revered the shorter blade, the *tantō*, used in hand-to-hand fighting. Vast collections and worlds of expertise are devoted to the accoutrements of both: mountings, belts, suspension braids, scabbards, scabbard knobs, hilts, handles, handle covers (ray skin gives a particularly good grip), sword collars, guards—all are subspecialties with their own arcane vocabularies and schools and histories.

Then there was the armor, which underwent its own evolution in response to the growing sophistication of weapons and tactics, from bows and arrows to swords, from infantry to cavalry, from warrior gangs to field armies. In Europe, the knightly armor made to be worn by horsemen eventually turned them into the military equivalent of crabs, so unwieldy that a fallen knight could hardly stand up on his own. In Japan, the style of combat with bow and sword meant that armor had to be kept flexible, which was done by using scores of little plates or scales sewn together to make so-called lamellar armor (in Latin, a *lamina* is a layer, from which comes *laminate*, and its diminutive, *lamella*, is a "little layer" or small piece of something, usually metal). Designs changed. Lamellar armor could be a misery in extreme heat or cold, and the

bindings became heavy in rain and tended to rot, all of which forced experimental variations in scales and single-piece elements. By the sixteenth century, armor had become so rich and varied that a battle array looked like a confrontation among many species of exotic beetle.

A rich samurai's ō-yoroi, or "great armor," had plates and scales bound into skirts and aprons and shoulder pads and shin pads and earflaps, all designed to stop arrows and deflect swords, but also to proclaim wealth and status, and at the same time allow the wearer to shoot and swing and ride and walk. His helmet alone was a work of art. Some helmets were made of dozens of semicircular plates, like the outside of a sliced-up half melon, others of a single piece of metal in a conical shape, like a witch's hat, with a visor and anything up to six side flaps to protect both ears and neck. Some helmets sported vast horns or wave shapes or mountains or crabs (to suggest crablike powers of self-protection) or rabbits' ears (to suggest longevity). The samurai might also have a mask covering the whole lower face, with a detachable nosepiece, a little hole in the chin for the sweat to run through and a built-in grimace to terrify the opposition. Often the inside was lacquered red, which would add a frightening reflected tinge to the warrior's eyes and mouth. It was a simplified version of the samurai mask, helmet and earflaps that inspired the design for Darth Vader from the shoulders up, though he lacks a hole at the top of the helmet through which the samurai passed his topknot or cap. Since the outfit covered the whole body, it was impossible to recognize who was inside, a disadvantage in the heat of battle, so our hero would be a walking, riding flag, gaudy with colored scales and flapping banners. And he would, of course, be carrying his two swords, bow, arrows and spare bowstring.

Though the decoration was rooted in practicality, once the Tokugawas had imposed peace in the early seventeenth century armor increasingly evolved away from its roots, being made not to protect its owner in battle but to proclaim an *image* of militarism, rather as Victorian grandees in England stocked their stately homes with mock medieval armor. For their theatrical marches from province to capital, every samurai lord and every samurai retainer wished to outshine his peers, lord it over lower orders and, in the second half of the nineteenth century, impress foreigners. Real military ability gave way to display. Old armor, once serviceable, was burnished and garnished with excrescences, new armor commissioned with ever more outlandish additions of lacquered scales, and these accretions spread like some sort of skin disease to retainers and their clothing, to horses and their accoutrements—all of it a way of claiming dignity and significance for men who were, after all, mere courtiers and pen pushers.

And, after 250 years of show, what happened to all these glorious accoutrements as the samurai neared the end of their days? They became the equal and opposite of the emperor's new clothes. In that story, the emperor wore none, but was flattered into believing himself richly attired. The samurai were richly attired, but in clothes that meant nothing. A whole class became all outward show, no substance. Over decades, the gorgeous remnants were sold off by a class unable to earn a proper living and snapped up by foreigners impressed not by power or glory but by sheer artistry.

And the swords, the wonderful objects that were the inspiration for the armor? They have entered another dimension. They are still as effective as ever, as anyone knows who has seen one cut through a soaked tatami mat or a plastic pipe. But no one ever again will hear two of them clash in conflict or

see a limb struck off. They are as useless as they are gorgeous, their power carefully controlled by health and safety regulations. Yet it is still there, and people tap into it vicariously. Instead of dealing in death with steel, they wield wooden swords and learn life skills: self-control, physical fitness, concentration and dedication.

4

THE COMING OF
THE AMERICANS

THE JOURNEY FROM JAPAN'S MOST SOUTHERLY PROVINCE TO
the shogun's capital, Edo (Tokyo to us), was an extraordinary
undertaking. It was mid-January 1854: winter, damp, with oc-
casional flurries of snow. Imagine one thousand people, all on
foot, spread out in three columns. Most of them are samurai
warriors in thick winter kimonos, armor of baroque complex-
ity and concave hats, with their two swords, one long and one
short, tucked into the sashbelts; others carry spears or staves.
The only one not on foot is the lord himself, who rides in a
palanquin like a burnished throne (there's one in Kagoshima's
Museum of the Meiji Restoration): heavy blackpainted wood,
lacquered to keep off the rain and decorated in squirls of gold,
with little sliding windows, each one flanked by two red tas-
sels. A black, lacquered beam like a girder runs through metal
clasps attached to the top, so that six men—three in front,

three behind—can carry this 150-kilo burden on their shoulders. For each bearer, that's the weight of a heavy suitcase to be carried for several hours a day, moving at a slow walking pace, to the shouts of arrogant samurai: "'Shita ni iyo, shita ni iyo!' [Get down, get down!], at which all men of low degree go down upon their knees and bow their heads in the dust while the great man passes." (The words were written by Algernon Mitford, one of the most remarkable characters of the Victorian era, who is worth the small digression when I introduce him properly later on.)

Walking for several hours every day, Nariakira's entourage would cover some twenty kilometers a day, depending on the terrain, for six or seven weeks. They circled Kinko Bay, turned inland at a village called Kajiki and struck up into the forested hills. The road would in former times have been a trail of slippery mud and tangled roots leading through firs and stands of bamboo, but this being the main route away from Kagoshima a previous daimyo in the mid-eighteenth century had paved it with great pillowlike slabs of rock. It is still there today, winding steeply upward through the gloomy forest, its stones slick with moss even in high summer. In winter, in armor, let alone carrying the palanquin, it would have been a misery. It took three days to reach the frontier between Satsuma and the next province, Kumamoto, a journey that today's bullet train makes in twenty minutes.

It was the first time Saigo had left his home province. Every day presented some new happening. Everyone knew they were coming. Traders crowded the roadside offering food, sweets and perhaps *shōchū*, the alcoholic drink distilled from sweet potato that Nariakira advocated as a cheaper alternative to sake. Messengers on horseback came and went on business from Kagoshima, or Edo, or other lords, or galloped back and

forth between way stations ahead. After two weeks of travel, they all boarded ferries to cross the few hundred meters of sea, the Shimonoseki Strait, that divide Kyūshū from the main island, Honshu.

Shortly before the crossing, a messenger had brought strange news from Edo: foreign warships had appeared in a bay near the capital. With progress along the coast easier now, it took only a month to cover the next one thousand kilometers, and on April 2, Saigo saw for himself the vessels whose arrival would blow open the country after 250 years of isolation and alter the course of Japanese history. They were the "black ships of evil mien" as the Japanese called them: the fleet of the American Commodore Matthew Perry.

For many ordinary Japanese, Perry's arrival was as amazing as an alien invasion, which is in fact what it was, technically. It was less of a surprise for the government, because they knew he was on his way. A Japanese sailor picked up at sea had spent years in America and had written an account of his stay, which was reassuring, if a little on the thin side. "The people of America are upright and generous," he wrote. "For their wedding ceremony, the Americans merely make a proclamation to the gods, after which they usually go on a sightseeing trip to the mountains. They are lewd by nature, but otherwise well behaved. Husband and wife are exceedingly affectionate to each other, and the happiness of the home is unparalleled. The women do not use rouge, powder and the like." The Dutch in Nagasaki were well informed, and some in Edo knew what pressures were building: that the United States was now a continental power, with whalers ranging the Pacific in need of provisions, traders eager for business and Americans at home and

abroad pressing for action to open up Japan. Every official in Edo knew of the insult delivered to Commodore James Biddle, who in 1845 had come proposing a treaty, been invited aboard an official junk and then, having misunderstood an instruction, been knocked down by a guard. To reinforce the message, the shogun's response was, in brief: sorry, but no trade can be allowed, except with Holland. Soon, given the pressures and America's injured pride, there would be a reckoning.

Here it was, in overwhelming force, personified by its leader. Scion of a naval family, and famous for his efficiency, Perry loomed large. At age sixty, he was as massive in body as in ego, with great bushy eyebrows, carefully curled hair and absolutely no sense of humor. As one of his midshipmen wrote, "No one appreciates a joke less than he does." He, unlike Biddle, would not allow a loss of "face," or anything else. Many feared him, but all respected him for his experience, fair-mindedness and learning. He had commanded the largest fleet in American history in the recent war against Mexico. His main vessel on this voyage, the *Mississippi*, his flagship in the Mexican war, was a three-masted, iron-clad paddle steamer and, he thought, the best ship in the world. He had twelve ships in all, 130 cannon and 2,600 men, enough to make history, as he intended. Forget Manifest Destiny and shore to shining shore: he foreshadowed American imperialism, pure and simple. "It seems to me that the people of America will, in some form or other, extend their dominion and their power, until they shall have . . . placed the Saxon race upon the eastern shores of Asia." Such was the importance of the mission and his own ambitions that he wished to record it himself. In fact he didn't because, as he said, he "had no talent for authorship." Instead, the task was done in three mighty volumes by a friend—ghostwriter, compiler and

北亞墨利加人
ペルリ像

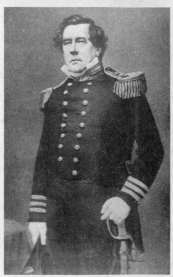

America's Commodore Matthew Perry, in a Japanese print and photograph. He was "as massive in body as in ego, with great bushy eyebrows, and absolutely no sense of humor"—but supremely efficient in opening Japan to the outside world.

editor—named Francis Hawks, doctor of divinity (DD) and of laws (LLD).[1] The books cover everything, from A (anthropology) to Z (zoology), including history, geography, politics and international relations, with particular attention paid to Russia. Luckily, several others on the voyage managed to keep surreptitious diaries, providing historians with other excellent sources. Never was a turning point so well foreseen, made and recorded.

The squadron traveled via China and landed in Okinawa, following the route of many previous foreigners as they approached Japan. Perry then traveled on up the coast with two iron-clad steamers, the *Mississippi* and the *Susquehanna*, and two sloops-of-war, *Saratoga* and *Plymouth*. With the steamers towing the sloops into a contrary wind, guns at the ready, Perry moved slowly through a thin mist toward Edo Bay, admiring the sight of Mount Fuji emerging above its surrounding peaks as the mist lifted. Ashore, the sight of these enormous black ships moving against the wind caused chaos. Fishing boats scuttled for safety, bells rang, ordinary people took shelter, officials gathered at the dockside. Perry dropped anchor just inside the mouth of the bay on July 8, 1853, determined to play high status, "to demand as a right, not to solicit as a favor, those acts of courtesy which are due from one civilized nation to another." He acted like royalty, remaining aloof, seeing only the highest officials, believing that "stately and dignified reserve joined to perfect equity" would earn respect and make the Japanese "suspend for a time their accustomed arrogance

[1] Publication costs, paid by Congress, amounted to $360,000—an equivalent of between $7 million and $10 million in today's terms. Perry got one thousand sets, which he shared fifty-fifty with his ghostwriter. (A thousand three-volume sets! Today, authors get a dozen of their hardbacks.)

and incivility toward strangers." It worked. Not that the Japanese had much choice, because they had only 11 cannon on the bay of the same caliber as the Americans' 130. After many contrived delays and negotiations about who could speak to whom, a letter from U.S. president Millard Fillmore was forwarded to the emperor, demanding a treaty to allow trade, guarantee the security of shipwrecked whalers and allow refueling. Perry—His High and Mighty Mysteriousness, as the Japanese called him—said he would be back the following year, and departed, to spend the winter, such as it was, in Hong Kong and Okinawa.

For Japan, Perry's demand was a crisis. Rejection would mean war, and disaster. Acceptance would mean the end of 250 years of isolation, and disaster of a different kind. Extremists denounced any contact with foreigners as pollution. The shogun was dying, and incapable of a decision. Opting for the lesser of two evils, the chairman of the shogun's council of elders finally decided to accept some form of treaty, with as many limitations, caveats and delays as possible.

But when Perry returned in early 1854 he was in no mood for delay and determined to get his way by any peaceful and diplomatic means. Other vessels had arrived to augment his force: the steamship *Powhattan* and two other sailing ships. This time he did not stop at the mouth of the bay but sailed straight up it as if to threaten the great castle of Edo itself, to the consternation of the Japanese. After days of negotiation, the squadron moored off what was then a fishing village, now the city of Yokohama. Here, in a hall of unpainted pinewood specially built for the purpose, Perry and the Japanese met. They professed undying friendship—which put both sides on steep learning curves, with many a surprise along the

way—and exchanged presents. The Americans' gifts, which filled several boats, included rifles and pistols galore, a set of Audubon's *Birds of America*, champagne, telegraph equipment and a miniature steam train, complete with tender, passenger car and rails. The Japanese gave, among other things, richly decorated writing instruments, tableware and three hundred chickens. They also put on a show of twenty-five sumo wrestlers, the first recorded by westerners in terms now familiar to all from seeing the sport on television: "their scant costume, which was merely a colored cloth about the loins . . . revealed their gigantic proportions in all the bloated fullness of fat and breadth of muscle." The largest wrestler was introduced to Perry, who "passed his hand over the monstrous neck, which fell in folds of massive flesh, like the dewlap of a prize ox." When they were asked to clear a space by moving fifty-five-kilo sacks of rice, one of the wrestlers carried a sack in his teeth; another, "taking one in his arms, turned repeated somersaults . . . with as much ease as if his tons of flesh had been so much gossamer."

Everything about the one side fascinated the other. The Americans were astonished by the way married Japanese women blackened their teeth,

which is done with a mixture of vile ingredients, including filings of iron and sake . . . This compound, as might be naturally inferred from its composition, is neither pleasantly perfumed nor very wholesome. It is so corrosive, that in applying it to the teeth, it is necessary to protect the more delicate structures of the gums and lips, for the mere touch of the odious stuff to the flesh burns it at once into a gangrenous spot . . . The effects of this disgusting habit are

more apparent from another practice which prevails with the Japanese as with our would-be civilized ladies, that of painting the lips with rouge. The ruddy glow of the mouth brings out in greater contrast the blackness of the gums and teeth.

It did not apparently occur to the Americans to wonder why such a "disgusting" habit should also be such an ancient one (answer: it protected the teeth from decay). The Japanese, many of whom recognized their ignorance of the wider world and their need for its products, were intensely curious, asking, looking, drawing and taking notes on guns, small arms, ropes, engines and clothes, with a "peculiar passion for buttons." There were many feasts, the Japanese surprising the Americans with what Americans would later call doggy bags, sweeping scraps together into long pieces of paper which they kept folded under their kimonos and hiding the "unsavory parcels" in their sleeves. This was not from "gluttony or a deficiency in breeding; it was the fashion," which they insisted the Americans also adopt.

After such effusive displays of friendship, the signing of the treaty on March 31, in English, Japanese, Dutch and Chinese, was a formality. Japan opened two remote ports, promised supplies when needed and agreed to the appointment of an American consul. It was, in Mitford's words, "the thinnest ghost of a treaty," soon to be superseded; but it was a start.

Two days later, Nariakira's slow-moving entourage came by on its way to Edo, traveling along the Tōkaidō, the southern route from Kyoto along the coast, staying at the fifty-three official way stations and having documents checked at the barrier eighty kilometers short of the capital. From the way station at Kanagawa, where the road dropped down to the

coast, Saigo had a view of little Yokohama, the wooden treaty hall and the seven American ships lying at anchor out in the bay. In all likelihood, the historian Mark Ravina suggests, they were "the first large-scale foreign objects Saigo had ever seen." Nothing could have been a clearer statement that the times were changing, and that Japan was way behind them.

5

THE WAY OF THE WARRIOR: CUTTING THE BELLY

IN MEDIEVAL TIMES, THE SAMURAI'S MAIN PURPOSE IN LIFE was to prove to his lord his courage and élan, which would win him status, power and wealth. But having gained these, he became a potential threat to his lord: how could a master ensure the loyalty of a bold, wealthy, powerful warrior? In the early days, he couldn't; turncoats were as common as loyalists.

The answer to this conundrum lay in making loyalty the ultimate virtue, guaranteeing status and glory both in life and in death. An eleventh-century tale captures the spirit of the warrior's ideal: "I stand ready to give my life in your service, pledged Takenori. I look on it as nothing more than a feather. Though I may die facing the rebels, never shall I turn my back on an enemy in order to live."

But death-defying bravery and an overriding ideal did not guarantee victory. What should the loser do, if he happened to

survive? The answer lay in the concept of loyalty unto death. This was first taken to its logical conclusion by Minamoto no Yorimasa, whose revolt against the ruling Taira clan was crushed in 1180 (revenge and final victory came five years later). When he saw all was lost, he was determined to die while his sons held off the enemy. He ordered an aide to strike off his head, but the aide refused, weeping, saying he could not do it while his master lived. "I understand," said Yorimasa, and retired into a temple. In one version of the story, he joined his palms, performed a Buddhist chant and wrote a poem on his war fan:

> Like a fossil tree
> Which has borne not one blossom,
> Sad has been my life.
> Leaving no fruit behind me.

Finally, he released his spirit, which traditionally resided in the abdomen, by thrusting his short sword into his belly. This was the first recorded instance of the painful and messy act usually known to outsiders as hara-kiri, which Japanese more commonly call seppuku.

"Cutting the belly" became an established way to avoid the disgrace of defeat. One of the best-known and most dramatic examples occurred in 1333, after a rebellion brought the Kamakura shogunate to an end. The rebels forced the shogun's troops to flee from Kyoto for fifty kilometers along the shoreline of Lake Biwa to a temple in the little post town of Banba (now part of Maibara). The story is told in the collection of war stories known as the *Taiheiki* (*Chronicle of Grand Pacification*), which, like the tales on which Homeric epics were based, were sung by blind bards before being collected to-

gether. In this tale, five hundred warriors gathered in the courtyard before the single-room temple. The general, Hōjō Nakatoki, saw that the end was near, and addressed his men in a moving speech:

> "I have no words to speak of your loyal hearts . . . Profound indeed is my gratitude! How may I reward you, now that adversity overwhelms my house? I shall kill myself for your sakes, requiting in death the favors received in life . . ." He stripped off his armor, laid bare his body to the waist, slashed his belly and fell down dead.

There was no expectation that anyone else would copy him. But at once, one of his vassals responded: "How bitter it is that you have gone before me! I thought to take my life first, to prepare the way for you in the nether regions . . . Wait a bit! I shall go with you." Seizing the dead man's dagger from his stomach, "he stabbed his own belly and fell on his face, embracing Nakatoki's knees. And thereafter four hundred and thirty-two men ripped their bellies all at once. As the flowing of the Yellow River was the blood soaking their bodies; as meats in a slaughterhouse were the corpses filling the compound."

The description is, of course, highly poetic, capturing the elements—commitment, failure, intense emotion, formality—thought essential by those who listened to it. But there was no exaggeration in the numbers: a priest recorded the names of 189 of those who killed themselves that day; the same priest had gravestones made for all 432, which still stand, running in five lines up a gentle slope.

Since relationships between lord and vassal varied in strength, vassals were free to make their own decisions. A member of a household might feel his lord's death as his own,

and choose death; a mercenary who would be able to offer his services to another lord could well choose life, as would a landowner with a workforce to look after. In this case, several dozen chose to live. Either way, living or dying, the samurai was asserting his control over his destiny and pride in his elitism.

After 1600, if the samurai could not live with dignity and pride, they could at least die with both. Seppuku remained the ultimate way for the samurai to preserve honor when faced with ignominy. With defeat on the battlefield removed from the equation, it became a crucial part of the samurai's sense of identity, undertaken either by choice to escape disgrace, or as a form of self-imposed execution ordered by the lord. For high-level samurai, it became the only acceptable form of capital punishment, avoiding the ignominy of a trial or enforced beheading.

But the act—the motivation, the decision, the consequences—involved many paradoxes. A famous example, perhaps the most famous of all, took place in 1701. By then, every daimyo had to maintain a residence in Edo and come to court twice a year, a system that demanded much time and money—the vast retinues, the weeks of travel, the displays of wealth, the endless rituals—and made the daimyos in effect hostages to the shogun.

That year, 1701, Lord Asano Takumi no Kami from Aki (present-day Hiroshima prefecture) was due to attend the shogun, having been chosen to entertain envoys from the imperial family. Head of protocol was a certain Kira Kozuke no Suke, a man who expected to be paid for instructing the lords in exactly how to behave in the court rituals. Asano, arguing that no man should be paid extra to do his job, did not pay, and Kira treated him with contempt during the lessons on pro-

tocol, until Asano, driven beyond endurance, drew his sword and tried to kill Kira, who escaped with slight wounds. Drawing a sword in anger was against the law, and doing so in the imperial palace a double crime. After an investigation by the inspector general, the shogun ordered Asano to commit seppuku, and his clan's assets were seized. His forty-seven followers were devastated: their master dead, they saw a future as lordless samurai, *ronin*, destined to wander, seeking whatever work they could find, perhaps eventually falling into destitution.[1] They swore revenge. For a year they waited, taking odd jobs, their leader adopting a dissolute life to allay suspicion. One snowy December night, the band attacked Kira's mansion (losing one of their number in the fight), found him, killed him, took his head to where their master was buried, and gave themselves up to the authorities.

The shogun was in a tricky position: Asano had been popular, his suicide a scandal, his followers admired and Kira widely loathed. But in the end he decided that the law demanded the death sentence and ordered the surviving forty-six to commit seppuku. This they did, winning instant fame for their loyalty to the spirit of Bushido, the samurai's code of honor. They became known as the League of Loyal Hearts (Chushingura), and have since become the subject of countless stories, plays and films, their motives and actions analyzed ad nauseam: Should the shogun have acted against Kira? Should the *ronin*

[1] Mitford defines the term *ronin* as follows: "Literally a 'wave-man'; one who is tossed about hither and thither, as a wave of the sea. It is used to designate persons of gentle blood, entitled to bear arms, who having become separated from their feudal lords by their own act, or by dismissal, or by fate, wander about the country in the capacity of somewhat disreputable knights-errant, without ostensible means of living, in some cases offering themselves for hire, in others supporting themselves by pillage." See Freeman-Mitford, *Tales of Old Japan*.

have acted sooner? Should they have committed seppuku at once, on the grave of their master? Given the popularity of the subject and the shrine, there seems little chance that the story will ever lose its appeal.

By the day of the forty-seven *ronin*, the act of seppuku had acquired all the ritual of a religious ceremony: a bath, the proper dress and hairstyle, towels to absorb the blood, two tatami mats covered by a white sheet, the careful presentation and consumption of two cups of sake and some food, a poem, a close friend or servant standing by with a long sword, a small group of onlookers to verify the act, a kneeling posture to ensure a fall forward rather than backward: then the dagger in the belly and finally, to ensure a speedy death, decapitation by a single sword stroke delivered by the aide. All samurai knew the ritual, in the unlikely event they would have to do it and the rather greater possibility that they might have to act as witnesses. In fact, as time went on, the event became less an evisceration and more a decapitation: at the moment the accused reached for his sword—which occasionally was either a dummy or simply a symbolic fan—his aide, the *kaishaku*, beheaded him.

This final swift action supposedly had a specialty of its own. As Yamamoto records, "In the practice of past times, there were instances when the head flew off. It was said that it is best to cut leaving a little skin remaining so that it does not fly off in the direction of the verifying officials."

Was this true? Was there ever a *kaishaku* who could cut with such accuracy? Well, possibly, because aspiring swordsmen were allowed to practice on the bodies of newly executed criminals. Here is Katsu Kokichi, the young samurai we met in chapter 2: "One day I went to the shogunate prison in Senju and tested my sword on the corpses of criminals who had been

executed. After that I became a student of Asauemon [the official executioner] and learned how to lop off the heads of corpses with a single stroke."[2] It is conceivable—just—that the perfect aide would practice enough to be able to end his strike a few millimeters short of complete severance, but I still don't know if anyone ever actually did it.

To outsiders, seppuku sounds like a form of insanity. Far from it; or at least far from any common definition of insanity. It only seems mad to outsiders because ritual suicide in public in any form is rare, and in this form unique to Japan. In fact, seppuku was undertaken by men in full possession of their reason and well practiced in the control of their emotions. Suicide is not necessarily an act of irrational despair; indeed, it can be seen as one of supreme rationality. In his essay *Bushido: The Soul of Japan*, written in 1900, Inazo Nitobe pointed out that in seppuku men could, at a stroke—literally—"expiate their crimes, apologize for errors, escape from disgrace, redeem their friends, or prove their sincerity." But it could not be done when in the grip of passion. "None could perform it without the utmost coolness and composure."

Is there any equivalent in any other culture? It shares elements of other forms of suicide: killing oneself to save others, or in response to social pressure, or as a means of nonviolent protest, or at the behest of some religious master. But seppuku is unique in that it was not done solely for any of these reasons, but because suicide was the only way for the disgraced individual to remain, in his eyes and the eyes of others, part of his group. Perhaps the closest in spirit was the Hindu act of suttee (*sati*), in which a widow voluntarily immolated herself on her dead husband's funeral pyre. The practice

[2] Katsu, *Musui's Story*, p. 11, footnote.

was banned by the British in 1829, mainly because it was often done under duress. But, if freely chosen, *sati* shared with seppuku an acceptance by the protagonist that identity was above life itself. The loss of identity, in life, would be a form of death; conversely its preservation, even in death, was a form of life.

Perhaps the oddest form of seppuku was the suicide performed upon the death of one's lord (a form of seppuku called *junshi*). In medieval Japan this had been rare, but it became quite common after 1600, perhaps reflecting the internal conflicts that samurai suffered in these peaceful times. When Tokugawa Tadakichi died in 1607, five of his followers committed suicide. On his deathbed in 1634, Sake Yoshinobu expressed the wish that no vassal should follow him in death even though "it is the fashion in contemporary society." Two did so anyway, and the fashion intensified. After one lord's death in 1636, fifteen committed suicide; in 1657, twenty-six. Eventually, in 1663, the practice was officially banned, though it still occurred occasionally.

As the rituals lost purpose, they gained in dramatic form. The result was recorded by the eminent diplomat and writer Algernon Mitford, who deserves a proper introduction. In the 1860s he served in the British embassy in Tokyo. An extremely handsome man, he supposedly had two children with a geisha, then nine legitimate children. According to rumor, he also had an affair with his wife's sister, Lady Blanche Ogilvy, which produced another illegitimate daughter, Clementine, who was to become the wife of Winston Churchill. Blanche dismissed the rumor: Clementine, she said, was fathered by another of her many lovers. Back home, Mitford was involved in the restoration of the Tower of London and the landscaping of Hyde Park, and inherited an estate, a new name and a title, becoming a Freeman-Mitford and Baron Redesdale. He was also

a noted historian, linguist and ethnologist, which is why he comes to our attention. In Japan, having picked up Japanese in a year, he collected a mass of material that he turned into two volumes of memoirs and a third entitled *Tales of Old Japan*. In this he recorded the first of the few foreign eyewitness accounts of a samurai committing seppuku, and surely the most vivid.

It occurred in early 1868, in Hyōgō (today's Kōbe), shortly after its port had been opened to foreigners, to the fury of those locals opposed to all foreign links. Troops set upon a Frenchman, and were then ordered by their commander to open fire at a crowd of foreigners, including some ministers. The Japanese soldiers had only recently received their rifles, so by chance the shots went high, inflicting only slight wounds on two men. Even so, the officer who gave the order to open fire was condemned by the emperor and ordered to commit seppuku, in the presence of seven foreign representatives who would witness that justice, if you can call it that, had been done. The foreigners discussed interceding for the officer's life, but finally agreed that mercy could be mistaken for weakness.

The seven, together with a matching number of Japanese, were ushered into the temple where the ceremony was to be performed. Mitford recorded not only the shocking details, but also the formality and reverence of the scene—and "scene" is the word. This was a drama, played out with powerful yet restrained emotions, rising to a sudden and horrifying climax. Like tragedy, it inspired awe, and sympathy, and also a sense of completion.

It was an imposing scene. A large hall with a high roof supported by dark pillars of wood. From the ceiling hung a profusion of those huge gilt lamps and ornaments pecu-

liar to Buddhist temples. In front of the high altar, where the floor, covered with beautiful white mats, is raised some three or four inches from the ground, was laid a rug of scarlet felt. Tall candles placed at regular intervals gave out a dim mysterious light, just sufficient to let all the proceedings be seen. The seven Japanese took their places on the left of the raised floor, the seven foreigners on the right. No other person was present.

After the interval of a few minutes of anxious suspense, Taki Zenzaburo, a stalwart man of thirty-two years of age, with a noble air, walked into the hall attired in his dress of ceremony, with the peculiar hempen-cloth wings which are worn on great occasions. He was accompanied by a *kaishaku* and three officers, who wore the *jimbaori* or war surcoat with gold tissue facings . . .

With the *kaishaku* on his left hand, Taki Zenzaburo advanced slowly toward the Japanese witnesses, and the two bowed before them, then drawing near to the foreigners they saluted us in the same way . . . Slowly and with great dignity the condemned man mounted on to the raised floor, prostrated himself before the high altar twice, and seated himself [i.e. knelt, as Mitford explains in a note] on the felt carpet with his back to the high altar, the *kaishaku* crouching on the left-hand side. One of the three attendant officers then came forward, bearing a stand of the kind used in the temple for offerings, on which, wrapped in paper, lay the *wakizashi*, the short sword or dirk of the Japanese, nine inches and a half in length, with a point and edge as sharp as a razor's. This he handed, prostrating himself, to the condemned man, who received it reverently, raising it to his head with both hands, and placed it in front of himself.

After another profound obeisance, Taki Zenzaburo, in a

voice which betrayed just so much emotion and hesitation as might be expected from a man who is making a painful confession, but with no sign of either in his face or manner, spoke as follows:

"I, and I alone, unwarrantably gave the order to fire on the foreigners at Kobe, and again as they tried to escape. For this crime I disembowel myself, and I beg you who are present to do me the honor of witnessing the act."

Bowing once more, the speaker allowed his upper garments to slip down to his girdle, and remained naked to the waist. Carefully, according to custom, he tucked his sleeves under his knees to prevent himself from falling backward; for a noble Japanese gentleman should die falling forward. Deliberately, with a steady hand, he took the dirk that lay before him; he looked at it wistfully, almost affectionately; for a moment he seemed to collect his thoughts for the last time, and then stabbing himself deeply below the waist on the left-hand side, he drew the dirk slowly across to the right side, and, turning it in the wound, gave a slight cut upward. During this sickeningly painful operation he never moved a muscle of his face. When he drew out the dirk, he leaned forward and stretched out his neck; an expression of pain for the first time crossed his face, but he uttered no sound. At that moment the *kaishaku*, who, still crouching by his side, had been keenly watching his every movement, sprang to his feet, poised his sword for a second in the air; there was a flash, a heavy, ugly thud, a crashing fall; with one blow the head had been severed from the body.

A dead silence followed, broken only by the hideous noise of the blood gushing out of the inert heap before us, which but a moment before had been a brave and chivalrous man. It was horrible.

The *kaishaku* made a low bow, wiped his sword with a piece of rice paper which he had ready for the purpose, and retired from the raised floor; and the stained dirk was solemnly borne away, a bloody proof of the execution.

The two representatives of the Mikado then left their places, and, crossing over to where the foreign witnesses sat, called us to witness that the sentence of death upon Taki Zenzaburo had been faithfully carried out. The ceremony being at an end, we left the temple.

The ceremony, to which the place and the hour gave an additional solemnity, was characterized throughout by that extreme dignity and punctiliousness which are the distinctive marks of the proceedings of Japanese gentlemen of rank; and it is important to note this fact, because it carries with it the conviction that the dead man was indeed the officer who had committed the crime, and no substitute. While profoundly impressed by the terrible scene it was impossible at the same time not to be filled with admiration of the firm and manly bearing of the sufferer, and of the nerve with which the *kaishaku* performed his last duty to his master.

Such was the tradition that Saigo absorbed from his earliest years. This was the end to which he would aspire, if things went wrong.

6

NEW WORLD, NEW LIFE

FOR A PROVINCIAL IN TOWN FOR THE FIRST TIME, EDO BAFFLED, challenged and dazzled. This was no imperial city—the emperor was four hundred kilometers away in Kyoto, in semi-divine remoteness—but Edo, the seat of the shogun, was the center of real power, wealth, entertainment, fashion and trouble.

Around the shogun's great castle and palace pressed everything that Japan's élite needed and wanted in an economy fueled by the needs and wants of the daimyos, the provincial lords whose regular presence was required by law. The palace-castle had spawned 18 great palaces and 270 or so smaller ones, each of which was a little universe of officials, servants and men-at-arms who had to be fed and serviced and entertained. Often, a street would be filled by a procession, its lordly palanquin accompanied by ranks of scowling samurai ready to whip out their swords. The economy was fueled by rice, which flowed

from the domains into the hands of merchants who acted as bankers and suppliers. By the mid-nineteenth century, Edo was one of the world's great cities with a population of over a million, bigger than fast-growing New York, on a par with Beijing and Paris (though still only one third the size of London, the world's biggest city). Visually, its charms were limited: apart from its grand palaces, it consisted of single-story buildings and narrow streets. "A bird's eye view of Edo," wrote Mitford, "is exactly like the view one gets when some Lowland cattle farmer takes one to a small eminence and shows one his cattle sheds in an interminable parallel line." But everything was to hand, from high to low. In theater-and-restaurant districts, merchants bought the attention of exquisite geishas and patronized fashionable Kabuki plays, with their elaborate scenery, bravura male-only performances and lively music. To the south were the back-alley prostitution dens of Shinagawa. Mitford had vivid memories of the Shinagawa district, on the main highway into the city, where poor samurai strutted and died as vengeful street fighters, with no master but their violent ways:

> The great straggling city swarmed with men-at-arms, some of them retainers of the different nobles, others *ronin*, desperadoes who had cast off their clanship . . . ready to draw blood on any or no provocation. Clan feuds, broils in which much blood was shed, were of common occurrence in that City of the Sword. Kataki-uchi [enemy slaying], a Japanese version of the Corsican vendetta, was one of the sacred duties of the samurai. "You killed my brother—I must kill you; and, cutting off your head, I must lay it upon my brother's grave, leaving the small knife of my dirk in your ear, as a gallant gentleman should, in order that your brother may

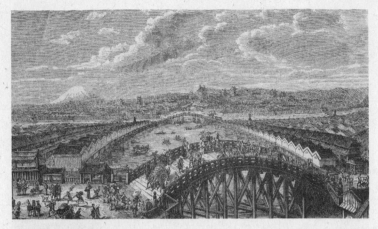

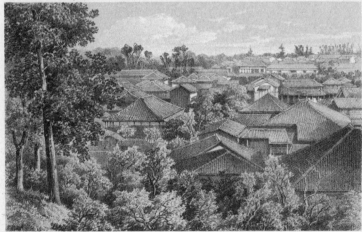

Away from the shogun's castle, Edo (today's Tokyo) in the 1860s was a mass of single-story buildings and narrow streets.

recognize the murderer and come and kill me—if he can."
The teahouses of Shinagawa, the suburb of Edo nearest to
Yokohama, could tell many a story of deadly encounters.
More than once, riding through that sinister and ill-famed
quarter at early dawn, we would come upon bloody traces
of the night's debauch. Under the heady fumes of the hot
sake men's blood would boil to fever point . . . An angry
word, a fierce dispute, a cry of hatred, a flash of cold steel—
and a headless body would be spouting blood upon the
mats.

If you had to go carefully in the streets of Edo, you had
to go equally carefully through the byways of the capital's
politics. Saigo, in his late twenties, was a young man of
intuition and action who did not seem at first cut out for dip-
lomatic delicacy. One of Nariakira's aides introduced him to
a new ideology that had seized the minds of many Edo intel-
lectuals, all the more since Perry's arrival. It was the form of
loyalism developed in Mito, one hundred kilometers north-
east of Edo, that wished to reject all dealings with foreigners.
The lords of Mito were descended from a side branch of the
Tokugawas, which inspired in them an inordinate, almost re-
ligious love of the emperor and the status quo. This they had
long justified by supporting an immense work that involved
writing the biographies of all emperors back to the sun god-
dess Amaterasu, a fairy-tale project that had already taken two
hundred years, and would take another fifty yet: the results
would not be published until 1906. Its basic proposition was
short, simple and very traditional: the emperor was divine and
reverence for him would protect Japan. His task was to reign
in glory, while the mundane job of ruling was to be done by
the shogun and the domain lords. Foreigners were anathema.

Sonnō jōi! was their slogan. Revere the emperor! Expel the barbarians—traders, diplomats, Christians, all of them!

This was the nationalistic ideology that seized Saigo's imagination soon after his arrival in Edo. He wrote that listening to Fujita Tōko, one of the senior exponents of "Mito learning," was like "bathing in the pure spring water: all unrest and confusion disappear." If Fujita's lord were to crack his whip and "lead the way against the foreigners, I would rush in without hesitation." Mark Ravina, in his superb biography, argues that Saigo's introduction to "Mito learning" was a turning point. Before, the emperor had not seemed all that important. Now, emperor worship became a passion that resolved all contradictions and conflicts. Did this passion threaten his commitment to Satsuma and Nariakira? Not at all, because they were earthly, while the emperor, with no army, navy, treasury, law courts or currency, was divine.

So when his lord's only surviving son died of dysentery in mid-1854, Saigo was free to stoke his passionate devotion to Nariakira to greater intensity. As when earlier children had died, people spoke of witchcraft by Nariakira's mistress, Yura, on behalf of her son, who was now a probable successor. Again, as if living out what he had learned in school, Saigo was aflame for action: intuition plus action would solve this and all life's problems. He longed to slay Yura, he wrote, expecting to be executed himself and thereby to "achieve the great peace of death and leap to the heavens." Was he serious? Not enough to take action on his own account; but if Nariakira had given him the go-ahead then yes, probably.

Such loyalty soon won him a political role, and involvement in affairs that were complicated, to say the least. This is a condensed version:

The shogunate was in disarray. The thirteenth shogun,

Iesada, successor to the one who died during Perry's visit, was in poor health, probably suffering from epilepsy. At the age of thirty, he had already had two wives, both of whom had died childless, and was now due to marry Nariakira's own daughter, Atsuhime; however, there had been numerous delays, and it seemed unlikely that he would father any children, so he needed to nominate an heir, a choice that would be rubber-stamped by the imperial court in Kyoto. One possible successor was the seventh son of the isolationist lord of Mito, Keiki. Adopted into a branch of the Tokugawa family with close links to the shogunate, Keiki had several names. As the head of his adoptive family, he became Yoshinobu. We shall hear more of him later, when he becomes the last shogun, in ten years' time. At this time, in the mid-1850s, he had a wide range of supporters, including Nariakira, and therefore the loyal Saigo. It all depended on how much influence could be brought to bear on the court. Nariakira had high hopes, because of his daughter's planned marriage to the shogun. Saigo would naturally do what he could. When Nariakira returned to Kagoshima in early 1857 Saigo went with him, only to be sent back to Edo to look after Nariakira's interests. Because it took weeks to send messages back and forth, he had to decide what to do on his own, which meant trying to pull the strings—in particular, to get Atsuhime married to the shogun—that would bar Yura's son from becoming heir to Nariakira and confirm Keiki as heir to Iesada. Like a lobbyist in Washington today, he had little formal clout and had to seek influence by cultivating friendships.

Nariakira made sure he had help, in the form of Hashimoto Sanai, a doctor, who backed reform and the acquisition of Western technology. Hashimoto talked avidly about the way Nariakira wanted Japan to develop, providing a balance

to the more extreme views of "Mito learning." Total rejection of foreign entanglements would not work, he said. There should be treaties, to acquire Western technology—but only as a means of strengthening Japan enough to keep the foreigners out. What was needed was a Japanese commitment to the old-fashioned virtues—benevolence, righteousness, loyalty, filial piety—combined with the machinery, the weapons and the other products of industrialization that would save Japan from the dreaded Westerners.

For Saigo, then, modernization and xenophobia went hand in hand. Once he got into an argument with a man who asked him to justify his attitude. He explained

> that truly civilized countries would have led the uncivilized ones to enlightenment by adopting a policy of benevolent and well-meant teaching, and that, far from this being the case, they have been barbarous enough to benefit themselves by conquering weaker countries by force of arms and treating them with a ruthlessness which becomes the more intense the greater the ignorance of the conquered.[1]

All seemed to be going Nariakira's way when Iesada at last married Atsuhime, apparently putting Satsuma's lord on track to influence the choice of the next shogun. But it was not easy: the shogun's mother rejected any hint of outside interference, and rather dramatically threatened to commit suicide if she heard any more on the matter. Her son the shogun and his new

[1] Quoted by Morris, *The Nobility of Failure*, from an unpublished manuscript by Sakamoto Moriaki, one-time professor at Kagoshima University, "Saigo Takamori's Posthumous Words."

wife were helpless. That left the only other source of influence: the imperial court in Kyoto. By tradition, the court never opposed the shogun's decision. But tradition was not what it had been. A new treaty with the Americans had been negotiated with the American consul, Townsend Harris. The shogun's top advisers, the Council of Elders, didn't want to approve it, and asked the court to reject it—an unprecedented step because it gave the court a primary role for the first time in Japanese history. This was the opening Hashimoto and Saigo needed. They would go to Kyoto and lobby the court directly to support Keiki, Nariakira's candidate, as heir.

By early 1858 Hashimoto and Saigo were in Kyoto, a very different place from Edo. The city was, in effect, a prison for an emperor whose sole task was to act as mediator between heaven and earth, and between his divine ancestors and his subjects. Government was beneath him. He had no power at all, could initiate no policy, could deny the *bakufu* nothing, could not escape from the necessity—called, of course, a right—to confirm every new shogun.

But it was a prison of exquisite comfort and beauty. It had long been a place of the greatest artistic achievements.

Here they refine copper, coin money, print books, weave the richest stuffs with gold and silver flowers. The best and scarcest dyes, the most artful carvings, all sorts of musical instruments, pictures, japan'd cabinets, all sort of things wrought in gold and other metals, particularly in steel, as the best-tempered blades, and other arms are made here in the utmost perfection, as also the richest dresses, and after the best fashion, all sorts of toys, puppets, moving

their heads of themselves, and numberless other things too many to be mention'd.

That was in 1691, as described by a visiting German, the naturalist and traveler Engelbert Kaempfer. Little changed in Kyoto over the next 150 years, except that Osaka and Edo overtook it in population and commerce. Today, new buildings have replaced the old in many areas, but it is still a place of palaces and gardens and great wooden temples set against steep forested hills famed for their gorgeous autumnal colors.

All this was as new to Saigo as Edo had been; but once again he had help, this time from Prince Konoe Tadahiro, a court noble related by marriage to the Shimazus. Attempting to influence the imperial court was a delicate, occasionally dangerous business, rather like being a CIA agent trying to plant some new policy inside the government of a foreign power: if things went wrong one might be assassinated or receive an order to commit seppuku. There had to be discreet—if possible, secret—contacts, in very private meeting places.

Konoe knew just the man, a priest named Gesshō, attached to one of Kyoto's great temples. Gesshō was a good choice: well known as a monk, in his midforties, a fine poet, but never until now involved in politics. The decision to put Gesshō and Saigo in touch was one of two events that would, in a few months, change the course of Saigo's life.

This was a relationship that went way beyond the bounds of politics. The two quickly became devoted to each other, so devoted that we would today call them partners.

The relationship raises the question of whether Saigo and Gesshō were "gay," in the modern sense, a question to which many Japanese scholars would answer, "Yes—and why not?"

There are two other answers: "possibly" and "no." "Possibly," because homosexuality—male/male intercourse—was common; and "no," because it did not exist *in the modern sense*, but in a completely different context, in which sex between men had none of the connotations of controversy, disapproval or assertion of difference that it has in the modern West. It was considered no more immoral than drinking. In some circumstances—between warriors—it was seen as a virtue, bonding two men in a web of support. In Satsuma's militaristic *goju* school, sex between boys was considered normal. It became problematic only when taken to excess, when lovers quarreled or when love involved a clash of loyalties.

And the point was love, not sex. Homosexuality was considered by many men the purest form of bonding—long lasting, intense, meaningful; based on mutual trust and the highest forms of honor. Men also claimed that sex between an older man and a teenager was not in any way corrupting, but a natural expression of love, based on mutual regard. In Japan, such practices were accepted both among samurai, of high social status but often less well off, and nouveau riche townsmen, of low social status but with wealth and scope to indulge their interests.

For homosexuals, whether samurai or townsmen, there were many books defining the proper conduct of male love, which ideally linked a teenage boy with an older lover. The relationship was as sexual and romantic as any between the sexes, and to a gay samurai infinitely preferable. In a book of homoerotic tales,[2] I found these words: "Male love is essentially different from the ordinary love of a man and a woman . . . Woman is a creature of absolutely no importance; but sincere pederastic

[2] Mathers, *Eastern Love.*

love is true love." Such commitment demanded all the hard work of a heterosexual relationship. "A young man should test an older man for at least five years," wrote Yamamoto Tsunetomo. "Furthermore the older man should ascertain the younger's real motives in the same way."

The best-known book on gay love was Ihara Saikaku's *Nanshoku Okagami* (*The Great Mirror of Male Love*),[3] with its subtitle *The Custom of Boy Love in our Land*, a collection of forty tales published in 1686. Saikaku (he is always referred to by his given name) was the first Japanese writer to live exclusively on his earnings, because he knew how to appeal to a readership intrigued by sex. He was part of the "floating world" of society, fun, prostitution and theater that characterized high life in Kyoto, Edo and his native Osaka. His market for this book was the samurai and townsmen who patronized Kabuki. His aim was to entertain, and he did so by overstatement and literary allusion and clever arguments; this is not a great revelation by a gay writer, but a professional author eager to exploit sexuality in all its accepted forms. He distinguishes between bisexuals and fully committed gays, so-called woman haters, who were of course a minority, and therefore had to be promoted by Saikaku as people of culture and discernment, in a word, connoisseurs. Male love, he argues, preceded heterosexual love, had Chinese precedents, was practiced all over the world, and was therefore nobler and more sophisticated than male-female attachment. "A woman's heart can be likened to the wisteria vine: though bearing lovely blossom it is twisted and bent. A youth may have a thorn or two, but he is like the first plum blossom of the new year ex-

[3] Other earlier translations of the title include *Conspectus of Sodomites*, *Mirror of Sodomy* and *Great Mirror of Pederasty*.

uding an indescribable fragrance. The only sensible choice is to dispense with women and turn instead to men."

As for the relationship between samurai and boy lover, he insists that it should be both moral and formal, with an exchange of written and spoken vows, and occasionally some sort of self-mutilation as a proof of sincerity. If a rival made a bid for a boy, the older man would expect to fight to save his honor. Ideally, the older man (the *nenja*) provided social backing, emotional support and a model of manly behavior. In return, the boy (the *wakashu*) was supposed to be a good student of the samurai lifestyle and ideals. His age was indicated by his hairstyle: a shaven crown with a forelock at eleven, the sidelocks cut off square at fourteen, and a completely shaved head at eighteen to proclaim adulthood and the end of being a *wakashu*. So the affair was as fleeting as youth itself. While it lasted, it was based on the model of a male-female relationship, with the literally and socially "superior" male penetrating the "inferior," "passive" "female." Since the relationship had all the intensity of a heterosexual one, infidelity might inspire equivalent jealousy in the older man and occasionally terrible acts of vengeance.

It was not all about adult-boy relationships, though, nor was it all fun and high ideals. In Kabuki theater, the use of boys to play the women's roles was banned in the 1650s, after which all roles were played by men. Homosexuality and prostitution were part and parcel of the system, which had its share of exploitation, hypocrisy and tackiness. The road to stardom, in Kyoto as in Hollywood, often started on the casting couch and led back to it, with increasing desperation as time went by. As Saikaku wrote, "since everyone wore the hairstyle of adult men, it was still possible at age thirty-four or thirty-five for youthful-looking actors to get under a man's robe. How strange are the ways of love!"

Note, finally, that none of the justifications and writings are from the point of view of the younger partners. This was, at heart, a relationship based on power. No one asked teenage boys what they thought about being on the receiving end. That something was amiss is suggested by the fact that in the Meiji era after 1868 the fashion for male/male sex went into sudden decline.

Whatever their views, Japanese homosexuals in the mid–nineteenth century had none of the social inhibitions that have characterized gay relationships in the West. Any male relationship might find sexual expression. Tradition emphasized the importance of love between Buddhist clergy and samurai, or between priests and their young acolytes. Despite the priestly renunciation of worldly pleasures, love (so its practitioners argued) could lead to spiritual enlightenment. Loyalty of a religious intensity combined with sex: that forged a bond of a strength hard for non-Japanese to imagine.

So did Saigo and Gesshō have a sexual relationship? Perhaps. It would not have mattered. But I think not, because of their ages, their circumstances and their characters. Saigo was thirty, Gesshō forty-five, and both were outside the worlds in which homosexuality thrived. Besides, for Saigo, sex was never a dominant aspect of life. His brief youthful marriage was over, unmourned; sex would not have been the defining characteristic of his commitment to Gesshō. The question has no answer, because no one knows. But in the end, who cares? There was so much more going on.

Was there anything else in Kyoto likely to tempt Saigo from the ways of virtue? Not much, I think.

I was with my guide Noriko, walking steeply up narrow streets toward Gesshō's temple, when a kimonoed figure with

piled-up hair shimmered across the road like a ghost. A gei-sha, who would not have been out of place in Kyoto when Saigo was here. Well, not quite a geisha. "She's only a *maiko*, an apprentice," said Noriko. "And it's afternoon, so she has no makeup on." She still had a long, hard and expensive road ahead of her. To buy her kimonos and decorations she would have to spend about $15,000 and her training would be rigorous. This was (and is) a profession, nothing to do with prostitution, everything to do with performance art—the exact ways to greet and sit, the learning and presentation of songs and dances by the score, the precise gestures in the making, pouring and presentation of tea, the symbol of the best of Jap-anese etiquette: grace, politeness, respect.

"Why would anyone do this?"

"Well, a geisha can earn about $1,500 a day. Rich business-men, politicians . . . For them it is a status symbol."

"We have nothing similar in the West."

Noriko, who had spent years in London, thought for a mo-ment. "Maybe an equivalent would be hiring a ballet dancer to perform at a private party."

Even that wouldn't quite measure up, actually. A geisha was and is a girl of many qualities: stamina, physical and social skills, and (I was surprised to learn) intelligence, because they were and are good at conversation. "They study newspapers every day, and are expected to be able to talk about every-thing, politics, history, drama. Even a girl of eighteen, like that *maiko*, should sound like an educated woman of twenty-five or thirty." And, of course, the art of conversation demands an-other virtue: discretion. "These girls are very secretive. They never talk about what was talked about."

But surely this is not a real life? What happens to them?

"At about thirty, it seems that they all start to think: should

I stay in or get out? Get married, or do something completely different, like teaching? But you can stay as long as you want, as long as you can still find employment, unless you get married. Then you have to quit."

"But it's not really a preparation for marriage, is it?"

"No. It's not like a finishing school. They don't learn about cooking or housekeeping."

Saigo was not attracted to the world of geishas. His divorce had left him wary of women. "I have kept a monk's vows as regards women," he wrote. "I have no desire to marry again." This would not remain true, on either count, because later he would remarry, and have two mistresses, and father children; but always sex, love and marriage took second place to whatever else was going on in his life, which at this moment involved some very discreet politicking on his lord's behalf.

Noriko and I had reached a flight of limestone steps leading up to a portico with upturned eaves. Behind was Gesshō's temple, Kiyomizu, one of Kyoto's finest and most famous, a place of huge wooden beams and overarching roofs and timber platforms jutting from the steep forested slope that rears up like a breaking wave and falls to Kyoto below. The place dates from the eighth century, when a priest first found the spring of "clear water" which gives the site its name, and dedicated the temple to Kannon, the god or goddess (he or she can be either) of mercy, seeing and hearing all with his/her eleven heads. Almost inevitably, given its wooden structure, the original temple fell prey to fire, to be replaced by the present seventeenth-century one. The temple is the quintessence of history, and therefore an essential educational experience. We could hardly walk for schoolkids, snatching pictures on their mobiles. When Gesshō was here, it was a sanctuary of chants and bells, well clear of the city.

But not at all suitable for clandestine meetings. Prince Konoe, the link between court and temple, could meet Gesshō innocuously enough in Kiyomizu (or rather in Gesshō's sub-temple, of which he was head). But to meet Saigo, Gesshō would walk a couple of kilometers to the southwest, to another complex of Zen Buddhist temples and sub-temples, Tōfuku. Today, it is surrounded by the city; but in Saigo's day it was isolated, because it was here, east of the Kamo River, that the bodies of executed criminals were dumped; few wanted to come this way, or penetrate the surrounding forest. Why would they when they would not be allowed into the temple complex?

Behind a gateway so gorgeous, immense and ornate that it is now an official national treasure lies the Abbot's Hall, with formal gardens of raked pebbles and checkered stone squares and azalea shrubs. Deeper into the temple, covered bridges and gates lead to twenty-five sub-temples, all hidden enclaves where the public doesn't go. One is the Hokoshui sub-temple, approached through a door held shut by a chain that rattles over a cog wheel. A maze of paths and trim hedges runs away up a hillside under overarching trees and past stone benches, all designed to empty the mind and encourage concentration. Here there was a teahouse.

A shaven-headed monk, with a powerfully handsome face and an aura of Zen calm, explained through my guide Noriko how perfect this secluded spot was for furtive meetings and secret talks. "This place was sponsored by the Shimazu family, and it had its own police, so even if the shogun's police wanted to arrest someone, they could not gain entry. The teahouse? Oh, after the restoration, when the Shimazus lost influence, the money stopped, and the teahouse fell into disrepair. It was over there"—he pointed to a space in the woodland—"but it

collapsed, and there's no trace of it anymore. It was called Collecting Firewood. Firewood is like knowledge, you see. You can collect it all you like, but if you don't know how to use it, it's useless."

So for a month whispers trickled from Saigo into Gesshō's ear in the shadowy garden of Hokoshui, from Gesshō to Konoe as the courtier visited his family graves in Kiyomizu, and from there into the galleries and painted rooms of the imperial palace. All seemed well. In March 1858 Saigo left for Edo, sure that Keiki was about to be nominated as the shogun's heir.

Not so. There was a countercurrent, much stronger than the current generated by Saigo. It came from the man who was soon to be Japan's most powerful figure, Ii (pronounced "ee-ee") Naosuke, the Ii family being the long-established rulers of Omi (roughly present-day Shiga prefecture). His aim was to kill off any move toward imperial independence and to shore up shogunal authority. Under his influence, a draft edict which might have strengthened the pro-Keiki gang was amended so that it simply urged the shogun to move fast to name an heir, any heir. Shortly afterward, in May 1858, Ii was appointed "great elder" of the Council of Elders—a sort of deputy to the shogun, the ailing Iesada, and in effect regent. He ordered approval of the stalled Harris Treaty, rejected Keiki, named a new heir and ordered Keiki's top supporters to be placed under house arrest.

Panic in the ranks of Satsuma. Saigo vanished posthaste to Kagoshima to consult Nariakira, who a week later sent him back to Kyoto to find some way of regaining influence. In the stifling heat of high summer, he started to arrange meetings to bring himself up to date and work out plans of action.

Then: catastrophe upon catastrophe.

Back in Kagoshima, Nariakira, still in the prime of life at forty-nine, had fallen ill with fever and diarrhea. Shortly after

midnight on August 24, he realized that he was dying and summoned his senior aide. With a two-year-old son who was too young to inherit, he authorized his retired father to nominate as heir either Hisamitsu, his former rival and half-brother, or Hisamitsu's son, Tadayoshi. He died later that morning.

The news reached Saigo in Kyoto eleven days later. He had only been back in the city two weeks.

7

THE WAY OF THE
WARRIOR: BUSHIDO

WITH THE END OF THE "WARRING STATES" PERIOD IN THE
years after 1600,[1] the Tokugawa shoguns who unified Japan
brought not only peace but remarkable stability through an
equally remarkable self-imposed isolation. From near-anarchy
the country turned to its opposite, imposing on itself what one
scholar has called "the most artificially and politically planned
and structured society in Japanese history."[2]

The most famous, and still puzzling, consequence of the
peace was the rejection of firearms. The new rulers knew the
power of the gun only too well, because in the crucial battle
of Nagashino in 1575 sword-wielding cavalry had been shot

[1] Actually, the last major action was the fall of Osaka Castle in 1615.
[2] Oishi Shinzaburo, quoted by Ikegami, *The Taming of the Samurai*,
p. 165.

down by a torrent of fire from muskets introduced by Portuguese traders. You might think this would have inspired the development of effective firearms. Quite the contrary. Ieyasu, the second Tokugawa shogun, centralized the manufacture of guns, with the government as sole purchaser. But with no enemies, government purchases declined to almost zero. Why this happened is much debated. One reason was the recognition that the gun made for social instability; another had to do with the Japanese fear of invasion and of gunpowder—remember the Mongols!—and the consequent rejection of foreign influences. Firearms, the symbols of barbarism, became detestable, samurai swords the guarantee of freedom and purity. As an island culture, Japan could turn fear into policy. It retreated from gunpowder, and into itself, for 250 years.

In one of the most extraordinary episodes in history, contacts with foreign powers went into reverse and virtually ceased. Christian missionaries had been effective for over fifty years, but Ieyasu turned against them. Converts were martyred by the thousand and missionaries banished, many of those who hung on being tortured and murdered. In 1639 the shogun slammed the door: no Japanese could leave, no foreigners could enter, and all foreign trade was restricted to one port, Nagasaki, which was under the government's direct control. Almost every European power gave up. Only the Dutch remained, effectively imprisoned on a little island off Nagasaki. Foreign influence and products became mere trickles, leaking in from Nagasaki, from Korea and—crucially for our story—from China, tiptoeing in along the newly conquered Ryukyu Islands to Kyūshū, Saigo's home province, in the far south. Two hundred years later, the "closed country" policy had become as fixed as holy writ, and Japan had fallen far behind "barbarian" powers in science, industry and military technology.

On the other hand, there were advantages. Japan preserved its independence from colonization; it maintained a remarkable social cohesiveness, undisturbed by class warfare; and despite its conservatism and the supposed inferiority of merchants, the economy grew strong, with signs of things to come: the house of Mitsui (yes, the forefather of today's corporation) gave away umbrellas as "free gifts" to people caught in the rain. In the early nineteenth century Japan was both a living fossil and also well prepared for change.

Low-level violence, too, declined, at least officially. According to the Tokugawa military code, "The governors of provinces and other lords are forbidden to engage in private disputes." Ieyasu decreed the destruction of all nonresidential castles, an order fulfilled with remarkable speed, mostly within days. Local communities lost their traditional independence. Merchants knew their place: they made and lent money, and encouraged the arts, but kept out of government. Religion was not a threat, since Buddhism made no serious claim to govern. The provincial and local rulers—the daimyos—though allowed to preserve their current defense levels, were forbidden to build ships, or extend their armies, or declare war. They had to undertake time-consuming, expensive stays in Edo, where they set up households and engaged in ceremonies of excruciating tedium and complexity. Ostensibly, all this was to show their loyalty; in fact they had no choice because their households in the shogunal capital were in effect hostages. Violence was severely punished. A Buddhist priest recorded what happened when some villagers fought over water for irrigation: "The 83 farmers of the Sesshu Province who were involved in the fight over water were executed . . . Even a thirteen-year-old youth was executed as a surrogate for his father." Overall, if a recurrent cliché in official documents is to

be believed, people were grateful for "the peaceful tranquility of the land." The Tokugawa peace froze Japan in its tracks, in a system that balanced top-down control and bottom-up independence, with the samurai acting as middlemen and enforcers.

Peace also froze the samurai. "Regarding quarrels and fights," ran an edict in one provincial code, "those who fight with other masters' samurai, even with good reason to do so, will be executed . . . Forbearance is the best policy in all situations." With battles and fights banned, the samurai and their Spartan ways might have died out, as outmoded as a cavalry charge against tanks. They were, after all, a small percentage of the population, probably around 6 to 7 percent, numbering about 750,000 in 1600.[3] They were bound to their provincial lords, cut off from their lands, forced to live in special quarters in towns, required to ask permission to inherit or marry, and made dependent on "stipends" of rice, in effect handouts. What a comedown for free-spirited warriors! In one sense, Rousseau's description of all mankind fits the post-1600 samurai class remarkably well: born free, but everywhere in chains. In another sense, they became parasites, in the words of the historian John Roberts: "There was nothing for them to do except to cluster in the castle-towns of their lords, consumers without employment, a social and economic problem."[4] They lived in paradox. Since the rulers themselves were samu-

[3] Rising with Japan's population, which reached about thirty million in the mid-eighteenth century. No one knows the exact figures, because the samurai were excluded from the data. Estimates vary from 5 to 10 percent of the population, which means that in Saigo's life the samurai numbered between 1.5 and 3 million. (See Ikegami, *The Taming of the Samurai*, pp. 162, 172.)

[4] Roberts, *New Penguin History of the World*, p. 841.

rai, and local lords still needed strong men as peacekeepers, the samurai as a whole were allowed to keep their weapons. They had a monopoly on violence, and the poorer ones roaming and drinking in back streets exercised it; yet the times, if not the back streets, were peaceful. "It is a historical irony," writes Eiko Ikegami, "that one of the most peaceful eras in Japanese history was obliged to celebrate . . . the role of military power."

The plain truth was that the old days of the violent samurai were over. Ah, the old days! One of the greatest seventeenth-century writers, Ihara Saikaku, put it clearly: "In the old days, the most important thing for the samurai was courage and unconcern for one's life . . . exalting his name through killing or wounding others on the spot and leaving the scene triumphantly. But nowadays such behaviour is not at all the real way of the samurai." [5] The master, he said, provides an appropriate stipend in order that the samurai should be useful to the lord. To throw one's life away for a private grudge is to ignore the debt to one's master: "Devoting one's life to *giri* [duty, obligation or responsibility] is the way of the samurai." It all sounds rather boring by comparison with "the old days." One eighty-year-old wrote in an essay in 1717: "In the old days at parties, both upper and lower samurai talked only about warfare . . . now on social occasions, they discuss good food, games and profit and loss."

How to live with the change from warrior to bureaucrat (or ex-soldier on the dole) and still be a samurai? How to fight for privilege and honor without armed combat? How to avoid demoralization and preserve dignity? How to be a parasite, yet

[5] Trans. Ikegami, *The Taming of the Samurai*, p. 239.

live a useful and fulfilling life? To find answers, the samurai had to reinvent themselves.

This is what human beings often do to preserve a threatened sense of identity. From tedious tasks and fears of uselessness they spin noble causes, and link themselves to ideals greater than life itself. "To want honour and dignity," said the philosopher Thomas Hobbes, "is a disease of the mind." Yet, he went on, all men naturally strive for it. They also strive to avoid shame. Few groups have been so dedicated to the preservation of honor and avoidance of shame as the samurai, and few so successful.

To preserve their power, wealth and identity, the samurai found in their old violent lifestyle a spurious chivalric glamor, and spun their simple fighters' code into a complex, artificial ideology, which claimed that they alone were allowed to be violent, they alone had "honor." Yet because this was an age of peace, and they were the upholders of peace, violence could only be expressed, if at all, in a rigidly controlled way—by word, by attitude, by clothing, by intellectual rigor and by training. This was the paradox at the heart of seventeenth-century Bushido, the bedrock on which Saigo built his life.

Paradox, inauthenticity: those are two words that come to mind. Another, rather more forceful word came to the mind of an expert in Japanese history who is a friend, so I won't mention his name. I had just started researching this book, and needed guidance. We were having a light lunch, smoked salmon and a salad, in Carluccio's, just off Russell Square. I mentioned the "paradoxes" that defined Saigo's life. How odd to adore the emperor yet lead a rebellion against him; to claim nobility of spirit yet be a traitor; to be a failure and yet one of Japan's greatest heroes.

"I suppose it was all down to Bushido," I said, pretending to knowledge I did not have.

"Bushido—," he said, then after a meaningful pause: "Bushido is bullshit."

I gave him a startled look, having taken the Way of the Warrior at face value until that moment.

"Well, I wouldn't express it quite in those terms in writing. But it's true. All this business about honor and ideals was retrospective, invented after the samurai lost their role as warriors in the seventeenth century. It was all about preserving their authority, finding a sense of identity by cherry-picking the past."

Not that passion died. Quarrels, though rarer and more constrained by law, provided a chance to flaunt the old virtues: aggression, spirit, courage, strength. Samurai sensitivity served their masters, who officially discouraged it but at a deeper level expected and accepted it. It was legally acceptable for a samurai to kill in three circumstances: if insulted by a commoner; if a wife and her lover were caught in the act; and if authorized to undertake a revenge killing. The last of these made it possible for samurai to act as private police, hunting down their targets—typically murderers—in any town or province, with the proviso that the vendetta stopped there. In this way the rulers were able to allow, even praise, the old samurai desire for violent resolution, while still controlling it. But a samurai—like a back-street gang member in any number of western cities—had to wrestle constantly with contradictions. If a man retaliated to an insult with a death blow, he could be executed; if he obeyed the law, he would be dishonored.

The samurai preserved their prestigious position in society by clinging to their rituals of dress and their outmoded beliefs, like drowning men to life preservers. If they could not fight,

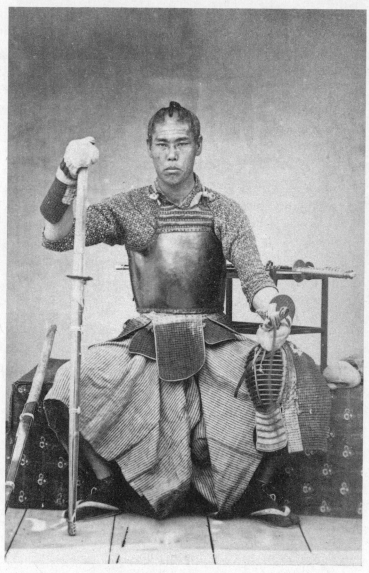

A samurai from Chōshū displays a double-handed sword, "smooth-style" armor and broad *hakama* trousers.

they could at least go on carrying their swords, serving a lord, disdaining lower orders, and committing suicide when things went wrong. Exotic armor and deadly weaponry became the symbols of their inner virtues. They were expected to be forever vigilant, never *fukaku*, "negligent" or "unprepared," as alert to insult as a Puritan to sin. They claimed the moral high ground, not so much in deed, because they could no longer act as warriors, but in word—literally. The ideal now became not that of the reckless warrior who despised learning, but of the Confucian warrior-scholar, seeking truth, delighting in scholarship, pursuing respect and self-respect in high-minded service, austere, self-disciplined and ruthless in defense of his superior status—all symbolized by the sword, as the symbol of all a samurai's ideals.

Though this drew heavily on the samurai ethos of the previous four hundred years, it was also something different. It may have been artificial, inauthentic, paradoxical (even bullshit), but it retained its power and influence. For post-1600 Japan, it was an everyday reality, and—since the samurai were to remain for another three hundred years—very much part of the emergence of the modern nation.

Yamamoto Tsunetomo's famous book of 1716, *Hagakure* (*Hidden Leaves*), expresses the essence of the new code. It is an eleven-volume collection of anecdotes and homilies, from the profound to the trivial, occasionally straying into the weird. At its heart lies a preoccupation—a psychologist might say an obsession—with death. "The way of the samurai means death. Whenever you confront a choice between two options, simply choose the one that takes you more directly to death." When faced with a quarrel, best not to think—just rush into the fray and either win or get killed; that way you can be sure to avoid shame. When Yamamoto was writing there had been no major

battle in Japan for over a century and he himself was never in combat, yet he advised every samurai to cultivate a mustache, so that when his head was cut off in battle it would not be mistaken for that of a woman and be thrown away. Since this was not a real threat, it had to be recast in terms of a theoretical brawl: never refuse a quarrel, he advised, because that way you were killed, either by your opponent if you lost, or—if you won—by the state, which had banned fights on pain of capital punishment. This, too, was unrealistic. Yamamoto's book is full of stories about people being "cut down" and heads being severed, but by the time it was written fights were so few that death had to be summoned up in the imagination:

> Meditation on inevitable death should be performed daily. Every day when one's body and mind are at peace, one should meditate upon being ripped apart by arrows, rifles, spears and swords, being carried away by surging waves, being thrown into the midst of a great fire, being struck by lightning, being shaken to death in a great earthquake, falling from thousand-foot cliffs, dying from disease or committing *seppuku* at the death of one's master.

That way, you could be free to devote yourself to your master, and "there will be no shame in one's service to the lord and in the martial way." It is hard for an outsider to feel at ease with such an ideology, but an insider like Saigo had no hesitation in taking it on board.

It is a strange freedom that is bound to service. It raises loyalty to an ideal of religious intensity, like the Christian prayer to God, "the author of peace and lover of concord . . . whose service is perfect freedom." This is something different from medieval feudalism, for it lacks the notion of reciprocity

and is rooted in a choice freely made, not an accident of birth. But that is the way it has to be for a man of honor, for how honorable would he be if his loyalty could be undermined by a random change of mind? The lord owes nothing, though in practice he needed his samurai to run his government or his estates; the samurai gives loyalty unto death, a devotion so intense and so internalized that Yamamoto calls it "secret love." To achieve this state, he says, one must "be dead to oneself." He could not have known it, but his ideals parallel those of St. Ignatius Loyola, founder of the Jesuits, who stressed absolute self-abnegation and obedience to superiors, "in the manner of a corpse." His famous "Prayer for Generosity" could be Yamamoto addressing his own lord in his mind, asking to be taught

> To give and not to count the cost;
> To fight and not to heed the wounds;
> To toil and not to seek for rest;
> To labour and not to ask for any reward,
> Save that of knowing that we do Thy will.

The devotion is not without responsibility, nor does it deny individuality or ambition. The samurai's duty is to something higher than the lord as an individual; it is to the *ideal* lord. Therefore it may be part of his duty to save the lord from errors of judgment. "It is an act of great loyalty to correct the mindset of one's master, and thus to confirm the foundation of the country." To do this, the samurai must speak with authority, which he cannot do if he is of low rank. He should work to advance himself and cultivate a spirit of independence if he is to give of his best.

Yamamoto's world view—which was also Saigo's—yearned

for simplicity, as if the samurai were no more than old soldiers doing their duty. In fact, they had the impossible task of trying to live up simultaneously to the often conflicting imperatives of their own ideals, their lord's will and the demands of the new state. If the worst samurai were mere thugs, the best were sincere men who desperately wanted to live with dignity and pride. Most of them succeeded.

8

A DEATH IN KINKO BAY

IN THAT SINGLE INSTANT IN SEPTEMBER 1858, SAIGO'S WORLD turned upside down. Three months earlier, he had been a major figure in national politics, looking forward to more influence and success in the shadow of the lord who had raised him from insignificance. Now he was in opposition, and in danger, someone who had schemed against both the shogun and Satsuma's new daimyo, whoever that might be. Moreover, Gesshō was equally at risk. Saigo was bereft, without a protector; his allies were under house arrest, their careers in ruins, in fear of execution or enforced suicide.

What now? Tradition dictated that the truly loyal retainer should commit suicide on the grave of his lord. It is said, without evidence, that Saigo considered doing just this, and that he was dissuaded by Gesshō, who argued that true loyalty lay in living, because he understood Nariakira's policies and was the best man to promote them. Whatever the truth, Saigo was,

A "wanted" poster put out by the shogun includes Saigo (*left*).

as he wrote to Gesshō, "like a man who has lost his ship and is stranded on an island." He spoke with friends of planning a military response, which was foolish, because the new power in the land, Ii, took brutal action, initiating what is known as the Ansei Purge, after the name given to the six-year period from 1854 to 1860.

In the year following October 1858, some one hundred officials lost their jobs and several leading pro-emperor loyalists—that is, those considered to be opposed to the power-behind-the-shogun, Ii—were imprisoned; two were later executed. Saigo's main contact, Prince Konoe, though himself shielded by his position at court, knew that Gesshō was on the list of those to be arrested and asked Saigo to take his friend to safety. Two weeks later, Saigo and Gesshō, accompanied by a servant, fled Kyoto for Kagoshima, just in time to avoid the shogunate's officials.

From the narrow isthmus of Shimonoseki, Saigo went on ahead through Kyūshū to make sure Gesshō would be safe. To his dismay, he found first that Satsuma was now being ruled by Nariakira's rival, Hisamitsu (though technically his son was daimyo), and second that the shogun had issued warrants to arrest not only Gesshō but also Saigo as his accomplice. Hisamitsu had no love for Saigo, but knew that to have him arrested would provoke a riot. Gesshō was another matter. Hisamitsu had no need to court trouble with the shogun by protecting a refugee monk who came from elsewhere. So Saigo was told he could walk free, as long as he changed his name and went incognito.

But Gesshō, following in Saigo's footsteps with the servant Jūsuke and a friend, Hirano, who had joined him en route, almost walked into a trap. An attempt to find sanctuary in a temple ended when the chief monk reported them, forcing a hasty exit into a safe house, where they stayed for a week, shut away from all visitors.

Clearly, Hisamitsu could not allow a wanted man to remain in hiding when any shogunal spy would have known where he was. He came up with a devious solution. Saigo would take Gesshō across Kinko Bay to the next-door province, then onward to an enclave, Hyūga, which was ruled by a Shimazu relative and was outside the domain's border checkpoints. In this way Gesshō—who had after all been helping the cause of Satsuma's previous lord—would not be handed over to the shogun's men; on the other hand, he was not exactly on Satsuma territory, so if they came to get him, Hisamitsu could truthfully say he had left Satsuma and deny all knowledge of him.

For Saigo, this looked like the end of all his hopes. He had no influence in Edo, or Kyoto, or Satsuma; he was a nonper-

son; and now his closest friend was to be hurried off into, at best, insecure hiding, and perhaps something worse, for Satsuma had a tradition of judicial murder at border posts, referred to as "getting sent off to the east." In Ravina's words, "Saigo saw only failure, isolation and loss." Gesshō felt the same. There was nothing for him in this life; better, he said, to go to "another place."

But Saigo had no intention of abandoning him. Shamed by his inability to protect his friend, he determined to share his fate, and to do it on his own terms. Had he been on his own, he would have committed seppuku; but nothing in Japanese tradition dictated how to kill yourself and a friend who, as a monk, did not carry a sword of his own. To get to Hyūga, he would have to cross Kinko Bay. Once there, he and Gesshō could find themselves under new guards. If he was to act, therefore, it would have to be out in the bay.

The next evening (December 19) the two friends, accompanied still by Gesshō's servant, Jūsuke, his friend Hirano, and an official escort, made their way to the shore, where the escort guided them onto a small, single-sailed boat. They had with them some basic equipment: a little food, sake, fuel, tinder. It was a clear, cold winter's night, with a full moon, and they had 15 kilometers to cover.

They slid quickly away northward, following the coast as it swung around to the east, with the great shadow of Sakurajima a few kilometers away to the right, the bare rock of its higher slopes glistening in the moonlight.

Something like half an hour into the trip, well away from populated areas, Saigo called Gesshō forward to look ahead, toward the shore where there was a famous temple named

Shingakuji.[1] He told a story about a Satsuma prince who had objected to a deal made with invaders by his elder brother in the sixteenth century. The prince had committed seppuku on the site of the temple, followed in death by many of his retainers. Shimazu retainers still went there to pray for the prince's soul. Would Gesshō also like to pray now, in the direction of the temple? Gesshō said he would. The two stood in the bows, facing the temple, and prayed. Surely they were also saying mutual farewells, for what followed could only have happened with Gesshō's agreement.

Then Saigo took Gesshō in his huge arms, held him tightly, and threw the two of them together into the chilly waters.

If the three others onboard did not see them jump, they heard the splash, saw the deck empty in the moonlight and rushed to help. Their official escort, Sakaguchi, drew his sword, slashed the sail down and swung the tiller, while the other two grabbed oars and rowed back the way they had come. There were the two men underwater, held just beneath the surface by their waterlogged clothing. They had been there perhaps five or ten minutes. They were drowning and, as drowning people grasp at straws, had locked arms around each other in instinctive desperation. They could be saved: the cold water had probably triggered the "diving reflex," which focuses the blood supply to the brain. All three crew members dived in, prised the two men apart, and somehow lifted them into the boat. Then they rowed them ashore, which must have taken another fifteen minutes. Once the boat was beached, one built a fire with the tinder and fuel onboard while the other two tried resuscitation, pressing on the prostrate bodies. Gesshō— older, slighter, more susceptible to cold—showed no sign of

[1] Now long gone.

life. But Saigo coughed up water, and then, amazingly, began to breathe, though he remained semiconscious from lack of oxygen. Nearby was a small house; here they took Saigo to make sure he really was going to live.

I can see much of this episode as vividly as a film, but some scenes remain maddeningly obscure—not surprisingly, given that most of the details are taken from an account by one of Saigo's future friends, Shingeno Yasutsugu, and Shingeno had them from Saigo—who was, of course, unconscious or semi-conscious for the return journey.[2] This house, for instance—why choose it? Perhaps because it was the only one? Was there someone living there, a couple perhaps, astonished at this disturbance so late at night? Did the three rescuers tell the truth, or make up some story to explain Saigo's state? Was there a fire still going? Were the two peasants—I am beginning to see them in my mind's eye, shuffling around in their simple little shack—able and willing to keep him warm and get some food into him? We shall never know. Anyway, the three companions then reloaded both bodies, one alive, the other dead, into the boat, and rowed or sailed back to Kagoshima.

About the only thing that is clear in this part of the story is the spot where he was saved, which is now a site sacred to the Great Saigo. You take the coast road away from Kagoshima to the north, following the railway for four kilometers as it winds past steep hills. You come to a crossing over the railway, which leads to a shrine—an altar of square stones, an engraved pillar, a couple of little sake cups to keep the memory alive—and beyond, crowded between railway line and rising

[2] Shingeno (1827–1910) was later president of the Historical Society of Japan—Ravina in *The Last Samurai* calls him "Japan's first modern historian"—which suggests he was reliable.

forests, a thatched hut of dark wooden planks, restored, with a notice in the shape of a stele announcing "House Where Saigo Takamori Recovered."

"Recovered" is an overstatement. He was quickly taken back to his home, where he remained delirious for three days from a combination of near-suffocation and despair, a despair deeper than that which drove him to attempt suicide. His bid for death had been like that of a "woman," without a sword; it had failed; he had accomplished nothing but the death of his closest friend. The guilt would remain with him for the rest of his life, recalled on every anniversary of his failure. Seventeen years later he wrote a poem to Gesshō imagining himself "standing before your grave, separated by death's great wall, while my tears still flow in vain." Seppuku with his short sword would have been a welcome release. But his family—his younger brothers and sisters—wisely refused to allow him to have it, and asked him a question, repeating it over and over: "Is your survival really a matter of luck? Could it be that heaven has a purpose in mind for you?"

Saigo, steeped in Buddhist traditions, did not believe in random events. The Buddha had said: "As a net is made up by a series of knots, so everything in this world is connected by a series of knots. If anyone thinks that the mesh of a net is an independent, isolated thing, he is mistaken." His survival must somehow be connected to his potential future. His life was not yet run, its purpose not yet fulfilled. But what, he wondered, might this unfulfilled purpose be? He had no idea. One thing was for certain: he could not discover it by committing suicide. If he was to make sense of what had just happened, he had to embrace life, wherever it might lead.

Very quickly, it led in a new and surprising direction. The shogun's police were still looking for him and Gesshō. They

probed the new daimyo's officials, who wriggled out of the difficulty with a half-truth: they said that both Saigo and Gesshō had drowned, and showed them Gesshō's corpse as evidence. What had happened to Saigo's body? The answer was a metaphorical shrug: lost forever in the waters of Kinko Bay.

But that left Satsuma's officials and the daimyo himself with an embarrassing problem, in that Saigo was very much alive. So it was decided to send him far away, into exile, where shogunal officials would be unlikely to pry. Anywhere on Satsuma's main island would be risky. But there were several possible places in the chain of islands leading south to Okinawa, the islands that formed the semi-independent kingdom of Ryukyu that had paid tribute to Satsuma for the past two centuries and more. The island chosen was the largest one, Amami Ōshima, a semitropical place of steep, forested hills; sharp inlets; and a local population regarded as utterly primitive by those from Japan proper.

He had already been ordered to change his name. He chose a new one with two parts: Kikuchi Gengo, the first element recalling his supposed samurai forebears who had fought against the Mongols in the thirteenth century, the second element meaning simply "myself." (This was not a big deal, except for historians trying to work out what to call him. It was common to have alternative names, and apart from "Saigo" he had had half a dozen as he grew up, some of which he used simultaneously for work, among friends or as pen names. "Takamori" was the name he took upon reaching adulthood. He would soon take one more.)

It was as if he had become one of the living dead, or worse. In letters to his friend Ōkubo just before his departure, he wrote of how he had "become dead bones in the earth, obliged to endure the unendurable"; yet somehow he would summon

up the strength built into him from childhood, somehow he would stay true to the agenda of his dead lord Nariakira: "Somehow I shall bear the unbearable for the sake of Emperor and Court."

Early in 1859 he boarded the sailing boat that would take him on the ten-day, four-hundred-kilometer journey into an exile that he fully expected to last the rest of his miserable life.

9

EXILE, AND A NEW LIFE

TODAY, IT'S AN EASY TRIP TO AMAMI ŌSHIMA. THE PLANE compresses Saigo's two-day journey into a pretty half hour, past Sakurajima's smoking crater, along the great peaceful inlet from the China Sea, over an ocean broken by another smoldering volcano and tiny unpeopled islands and the occasional boat trailing a wake like a comet's tail. Then it's down into a different world of twisting coastlines and steep semitropical forests, where boar still run wild and you can hear the crowlike call of a rare species of jay,[1] and the *habu*, a local pit viper, lies in wait. Also, it rains a lot.

Locals downplay the *habu*, but locals always downplay dangers they know. Not many people get bitten, they say. For outsiders who step off the road to admire a distant beach and rolling breakers, it's unnerving to stand in lush long grasses

[1] Lidth's Jay, which occurs only here and on the next island to the south, pine-forested Tokunoshima.

beneath a shady tree and then suddenly see a notice attached to the trunk reading—in English—"There are many poisonous snakes around here." This outsider lost interest in the view and retreated, very carefully, to the road. Back home, I wondered if I was overreacting. "Relatively small, not usually getting longer than five feet," said one Web site. "Rarely aggressive. Bites only if provoked. Not as deadly as cobras or mambas." Well, that's reassuring. I'm not surprised not many locals get bitten. Only idiots would risk meeting a *habu*.

Of course, they know all about Saigo on the island. Michiko and I were met by a group of middle-aged, smartly dressed ladies with careful makeup who were the leading members of a society dedicated to him—though the chief spokesperson was a slim, gray-haired man, Mr. Yasuda, who owned the van which carried us all. I wondered why Saigo was so popular with the island's women. But as we proceeded in a convoy to the place where Saigo landed that day in January 1859, it emerged that he was not quite as much of a local hero as I had assumed.

On clear days Tatsugo Bay is postcard gorgeous, with twisting inlets and forests plunging to the shore. The view is not unspoiled, because there's a coast road and vast piles of concrete caissons lying about, as if tossed at random, to take the force of breakers rolling inland from typhoons. Back then, there was only the shallow blue water, the beach of gray pebbles and a fishing boat or two. Saigo's ship, used to transport the island's only product, sugarcane, moored out in the bay, and he was rowed ashore, stepping up to a beachside track and the first line of steeply rising pines. One is of particular interest: it's called the "Saigo Pine," because as the sign says, this tree was the one around which his mooring rope was wound. A portrait shows him as the countryman, with fishing rod and dog. He

liked dogs: so much, indeed, that in portraits a dog is his prime attribute, like Zeus's thunderbolt or Cupid's bow.

He scared them, this giant of a man with protruding eyes and grim expression. Though an exile, he was still a Satsuma samurai, exuding prestige and power like an aura. A local photographer painted a portrait of him that hangs in the island's museum, a weird and powerful image of a heavy-jawed man with vast eyes and eyebrows like mountain ranges. If this was how he seemed to the islanders, no wonder they were afraid of him: who knew what this mighty samurai might do to strengthen Satsuma's rule here?

For this was Satsuma territory, had been for 250 years, and officials came here to ensure that taxes were paid and sugarcane delivered. Otherwise, the place was virtually untouched. If any Chinese made it this far north from Okinawa, no one recorded their visits. An American commander named Glynn claimed to have "discovered" the island in 1846, apparently oblivious to its long-standing occupation by the islanders and the occasional official visits from Okinawa and Satsuma. No one tried to turn the islanders from their traditional ways, which included the Neolithic habit of unearthing the dead after three years and reburying them in caves. Buddhism and Shintoism were unknown here. Life was basic and primitive beyond anything Saigo had ever seen, not least in consequence of Satsuma imperialism. In the mid-eighteenth century, the daimyo realized the possibilities of sugarcane and forced the islanders to cut back on their poor-quality—but vital—rice and start growing sugarcane instead, imposing his will by granting estates to overlords. They quickly became slave owners, with dire consequences, because the locals were not allowed to eat the sugar they grew. A Satsuma official had reported:

"There isn't a home on the island where I would even want to sit and wash my feet. The people worry about their next meal day and night and they eat broken bits of seaweed from the beach . . . Today I suddenly understood the depth of human anguish."

Saigo was a guest of the island's top family, the Ryu, living in a thatched house that was part of the little family community crowded between the hills and the bay. The village was called Obama (a meaningless coincidence, nothing to do with a Luo family of the same name whose menfolk were at this time herding goats on the shores of Lake Victoria in Kenya). The Ryu were well to do, with a household staff of over seventy— products of the island's appalling slave system, according to which locals who could not produce enough sugarcane from their small farms had to offer themselves as house slaves.

Saigo, who had after all been raised in poverty and was used to simple living, insisted on gathering his own firewood, and doing his own cooking and cleaning (so the ladies told me). He was a forbidding figure, depressed, taciturn and angry at the contrasts between what he had been, what he had hoped for and what he had become. He referred to himself as a despicable person, or a hog. He could look forward to nothing in a place he regarded as a dump. He was appalled by what he saw. "It is painful to see the extent of the tyranny here," he wrote to two friends. "The daily life of the islanders seems honestly unendurable . . . I am astonished by the bitterness of their lives: I did not think there could be such hardship." [2] At first, he despised the primitiveness of the locals, referring to them as *ketōjin*, which means literally "hairy Chinese person" and had come to be a rude word for foreigners. For someone

[2] The quotes are from Ravina, *The Last Samurai*.

who for several years had been close to top people, he wrote, "it is difficult to mingle with these *ketōjin*." They still haven't forgiven him for it.

Yet it was precisely the degraded quality of the local people's lives that began to lift his spirits. His natural sympathy for the poor and suffering led him to make friends. It so happened that Ryu's second son had a house in Obama, and he had a daughter named Aikana (or Aigana). It was inevitable the two would meet. A portrait of her shows quite a beauty, a dignified girl with delicate features and dark hair piled up into a bun with a peg to hold it in place. Undoubtedly, though, Saigo's first impression of her would not have been good, because she, like most local women, had retained the ancient, "primitive" habit of tattooing the backs of her hands, the intricacy of the designs—arrow points going up the fingers, with dots and swirls and crosses on the flat parts—reflecting her status. The designs are on show in the local museum, where the grayhaired Mr. Yasuda explained them.

"Island girls started with the left hand when they got their first periods," he said. "When they were of a marriageable age, they did the right hand."

The practice died out in the late nineteenth century, because girls discovered that outsiders thought it looked tribal, primitive, even barbaric. It didn't bother Saigo for long, though, if at all, because within a year of his arrival they were together— some sources say "married," for which there is no evidence, others that she was a local mistress—and within another year or so (in February 1861) Aikana gave birth to a son, Kikujirō. For someone who was famously uninterested in sex, nothing could have better expressed Saigo's urge to reconnect with people and put behind him the depression with which he had arrived.

Top: Saigo as seen by a local artist in Amami Ōshima. *Middle*: Saigo's "island wife" Aikana. *Bottom*: The tattoos with which local women marked their hands.

In addition, he was by no means completely isolated from events back in Kagoshima and Edo. His childhood friend Ōkubo had arranged for another official they had both known as boys, Koba Dennai, to be posted to the island as an inspector. Information about the shogun and his opponents came in with the sugarcane boats. Ii, the shogun who had destroyed the advocates of more imperial authority and approved the Harris Treaty allowing foreign powers greater freedom, seemed supreme. The pro-emperor party despaired, and spoke of killing him. Letters went back and forth, bearing information and advice. To Ōkubo, the leading Satsuma loyalist in Saigo's absence, Saigo urged caution: better to plan carefully than risk all too soon. It seemed to work. Satsuma's lords, Tadayoshi and his father Hisamitsu—those who had exiled Saigo—promoted a few who had supported the radical Nariakira. The loyalists began to refer to themselves as the Band of Loyal Retainers, working to form alliances and get Saigo back to Satsuma.

In March 1860, just over a year after Saigo had been sent into exile, their cause received a dramatic boost. A band of eighteen samurai assassins, almost all from Mito domain, attacked Ii's cortege just outside one of Edo Castle's main gates, and cut off his head. One of the assassins—the only one from Satsuma, the younger brother of one of Saigo's friends—ran off with the head before dying of his wounds. The crime was a dire blow to the shogunate, which tried, ludicrously, to claim Ii was still alive, undermining its authority still further. When Saigo heard the news, he ran outside barefoot and with his sword hacked at an old tree to express his joy. He had hopes of a pardon, and of rejoining the movement to reform a society which was becoming ungovernable. But no pardon came, and his hopes died.

Not that this cast him into a new depression. He had with

him not only his childhood friend Koba but also a local man named Toku, a constable who shared with Saigo a total lack of interest in wealth. The two loved fishing together. If only he could just serve his country loyally and go on living quietly, fishing with friends, then—Saigo told Toku—he would be happy.

And he had Aikana, and a baby boy, and then another child, a girl called Kikuko. The family lived together happily, by all accounts, even building a new house for themselves close to the village, a few dozen meters back from the bay. It was a simple place, just two rooms, raised half a meter on a platform, with sliding panels for doors: a perfect base from which the children could play and the master of the house go off into the hills to hunt boar or down to the shore to take a boat out fishing. It, or something like it, is still there today, being run as a historic site and tourist attraction by one of Aikana's descendants, Ryu Masako, who lives in a modern house alongside.

With Koba to help him keep abreast of affairs on the mainland and Toku to help keep local officials in check, he was becoming a respected member of the local community, teaching children and doing his best to redress wrongs, of which there were plenty. Officials would arrest islanders and torture them to make them reveal hidden produce. There were cases of prisoners becoming so desperate they tried to bite off their own tongues. Saigo complained to the island's boss that this brutality, and the high level of taxation, disgraced the name of Satsuma. He said they might as well murder the islanders then and there. When told to mind his own business, he said anything that touched on the honor of Satsuma was his business, and unless these practices stopped he would make a detailed report of the offenses. They did not stop, but they did diminish.

As the ladies talked, I realized why the members of this Saigo society were mostly women. It was actually an Aikana society. She was a local woman, as they were, and Saigo was the outsider. It was the illiterate Aikana who had turned him from a forbidding samurai-scholar-official into a human being. She used to sit on his lap in a display of relaxed domesticity. Not that all was sweetness and light, because they fought sometimes. Of course she knew that he was an important person and would one day go back to the mainland, so when she was combing his hair she would gather some of it up and keep it. Did I know that after his death, when his head was retrieved, the hair gathered by Aikana was used to establish his blood group, and that the head was really his? I didn't. It's a great story, but doubtful. If there's truth here, it's well hidden, because blood groups were not discovered until 1900 and his head was very obviously his, in death as in life.

The group was full of stories like this. He often went fishing, they said. People were eager to go with him, even though he was so big that when he moved around the boat water used to flood over the side. It didn't matter because they had a bailer to throw the water out. "One time," said Mr. Yasuda, to widespread laughter, for the group knew what was coming, and this was not a story to be told by women. "One time he got a terrible stomachache, and had to relieve himself in the bailer, which he then held in the water to attract fish, which he used to make a sashimi meal. Naturally no one would eat it."

To hear them talk, you would think that Saigo became an angel thanks to Aikana. He was good and kind. He received a stipend from Satsuma, but courted poverty by giving much of it away to help the poor. He taught the local children how to wrestle. He loved hunting boar, even though he was not a

good shot, and when he got anything he would share it with the people. When locals were jailed by unscrupulous officials for not producing enough sugar, he got them out.

"So he was prepared to go against the government?"

"Not really. It was the local abuse of power that he fought. There was so much profit to be had here that officials had to build a special warehouse in Kagoshima."

These years marked another long turning point in a life of many turning points. Saigo had arrived a broken man, responsible for the manslaughter (as a western judge would put it) of his best friend, shamed by his failed suicide, destroyed by the collapse of his hopes and facing the possibility of eternal exile in a place he loathed. After two years he was, if not content, then at least reconciled to his new life, and accepted, and a pillar of the community, fully restored to physical and mental health.

In that case, I wondered, why the undertow of disapproval from the ladies, the determination to make Aikana the real angel? Partly because Saigo was embarrassed about her. He hardly mentioned her in his letters, and in one passing comment about the birth of his son he wrote: "I have done something unseemly in the wilderness." But there is another, deeper reason, which involved what happened when he left the island.

It was early 1862 when astounding news arrived. He had been on the island for three years, and the new house had been finished just a couple of months earlier. Now, back in Kagoshima, Hisamitsu, the still-powerful father of the daimyo and the moving force behind Saigo's banishment, had come to the decision that he needed to expand Shimazu influence. His plan was to mount a huge embassy to Kyoto to persuade the emperor to order reforms, in particular to appoint a guardian

for the young shogun. He needed imperial loyalists onside, but without the risk of violent radicalism. Ōkubo pointed out that Saigo, admired by loyalists but untainted by violence, was just the man.

So the order came. And Saigo, the loyal retainer, remembered that he was surely destined for great things, and left.

Aikana and the children stayed. There was no question of his bringing an "island wife"—that is, a local mistress—to the mainland, where she would have been utterly out of her depth. Saigo never forgot her, and would see her again rather sooner than he expected; and later he sent for the children and had them educated in Kagoshima. Indeed, their son Kikujirō was sent to America for a couple of years, fought alongside his father and survived, and went on to become mayor of Kyoto. But Aikana stayed on the island, alone. "How sad she must have been," said one of the ladies over a lunch of miso, noodles, tea and guava juice. She lived to the age of sixty-seven, weaving silk to make a living (as people still do), and is buried close by.

We stopped to pay our respects. There were flowers on her tombstone.

"We remember her," the ladies agreed. "Because she is a role model for people who love this island."

10

A BRIEF TASTE OF POWER

TALK ABOUT TURNING POINTS: IT WAS MORE LIKE A RESURREC-
tion, from near death to a new life and, it seemed, a return to
the center of the political web, an insider charged with master-
minding a revolution. That was in March 1862. Two months
later he was out again, cast into an oblivion way beyond
Amami Ōshima. What on earth went wrong?

This is where things stood on his return: Nariakira, Saigo's
revered lord, had started modernizing before his death. The
new lord was Tadayoshi, but power was in the hands of his
father and guardian, Hisamitsu, who carried on Nariakira's
policies: industrialization to produce steel and textiles; new
weaponry; more power to the emperor, more to the daimyos,
less to the shogun. The danger was that this strategy, which
was very appealing to Satsuma's samurai, would inspire
violence among the younger, lower-rank, more volatile ones.
Tadayoshi had once written the group a letter, addressing them

flatteringly as "sincere and faithful samurai." They had seized on the phrase, and named themselves the League of the Sincere and Faithful. If the League were protesters on the march, they would shout: "What do we want?—Emperor power!—When do we want it?—Now!" and then set about getting it, with drawn swords. That's why Hisamitsu needed Saigo, to pilot through reform, while reining in the hotheads.

As soon as Saigo arrived in Kagoshima he was led into a meeting with top aides of Hisamitsu, who explained the plan—a large force marching to Kyoto in two weeks' time to demand an imperial decree imposing reform on the shogun. Saigo would head this force, in effect a revolutionary army. He would then take it on to Edo, confront the shogun, who, with a pistol (as it were) to his head, would instantly comply. However, this must not *seem* like revolution; it must come across as merely reform to give Satsuma a greater say in national affairs.

They wanted Saigo because he was experienced. And on the basis of that experience, Saigo turned them down flat. It was a crazy scheme, he said. What was the backup? He ticked off grim alternative scenarios. What would happen if the emperor refused? How long was this samurai force to sit around in Kyoto? What would happen if the shogun teamed up with foreigners to raise an opposing force? What guarantees did they have that upper and lower samurai would not fall out? Whichever way you looked at it, locally, nationally, socially, the plan was a disaster in the making—a recipe for civil war. Hisamitsu disagreed, arguing that the shogunate was fatally weakened and ready to be reformed. He was determined to go ahead, whatever Saigo said. The most he would agree to was a month's delay.

Frustrated, Saigo went off to restore his spirits by burying himself in hot sand. This was not as eccentric as it sounds.

Forty kilometers south of Kagoshima, the subterranean furnaces of Kinko Bay—the same ones that keep Sakurajima's internal fires belching smoke on a daily basis—come close enough to the surface to force heat through the dark, volcanic sands that fringe the village of Ibusuki. Since the eighteenth century, people have claimed that lying in the hot sands cures all sorts of ailments, especially rheumatic ones. In Saigo's day, the sands were open to all; today, you pay to change into a light kimono and walk down steps to a line of tents, where attendants in tracksuit trousers and T-shirts wait with spades to cover you up to the neck. People lie in neat rows, like badly buried corpses, heads swathed in towels.

It's an odd experience, in fact a whole series of experiences, none of which I could have predicted. First, you lie in your newly dug grave, head on towel, carefully arranging your kimono. Then comes the weight of the warm, coarse, volcanic sand as your attendant covers you. The heat is delicious, like a sauna, except that your breathing is not oppressed by heated air. The sand presses your chest, moving slightly with every breath. The pleasure lasts for half a minute. Then you realize that you are actually beginning to cook. Where the pressure is greatest, namely on your buttocks, it's really burning. You shuffle your hands under your buttocks, relieving the pressure and the heat. So you relax, and all is well. You drowse. Not for long, because now you're beginning to sweat. Drops trickle and tickle down your forehead. You want to use the towel, but your hands are locked by sand and buttocks. After fifteen minutes, I burst out like a zombie breaking free from a tomb, dripping sweat and sand. Yes, it made me feel good, twice over—from the heat and from having endured an invigorating and mildly uncomfortable experience: rather as a monk might

have felt after removing a hair shirt. It would have suited Saigo very well.

Two weeks later, Saigo's friend Ōkubo tracked him down in Ibusuki and persuaded him that he should at least see what other samurai thought by crossing Kyūshū to the ferry at Shimonoseki. Surely he had a duty to make contact with the League of the Sincere and Faithful and make sure they did nothing stupid? Assuming he was impressed, he could join Hisamitsu and go on to Kyoto. He agreed.

At Shimonoseki he was overwhelmed by the reception he received from, among others, his friend Hirano, one of those who had pulled him out of the sea after his suicide attempt with Gesshō. All samurai knew of him, all adored him—the one who had risked all for his ideals, unparalleled in courage, unequaled in suffering: he was just the person to speak for the samurai in Kyoto. And they all knew about the planned march on the imperial city, which they assumed would be the beginning of an armed uprising. Already many were gathering in Kyoto, awaiting his arrival. He, Saigo, was the one to defuse this volatile situation—but it had to be done fast, by first sailing to Osaka, a 350-kilometer journey that would cut several days from the journey to Kyoto. There was no time to wait for Hisamitsu as planned, or to ask permission. He, Hirano and two others left at once.

In Osaka, his worst fears were realized. The place was alive with young samurai eager for violence, all, as he put it, warriors "on the field of death"—or "deadly ground" in another translation—"with whom I would like to die in battle," all having left their families, "all counting on me." Mark Ravina suggests that the words "the field of death" or "deadly

ground" are references to *The Art of War* by the fourth-century BC Chinese strategist Sun Zi (Sun Tzu), who lists "deadly" or "desperate" ground (translations vary) among the nine varieties of battleground. In this case, in which death seems inevitable, there is no choice but to face death with resolve: "Throw the troops into a position from which there is no escape, and even when faced with death they will not flee. For if prepared to die, what can they not achieve? Then officers and men together put forth their utmost efforts. In a desperate situation, they fear nothing; when there is no way out they stand firm." Already Saigo apparently believed that the cause was worthy enough—*made* worthy enough by the bravery of the warriors—to risk, even court, death. This would be a default position for him from now on.

Next stop would be Fushimi, a great mountain shrine close to the temple where Saigo used to meet secretly with Gesshō. He never made it. Hisamitsu, already angry that Saigo had gone ahead without permission, heard about what he was up to, mainly from Hirano, who had convinced himself that Saigo was about to lead a samurai rebellion. Hisamitsu leaped to the same conclusion and ordered Saigo's arrest, refusing to listen to any evidence on Saigo's behalf.

After six months in the spotlight, Saigo was suddenly powerless again, locked up in Yamakawa at the mouth of Kinko Bay, awaiting judgment. It came in July: guilty on four counts, namely, leaving Shimonoseki without permission, conspiracy, incitement to violence and treachery. Saigo, who had acquired almost mystical status among rebellious samurai, was too dangerous to be allowed to return to friends in Amami Ōshima. The verdict: exile again, this time as a criminal, on Tokunoshima, the island next in line to the south of Amami Ōshima. It was fifty kilometers farther away, under half the

size, but with similar forested mountains, and its own subspecies of *habu*.

Saigo was naturally bitter: "Even men whom I thought of as family branded me a criminal without so much as asking for the truth . . . I want nothing more to do with this stupid loyalism." Bitter, but more resilient this time. There were no thoughts of suicide. If this was what fate had in store, so be it. He would happily put the disgusting world of politics behind him, and prepare to make whatever he could of island life. One thing he could do was check up on his family. Soon after his arrival Aikana turned up with the two children; but Saigo was not going to share his tough existence with them, only ensure there was a friend at hand on her home island who would buy the silk she wove and make sure she didn't starve.

He didn't get the chance to make anything of life on this new island, because there was no time. In August, a month after his arrival, constables from Kagoshima stepped ashore with the news that his daimyo had concluded he was too dangerous, even there. He would be transferred instantly, in close confinement, to an island even farther off, even smaller and much harsher. The place was a penal colony, and he was to be kept in a cell, alone, with the door always locked, under constant surveillance by two guards. It was a sentence harsh enough to freeze the soul.

11

THE PRISONER

HOW DECEPTIVE FIRST IMPRESSIONS CAN BE. OKINOERABU—
the vowels separate out in pronunciation, "Okino-erabu"—is
the opposite of Amami Ōshima: no hills, no delightful inlets,
no beaches, no forests. It is shaped like a cartoon version of a
Stone Age club, as if dropped by a giant on his way to batter
Japan. Officials back in Kagoshima thought they were sending
Saigo to a hardscrabble, poverty-stricken back of beyond, yet
what he found here enriched him beyond measure.

As I approached from the air, I saw a grim pancake of an
island, all fields of either dull green or bare red earth edged
with rough rocks—coral, as I discovered—too low to count
as cliffs. Yet what I found was entrancing, not because of its
landscape, but because of its people. Why such a place should
produce inhabitants of such zest and charm I have no idea. But
it does, and Saigo thrived there.

He came prepared for the worst, and that helped. The

officers escorting him carried the order that he was to be kept in an "enclosure." On August 16 one of them came ashore from the little ship and hastened to the capital, Wadomari, four kilometers away, with the order. But there was no suitable enclosure. The island's superintendent, Tsuzurabara, would have to make one, fast. He was puzzled. There were about one hundred people in exile on the island, but they were all free to walk around. This was an unprecedented order, applying only to Saigo. What could it mean? He assumed that the word meant a prison of some kind, so he ordered one built. Meanwhile, Saigo had to remain onboard for two more days.

What happened next, like almost everything to do with Saigo on Okinoerabu, is a matter of both detailed historical record and folklore. It's not often the two come together, but the islanders are well educated, meticulous and great storytellers, largely thanks to Saigo.

We were quite a party. Since Michiko had worked here and was given an ecstatic welcome, I had the benefit of two ancient scholars in white floppy sunhats, Saoda Tomio and Oyama Yasuhiro, who were not only well educated, meticulous and great storytellers, but also displayed a terrific combination of older expertise and youthful enthusiasm, having written a book together about Saigo's stay here. We were being driven by another enthusiast, Take Yoshiharu, who was, basically, an extremely cheerful cube, as broad as he was tall and as enthusiastic about tennis and sake as history.

When the prison was ready, officials came to the landing site to welcome the Great Saigo, bringing a horse to carry him, his size being well known.

"And our first words to him," said the eighty-year-old Saoda, as if he had been on the spot, "were, 'We have prepared a horse for you. Please ride, and we will accompany you.'"

I could imagine the scene, because we were at the place where he landed: the little port of Inobe, now fringed by an immense wall scattered with piles of vast four-pronged bits of concrete, as if that passing giant's child had tossed down a handful of jacks. They were there to defend the shore from typhoons, which in the old days would sweep inland three or four times a year. But the beach of white coral sand was still there, and so were the rolling breakers beyond the wall.

My apologies for interrupting Mr. Saoda: "—and we will accompany you." To which Saigo, with great dignity, replied— well, his words are recorded on a pillar that marks the spot and the date: a new one, because the old one was destroyed in a typhoon in 1947. But the words on the pillar are rather formal. I prefer Mr. Saoda's version: "'I am very grateful to you,' Great Saigo said, 'but please let me walk, because this is my last chance to step on the soil.' So the officers and the horse all walked with him to Wadomari. That was really touching. The people who came to welcome him were very impressed with his attitude."

We walked the same path, beside a sugarcane field (for this island, too, was all sugarcane fields farmed by slave labor imposed from Satsuma). When Saigo came by in mid-August it would have been in full, head-high growth. We trailed a river, now hemmed in with concrete walls and clogged with grass, turned a corner and were back almost at the sea. There, in an open area some two hundred meters inland, was the prison.

I saw a cage, a cube of wooden slats, two meters square, two meters high, just about big enough for Saigo to lie down and stand up. It had a shaggy thatched roof, but no walls to keep out wind-driven rain. A half door was made of the same slatting, chained and padlocked. Yes, I saw at once it could have been built in two days. What a fearful place to spend the

rest of one's life, which was the prospect facing Saigo when he arrived. Inside was a dim figure, a statue of Saigo sitting cross-legged, in a meditative pose. I saw, and believed. This was "his prison," and he was on the island for eighteen months, therefore this is what he suffered for all that time, in solitary confinement. Any naive new arrival would, I think, feel the same, sympathy for the prisoner vying with admiration for his powers of endurance.

I was wrong, in many ways. The truth, as it slowly emerged that day, was far more interesting, and also in a small way raised the question of the nature of authenticity in historical evidence.

I went forward to examine the cage, to touch the wood that Saigo had touched, and found that it was not wood at all, but concrete disguised as wood.

"That's because there are typhoons every year," said Michiko. She was a model of politeness, but I can imagine what I would have thought in her shoes: wood and thatch surviving for a century and a half, in the tropics? What was I, dumb or something?

And another thing. This reconstruction was on the edge of the riverbank, now safely encased with concrete to funnel the daily tides and occasional storm surges. But there was a drainage hole in the wall. This whole area was still liable to flood.

Ah, well, this was not where the prison was originally, said Mr. Saoda. The mayor's office used to be in the middle of this space, well away from the riverbank, and the prison was built beside it. And the police office was over *there*, and two storehouses *there* . . . And—as I discovered later from the book written by Messrs. Saoda and Oyama—the prisoner was not quite as deprived as I had imagined. He had a servant with him, Kanaka Kuboichi, a lower-class samurai from

Kagoshima; what he was doing before he joined Saigo is not recorded. Anyway, there he was, keeping an eye on his master. All of which put things in a different light. Saigo's prison had been in the heart of a little community.

But it was still a prison, still an earlier version of the one you see today. Mr. Take, the cubic tennis player, appeared with a key. Stooping through the half door gave a feel for what Saigo was supposed to endure day in, day out. It was little more than an animal cage. A bamboo floor, with a single mat made of rice straw, a toilet box of sand in one corner, a fire pit in another, all now modeled in concrete. There sat a plaster Saigo, meditating, eyes closed, legs crossed, feet turned up, fingers interlocked, thumbs together. It looked extremely uncomfortable.

"He was used to it," said Michiko from outside. "Remember you saw where he practiced meditation with Ōkubo at the Meditation Stone in Kagoshima?"

Actually, now that I came to look more closely, this figure was nothing like him. It was emaciated, haggard even, and bearded. If this was Saigo, it was more in spirit than in flesh, because for a while he did indeed suffer. Mr. Saoda clambered in with me. There were flies, he said, and mosquitoes, and summers are hot and sticky here, and there was the smell of the toilet, and there were typhoons, which blasted him with spray and small stones, because the whole open area was covered with pebbles. The stones hit with enough force to draw blood. Yet he bore the conditions as a stoic and as a samurai loyal to his lord's orders. That meant he regarded himself as a criminal, and his punishment as just. There was nothing for it but to endure.

"When in prison, he sat all the time like this, eating just what was brought to him: rice, water, a little greenery. He had two sticks which he could use to bang on the side of the prison

to get attention, but he never used them. He used to say, 'Even if people pay no attention to me, heaven looks after me.'"

The picture was changing, becoming richer, like an old-fashioned black-and-white photograph in a tank of developing fluid. Saigo was no longer a mere victim of a sadistic system, but an ascetic at the heart of a group of sympathizers and admirers, who did not like what they saw: a good man fading away.

Back in Japan proper, matters took a dramatic turn. One month after Saigo's arrival in Okinoerabu, an Englishman was murdered in Yokohama. Most Japanese at the time, certainly most samurai, would have shrugged. A foreigner killed: so what? His fault for being foreign. It happened far away, and Saigo never mentioned it, but it would turn out to have been one of the first gusts of wind driving Japan toward the maelstrom that Saigo would help create, and which would eventually drag him down.

On September 14, 1862, three English men and one woman set off on horseback from Yokohama, intending to take a boat to see a temple. One of the men was Charles Richardson, a merchant from Shanghai on his way back to London. The woman was Margaret Borradaile, wife of a Hong Kong merchant. They had gone twelve kilometers along the busy Tōkaidō road, which Saigo had traveled on his way to Edo, when at the village of Namamugi, now a Tokyo suburb, they came upon a column of samurai marching toward them at the head of a procession. They edged past between the wood-and-thatch houses and the surly two-sworded men, and were approaching the lord's palanquin when his retainers waved for them to turn back. They were in the process of doing just that when several samurai, apparently taking offense at the

foreigners' lack of respect, attacked with drawn swords. One struck at Mrs. Borradaile's head. She ducked, and the sword cut away her hat and a lock of hair. Others went for the men, cutting down Richardson, who fell, fatally hurt, and wounding the other two—one of them receiving a cut halfway through his left arm—who shouted to Mrs. Borradaile to ride on. She broke free, so panic-stricken that she galloped into the sea before regaining the road. Her horse fell twice, but somehow, she couldn't remember how, she regained her seat and arrived in Yokohama's foreign settlement "in a fearful state," according to a letter in the English-language *Japan Herald*, "her hands, face and clothes bespattered with blood."

At once, though with some confusion about who was in command, half a dozen English and French officers tore back to the scene, to find the two wounded men in the American consulate in Kanagawa. But where was Richardson? Everyone they asked denied all knowledge, until a little boy directed them to the side of a cottage off the road. There they saw a mound covered over with a couple of old mats,

> which on being removed revealed a most ghastly and horrible spectacle. The whole body was one mass of blood; one wound, from which the bowels extruded, extended from the abdomen to the back; another, on the left shoulder had severed all the bones into the chest; there was a gaping spear wound over the region of the heart; the right wrist was completely detached, and the hand was hanging merely by a strip of flesh . . . and on moving the head the neck was found to be entirely cut through on the left side.

Clearly, some of the damage had been inflicted after death. Why might this have anything to do with Saigo? Because

the lord in the palanquin, the commander of the samurai and therefore the man responsible for the attack, was Hisamitsu. He was on his way home, having demanded a new power-sharing arrangement in which the most important daimyo would share decision making with the shogun, and in which the emperor's authority would be boosted by giving him the power of approval.

The news of Richardson's murder put the community of foreign traders into a ferment of anxiety and anger. In meeting after meeting, many were for whipping up a military force to seize Hisamitsu, until the chief British representative, Lieutenant Colonel Edward Neale, pointed out that this would be tantamount to a declaration of war. As another diplomat, Ernest Satow, later wrote, it might also have unleashed a whirlwind of violence, leading to the mass murder of foreigners, the collapse of the shogunate, the dispatch of armies and navies by Britain, France and the Netherlands, and the dismemberment of Japan. Best let diplomacy take its course.

Which it did, with the usual delays. Six months later, the British Foreign Office took action that would devastate Saigo's hometown.

The one who was most sympathetic to Saigo was his main guard, a man named Tsuchimochi Masateru. For four months, he brought Saigo's rations. He saw what happened when a typhoon struck, which it did perhaps two or three times in those four months. The two became friends. Tsuchimochi's admiration for his charge grew into hero worship. That much is a matter of record, to which Mr. Saoda added color. At home, the guard's mother cooked extra food for Saigo. No, no, he said, I am a police officer, I cannot break the law by giving him extra food. "You must be a man!" said his mother. "You have

to help him!" So he tried; but Saigo refused. To accept would be disloyal to the orders of his lord.

"The guard thought, 'We shouldn't let him die. We have to keep him alive.'" This was Mr. Oyama speaking, the younger of the two floppy-hatted Saigo experts. It was perhaps Hisamitsu's intention that Saigo should die, but there was nothing about death in the order. He could hardly be kept in an enclosure if he were dead. "So he took another look at the orders. There was this word—"

"*Kakoi*," put in Michiko. "It means"—she checked her dictionary—"yes, a fence, or an enclosure."

"But it did not say where it had to be. It did not have to be outside. It could be inside."

Tsuchimochi pointed this out to the superintendent, who agreed that it was ambiguous. So Tsuchimochi built another simple wood-and-thatch house, with a prison room inside it. The work took about twenty days, and for that time he let Saigo go free so that he could regain his health.

Saigo wanted to express his gratitude to Tsuchimochi, but, having been declared a criminal, he had no stipend and nothing to give, so he told the guard he would teach his children sumo wrestling. That was how a new life started: first the wrestling, which attracted a crowd of up to twenty children, and then, when he was inside his new "prison," which was not so much a prison as a study with a lock, he was free to teach and talk and read and—

To *read*?

Oh, yes. He had his books.

No one had mentioned the books. He had brought three trunk loads of them, said my experts; so we should revise the image of the procession from the landing site to include first

the servant Kanaka and now a handcart or two to carry his books.

"Three trunks," Mr. Saoda said, "containing twelve hundred Chinese and Japanese classics."

Quite a library. Saigo quickly became the center of a study group, with classes for the children on history and literature, backed by long conversations with local scholars. These included one Misao Tankei, whose father had left an extensive book collection, and a calligraphy teacher named Kawaguchi Seppō, a Shimazu retainer who had been exiled ten years before with his family. This was a mini-university in the making. "I am undisturbed by daily affairs," Saigo wrote, "so I can devote myself without distraction to learning and it seems as though, at this rate, I will become a scholar." His calligraphy improved. He returned to his old passion, classical Chinese poetry, with its strict rules on the number of syllables per line and lines per verse.

> A sunflower turns towards the sun
> as though the light were unchanged,
> So I will remain loyal,
> even if my fortunes are unchanged.

Saigo's talents and interests triggered something latent in the islanders—a love of learning; and also something new—a love of good government: new because local autonomy was not part of their history under Satsuma's oppressive rule.

Near the prison is another open space where in 1911 they opened a library named after him, the first library in any of the Ryukyu Islands. Now the library is gone, replaced by a shrine—a temple, an altar a few steps up—funded by a corporate boss

who admires Saigo. We all made ritual bows to Saigo's memory. Alongside is a statue, a copy of the most famous statue of all, in Tokyo's Ueno Park, showing him striding along, kimono flowing in the wind, leading his little dog. It had been made in 1977 to commemorate the centenary of his death, displayed in Kagoshima, and then brought here. Mr. Saoda became quite lyrical about the scene before us, his eighty years seeming to fall away as he spoke.

"He read seventeen hundred books [the number, I noticed, was increasing] while he was in prison, so we thought he was a very wonderful man. We paid our respects to him by calling him Great Nanshu ["of the South," the name he used when he arrived], or Teacher Saigo. Everyone remembers how hard he studied. We thought we should study as hard as he did, so we built the Nanshu Library here. I remember it from when I was a child. We used to come here on Sunday mornings to play and listen to talks from our seniors, as part of *goju* education. They still say, "Let's go to the Nanshu Library," meaning this place, although it's long gone. Now it's been replaced by a better one. You will see."

The new library is indeed a fine one, with a room devoted to Saigo. Our little group treated it as another shrine, everyone falling silent as they browsed through the collection of historical texts and secondary works. They really are a community of book lovers, all (they say) thanks to Saigo.

There was more. Mr. Saoda and Mr. Oyama invited me to sit and listen, to make sure I understood the nature of the change brought about by Saigo. Amami Ōshima had brought him back from the dead; but it was on Okinoerabu that he rediscovered his passion for life.

As indeed anyone would, when presented with a culture so proud of its dialect and its traditions—this was after all

a separate nation before Satsuma took it over—including its music and its dances, displayed to us one evening by two ladies in patterned kimonos and vast red-and-white hats, as wide as the women and half a meter high, in the form of flowers. Their stately performance was followed by a storming, stomping drum dance by Mr. Take's exuberant teenage son and daughter in black warrior costumes. If Saigo saw a tenth of what I saw that evening I'm not surprised he fell in love with the place.

Cut off from his old world and then connected to a new one, surrounded by his books and the intense interest of the islanders, with nothing much else to distract his attention, Saigo used his time to refine his philosophy of life. His thinking was rooted in his childhood reading of the Confucian classics and their interpreters, Zhu Xi and Wang Yangming, and their nineteenth-century exponent Sato Issai. In fact, as a student Saigo had copied out 101 of Sato's pithy aphorisms in a little handbook, which he kept with him to study. From his studies, he came to the conclusion that heaven was the key to morality (as Charles Yates sets out in his superb biography). "In all one does, one must have a heart that follows heaven," reads one entry, and another: "One must accept that one's flesh is the property of heaven."

Sometime after his survival in Kinko Bay, he came to believe himself to be in heaven's hands. Perhaps this notion grew in him while he was on Amami Ōshima. Perhaps, as some have suggested, for him to believe that his rescue was heaven's will was a way of absolving himself from shame at his own incompetence and guilt at his survival. Perhaps there was in him not only a drive to live morally, but also a drive to die morally, as he had tried to do with Gesshō.

While he lived, however, Saigo felt himself bound by a chain of morality to heaven. Heaven is embodied in the emperor, and

the emperor delegates his authority to the daimyos, and the daimyos delegate authority to their officials, who must never forget that they owe their authority, ultimately, to heaven. Since it was axiomatic that the emperor was descended from the sun goddess, the imperial dynasty was eternal. The officials under him, however, were not. While the emperor reigned immutably, it was his ministers, including the shogun, who did the actual ruling, and they could be removed if found wanting. So the duty of any official, however lowly, is to reflect heaven's will and administer well, eliminating selfish desires. An official position is not a possession, but a sacred trust. The proof of an official's success is the happiness of those at the bottom of the chain of command. If the people are content, heaven is content; if they are not, it's the fault of those who rule in heaven's name.

With this in mind, Saigo coined a simple four-word mission statement, which deserves capital letters, because it was the key to his beliefs and actions:

REVERE HEAVEN, LOVE MANKIND

Keiten aijin: you see it everywhere on Saigo memorabilia. But this was not just a private motto. People quote it as the principle that underlay his lasting gift to Okinoerabu. Those twenty children who studied under him on the island became leading officials, the heart of this little society, and carried his principles down through the years, putting into practice Saigo's main moral rule: the duty of government is to serve the people. They had it in writing, because Saigo spelled out the proper tasks of the village leader to his guard, Tsuchimochi, and his words were taken down at the time in classical Japanese (now translated into modern Japanese by Saoda and Oyama). So after he

left, local officials worked out how they could best serve their people, and came up with an original self-help scheme. Saoda and Oyama spelled it out for me, speaking in turns.

"Every year, this island had been hit by typhoons, which ruined crops and threatened starvation. So we realized we had to cooperate. Some years we had good harvests, and in those years everyone donated rice."

"We were then prepared for the bad years, and we could draw on our reserves. Thanks to this, Japan's first insurance system, the people did not suffer any longer from starvation."

The system came into effect only thirty years after Saigo left, but Saoda and Oyama had no doubt it arose out of Saigo's moral code.

In March 1863, seeking satisfaction at last in the matter of Richardson's murder, the Foreign Office sent its man in Yoko-hama, Lieutenant Colonel Neale, to Edo with a demand for $150,000 for allowing the murder of a foreigner and making no attempt to find and punish the murderers. In addition, if necessary, a ship would go to Kagoshima and demand that the daimyo arrange the trial and execution of the murderers and the payment of $12,500 to Richardson's family and the three other victims. The shogun had twenty days to reply, or else.

Word got around that war was coming, and/or civil war, for there were many factions dividing the emperor, the sho-gun, the many lords and the free-booting, masterless *ronin*. The shogun's people ducked, weaved, delayed, prevaricated and negotiated new deadlines. Japanese staff vanished from the foreigners' enclaves—in the case of the British diplomat Ernest Satow, along with a revolver, a Japanese sword, several spoons and forks "and the remains of last night's dinner." Vio-lence was just below the surface, and occasionally above it. A

Frenchman shot a merchant who tried to claim payment of a debt with force. Two Americans were assaulted.

The shogun's council agreed to pay in seven installments, then missed the first. The emperor instructed the shogun to close all foreign ports and expel all foreigners at once, an edict ludicrously out of touch with reality, particularly as there had also been hints that the shogun might perhaps call on foreign ships to help put down any uprising being fomented in Satsuma, among other places. As Neale put it in his reply, it was an order "unparalleled in the history of all nations, civilized or uncivilized." It was, in effect, a declaration of war, calling for the "severest and most merited chastisement." "A pageful of notes of exclamation," wrote Satow, "would not be sufficient to express the astonishment of the foreign public of Yokohama." But squadrons of English and French ships in the harbor reassured them of the order's unreality.[1]

There was still the little problem of wringing reparations from Satsuma. Clearly the central government was powerless, so Neale took the task upon himself, with the help of seven British warships under Vice Admiral Augustus Kuper. After a six-day voyage, the little fleet anchored off Kagoshima on August 12, well clear of the shore-based guns. Sakurajima loomed across the bay to the east, with the village at its base and, moored close by, three foreign-built steamers. To the west lay the town: a line of forts, the castle a kilometer inland backed

[1] Satow, who drew on no written sources but relied solely on his diaries for the "reminiscences" recorded in *A Diplomat in Japan*, says that the Japanese paid up in cash, in full, in June 1863. In fact, he seems to be referring to only one of the many negotiations about payment. The *Illustrated London News*, in a dispatch dated Thursday, December 17, reports the actual payment being made "at the close of last week," i.e. December 10–12.

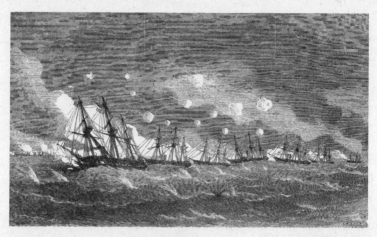

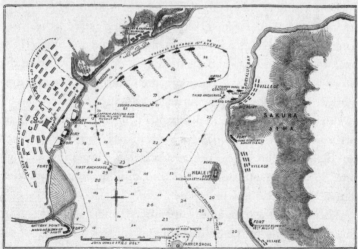

The seven storm-tossed British ships bombarding Kagoshima on August 15, 1863, their maneuvers between Sakurajima and the town marked in the chart above.

by the green hill of Shiroyama, and to the right, where the hills crowded the coast, the royal gardens and the ironworks and factories constructed by Nariakira.

Hisamitsu dispatched a delegation of forty to see Neale, intending apparently to seize his ship, a scheme foiled by the crowd of marines onboard. Neale sent a letter to Hisamitsu, demanding the reparations and the murderers. Back came the reply: Richardson's death was his own fault for "impeding" the daimyo's progress, and there could be no talk of reparations until the murderers were found, which they could not be.

That was that. Reprisals had to be taken.

The morning of August 15 dawned under gathering clouds and the rising wind of an approaching typhoon. Four ships steamed the two kilometers to Sakurajima, seized the three foreign-built steamers, lashed them alongside, hauled them back to the anchorage and awaited developments. At noon the shore-based batteries opened up, including two big cannons made by Nariakira's new furnaces. Their 4.5-meter barrels could lob 70-kilo shells 3 kilometers, which meant that the British ships were within their range. Kuper ordered the captured ships to be set on fire and scuttled, giving just enough time for certain officers, sailors and diplomats, among them Satow, to snatch some plunder.

Then, with the Japanese ships ablaze and cut adrift, came the British reply to the bombardment. All seven vessels set off on a curving course that took them parallel to the town, some four hundred meters offshore. Both shore and ships were firing. A round-shot struck Neale's flagship, the *Euryalus*, and by an extraordinary stroke of luck, considering the atrocious conditions, took off the heads of two senior officers who happened to be standing one behind the other, talking to the vice admiral. A shell also exploded on deck, killing seven other

men. Another ship ran aground but was successfully towed off, under constant but inaccurate fire from a nearby fort. Satow, on the *Argus*, described his amazement at the sight of cannon-balls flying harmlessly overhead, his ship receiving just three insubstantial hits. By 5:00 P.M., the fleet was back at anchor, with the loss of nine or thirteen lives (sources vary).

This was what is now known as the Anglo-Satsuma War, surely one of the shortest and least satisfactory wars on record. On shore, the British guns and rockets had killed five people, flattened a temple they thought was the daimyo's residence, set the factories ablaze and burned some five hundred wood-and-paper houses—the fire being whipped up by the high winds to form "an awful and magnificent sight," in Satow's words. There had been no landing, no taking of prisoners, no seizure of guns. It was hardly a victory, more of a draw, but enough to make a point. The British buried their dead and sailed back to Yokohama, where relations between foreigners and Japanese settled into precisely the same pattern of bitterness, fear and occasional violence as had existed before.

Rather oddly, however, Satsuma did pay the indemnity and apologize for Richardson's murder, also making promises to catch and execute the killers. No one believed this, because the person most to blame was Hisamitsu himself. In the end, the gesture cost Satsuma nothing: they borrowed the cash from the shogun, and never repaid it because events soon spiraled out of control.

Richardson's murderers were never found, not surprisingly, given that in Japanese eyes they had done nothing wrong. In fact, almost certainly there was only one culprit—the one who struck the first blow—and he is buried in the Tōfoku temple complex in Kyoto, the place where Saigo and Gesshō used to meet. His name was Shinichi Arima, said the monk who

showed me around, and his tomb is still respected, because, after all, "he was protecting the country's honor."

We, like Saigo, are being drawn into the whirlpool of events that sucked Japan into the 1868 revolution, the end of the shogunate and the restoration of the emperor in the person of the young man who came to be called Meiji. There was a lot of fear, and a lot of chaos. As in most revolutions, things happened very fast, possible outcomes emerging and sinking day by day, hour by hour. Some details are still obscure. But two things are remarkable when the Meiji Restoration is compared with other world-shaking revolutions, particularly those in France, America and Russia. The first is that there were very few deaths, despite months of civil war; there were no nationwide or even city-wide riots and no mass executions. This makes the restoration less a revolution, and more of a regime change in which one oligarchy replaced another. The important decisions were made in back rooms. And the reason—the second remarkable feature—was that everyone agreed on one thing: the emperor was sacrosanct. This was the fixed point around which chaos swirled, the element that assured continuity and, in the end, a nation at peace with itself at home (though to assert itself over coming decades in ways that were not at all peaceful abroad).

This is how chaos came to Japan, and why Satsuma was at the center of it, and why Saigo would not be allowed to remain happily in exile:

Hisamitsu's attempts at reform—at forcing the shogun to share power with the daimyos, the emperor to be given approval of their decisions—had come to nothing. No one at court, let alone the emperor, had a clue about managing a modern state. The daimyos were more eager to grab power for

themselves than to cooperate with each other, or the shogun, or the emperor. In addition, some of the more extreme samurai thought the answer to all problems was, as ever: *Sonnō jōi!*—"Revere the emperor! Expel the barbarians!" These people were terrorists, pure and simple, killing foreigners, harassing the shogun's demoralized armies, burning the houses of opponents, even attacking imperial officials. One senior court noble received the severed ears of a "treacherous" Confucian official; another was sent a severed hand. The shogunate was dying, and helpless to do anything to save itself.

To add to this mayhem, Saigo's own province was almost at war with its near neighbor and great rival, Chōshū, as it was generally called; in fact that was the name of the clan, which ruled what was then Nagato province (the western part of today's Yamaguchi prefecture) and thus dominated the Shimonoseki Strait, with its steady back and forth of foreign ships. Chōshū and Satsuma, each of which might have been able to save both emperor and shogunate, had a love-hate, hot-and-cold relationship, which at this moment was shifting toward hatred and coldness. Five dissident nobles had defected to Chōshū, where the pro-imperial radicals had seized power. They were all for revering the emperor and expelling barbarians, to the point of undermining Japan's future, by (for example) opening fire on western vessels passing through the Shimonoseki Strait. Chōshū was also eager to undermine Hisamitsu's more temperate influence at court.

Desperate to retain power, Hisamitsu agreed to a quick alliance with another domain (Aizu, part of Mutsu province) and tried to organize a coup by seizing control of the emperor. On September 30, troops from the two domains attacked the imperial palace in Kyoto, a place of vast gardens and unpretentious but extensive single-story wooden buildings, which in

Saigo's day had been there less than ten years, the previous ones having been destroyed by fire. The attackers had allies inside, so the task quickly ended with the Satsuma men ousting those from Chōshū.

But for Hisamitsu to be on the inside did not achieve anything. There was too much hostility toward him. In these dire and worsening circumstances, Hisamitsu could do with all the help he could get, even from a man he himself had condemned to exile, imprisonment and possible death.

He sent for Saigo.

At the end of March 1864 a steamship—perhaps the first seen by the islanders—arrived at Okinoerabu bringing three of Saigo's friends, who carried the astonishing news that he had been pardoned and was summoned to return as soon as possible.

Nothing could have surprised or delighted him more. At once, he disposed of his property: his books to the island, the rest—kimonos, kitchenware and fire stove—to individuals. His servant, Kanaka, received an iron kettle and a teapot, which would come in handy, because he stayed on and married an islander. There was just time to compose one last poem to his guard and savior Tsuchimochi:

Parting seems like a dream, like a cloud
The desire to leave, the longing to return, my tears fall like rain
The kindness you bestowed on me in jail is beyond words of thanks.

Onboard ship, he realized that he had not properly thanked his cook, who was among the little group seeing him onto

the vessel. So, the story goes, he took off the top kimono he was wearing and wrapped it around the cook's shoulders. The name of the cook is recorded: Shimatomi. Perhaps it was he who produced the extra food in the kitchen of Tsuchimochi's mother. It's a nice touch. Who knows, it might even be true.

And then he was on his way, insisting on a stop to see his "island wife" Aikana and two children on Amami Ōshima. He was there for three happy days, before leaving her for what would be the last time.

On April 4, he was back in Kagoshima, and three weeks later in Kyoto, preparing to be briefed by his former oppressor, now his rescuer, his lord's father, Satsuma's regent Hisamitsu.

12

INTO THE MAELSTROM

YOU KNOW THE NIGHTMARE IN WHICH YOU ARE ONSTAGE without knowing the story, let alone the script? That was Saigo in April 1864, suddenly finding himself in charge of Satsuma's military affairs locally and the domain's ambassador in Kyoto. Luckily, he had the support of his childhood friend Ōkubo; luckily also, he was in no worse a position than the court and shogunate, both of which were responding to events as they happened, with no coherent policy.

To tell the events that followed over the next few months in detail would be tedious. As they unfold in my mind's eye, I see not a play, but a film, a Kurasawa black-and-white, speeded up, all flickering images, compressing time, in which Saigo dashes back and forth, changing his plans and his mind with every new twist in the action.

Chōshū obsesses him. Its opposition demands a response. But to attack Chōshū will play into the shogun's hands, and

besides, western powers are planning their own assault as a punishment for shelling their ships. For Satsuma to attack Chōshū right now would seem pro-foreign, which is precisely what Satsuma is not. If only he could know what Chōshū's plans were! Then he would know if they were good or evil. The thought gives him an idea, a typically impulsive one. He will meet with Chōshū leaders and ask them their intentions. If they kill him, so what? It's in a good cause. At least his lord will know where Chōshū stands. Is he serious? Probably. But Hisamitsu rejects the idea, and then suddenly it's irrelevant, because on August 20, Chōshū, determined to seize power back again, attacks the imperial palace and its Aizu and Satsuma defenders. The battle rages at several gates, bullets flying (you can still see the indents in the wooden gates and posts), until reinforcements called in by Saigo—his first time in action— take a few prisoners and force the Chōshū men back.[1] That solves Saigo's problem: Chōshū is irredeemably evil. Heaven's punishment is required. The shogunate demands a punitive attack. Saigo is passionately for it. Not quick enough. Four western powers get their punishment in first, sending ships to shell Shimonoseki and force Chōshū to sign a peace treaty. The shogunate, distracted by another insurrection, can't get troops together or find a commander for its own campaign.

We are now at the end of 1864, and the fast-forward slows briefly. On October 11, Saigo had a meeting that changed him, and thus had a profound effect on Japanese history. He was introduced to Katsu Kaishū, commander of the shogun's navy. Katsu is worth a brief diversion. His father was a lowly samurai, that charming drifter who once practiced swordplay

[1] This "incident" has several names: the Forbidden Gate, the Hamaguri Gate or the Kimmon.

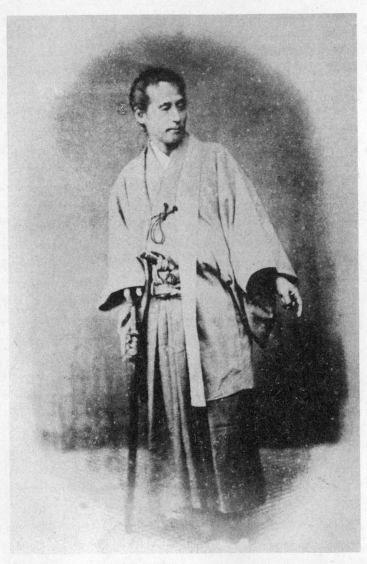

Katsu Kaishū, commander of the shogun's navy, in peacetime samurai dress, with his two swords. Katsu persuaded Saigo that the shogunate was finished and that the emperor's powers should be restored.

on dead criminals and in later life wrote the story of his adventures in *Musui's Story*. Katsu had all his father's intelligence, all the ambition his father lacked and a good deal of arrogance that was all his own. He studied Dutch and military history, and then captained the first Japanese steam-powered warship, which in 1860 carried the first Japanese delegation to America to ratify the Harris Treaty. Working his way up the naval hierarchy, he argued in favor of a unified naval command and became director of the leading naval college.

The two men were very impressed with each other. "Smarter than anyone I know," said Saigo of Katsu; "I am utterly enthralled by Katsu." Katsu was left wondering if Saigo was perhaps "the one to shoulder what people call the great burden of the realm." What really impressed Saigo was Katsu's forthright opinion that the shogunate was finished, that the entire system was incompetent, indecisive, rotten. What was needed was an alliance of daimyos rallying behind the emperor, an end to "expel the barbarian" and a government of national unity that could deal with the West.

Saigo had never considered a Japan without a shogun. It all made sudden sense. Chōshū would still have to be punished for its treachery, but then brought on board. With that little problem out of the way, and with the shogun gone, Japan's daimyos could cooperate, unite, renegotiate treaties with the foreigners, restore imperial honor, create proper armed forces and build a new Japan.

And the next month it all looked possible. Saigo, already responsible for Japan's largest army (Satsuma's), was appointed war secretary by the shogun and given command of the campaign against Chōshū. But Saigo now had a long-term agenda of his own: first to crush Chōshū, but then to win it over. Foreshadowing Theodore Roosevelt's aphorism, he would carry a

big stick, but speak softly. Using the stick alone would merely strengthen Chōshū's belligerence. So his demands would be moderate, targeting individuals rather than the whole domain.

At a meeting with an intermediary on Chōshū's borders, he put his rock-bottom demands: the severed heads of those behind the attack on the imperial palace; the execution of its leaders; and the return of five dissident nobles who had fled to Chōshū. To show his goodwill, he released the Chōshū prisoners taken in their attack on the palace.

It worked. He was thanked for his "great mercy." Heads were delivered, and checked. Executions followed. All seemed to be going smoothly . . .

. . . when Chōshū collapsed into civil war because radical loyalists objected to what they saw as weakness. In the chaos, the loyalists spirited the five nobles into hiding. That meant that Saigo's final condition could not be fulfilled. A lesser man might have despaired. But Saigo—committed to virtuous action, always willing to risk life itself for what he believed—contacted the loyalist rebels, set up a meeting deep in their territory, and went to see them. Once again, he entered "the field of death" to prove his sincerity. They listened, and—because both sides were at one in their adoration of the emperor, because of Saigo's bravery, because of his obvious sincerity—he won a concession. The five nobles would be transferred to neutral territory, under neutral guards. Face was saved, Saigo's mission was accomplished and his troops could go home. Civil war in Chōshū continued, but—as he said—there was nothing more to be done until violence ended.

By any standards, Saigo's achievement was a triumph. Back in Kagoshima in early 1865—he was traveling back and forth by steamer via Osaka these days—he was given an ecstatic reception: a letter of gratitude from Hisamitsu, a top-quality

sword, promotion to the fourth-highest position in Satsuma, a vastly increased stipend and (the following year) a place on the Council of Elders, making him one of the most eminent men in Japan.

He also got married, to Iwayama Ito, the daughter of a senior official in Kagoshima. There was no great romance. This was an alliance between the Establishment and Fame, a statement by Saigo of his arrival at the heart of power and influence. There would be a son and two daughters, but the basis of the marriage seems to have been that the two were useful to each other, in a perfectly friendly way. No letters between the pair of them survive. He once wrote a poem about her, describing her as a good wife who did not complain: hardly enough to guarantee her a place in history.

Besides, Saigo also had a mistress in Kyoto, where, as a well-respected official, he often went with friends to teahouses to be entertained by geishas. He struck up a friendship with a geisha about whom very little is known, perhaps not surprisingly given the traditional discretion of the geishas and the care with which their world was entered. There was another reason for secrecy: she was enormous, and therefore the cause of hushed comment and some inappropriate hilarity. According to the only source, Katsu Kaishū, the naval commander who had inspired Saigo with his ideas on the need to restore the emperor, she was known as "Princess Pig." The two apparently made a powerful impression on Saigo's colleagues, this robust woman a suitable match for his massive, 110-kilo frame, now restored to its full bulk after the rigors of exile. But discretion being the better part of rumor, nothing more is known about the depth of the relationship, which is precisely as Saigo would have wished.[2]

[2] This paragraph is based upon Ravina, *The Last Samurai*.

High office, wife, mistress. What an extraordinary turn-around in two years: from exiled and impoverished criminal to government minister, commander, man about town and national hero.

The shogunate continued to slide toward extinction. Having crushed an insurrection in Mito province, the government executed some 400 rebels—a disastrous act, guaranteeing widespread hostility—and exiled another 450, asking Satsuma to take 35 of them to Amami Ōshima. Saigo was outraged. Ordinary soldiers should be pardoned and released, as he had released the Chōshū captives. As for Chōshū itself, the anti-shogun radicals were back in charge, and the shogunate was again talking of reprisals—which it could not possibly undertake. If the shogunate ignored fundamental morality and continued to act so foolishly, in Saigo's view it did not deserve to survive.

It was becoming ever clearer that Chōshū and Satsuma, both opposed to the shogunate, should be partners, not enemies. What brought them a little closer together was a new and highly effective form of firearm, which demands a little background explanation.

Up until the mid-nineteenth century soldiers relied on smoothbore flintlock muskets. These were basically smooth tubes into which the user poured gunpowder, dropped a ball of lead and rammed down a plug of paper to stop the ball from falling out. He sprinkled a bit more gunpowder in a pan at the firing end of the barrel, which he lit by pulling the trigger, which released a lever that struck a spark with a flint. Misfires were common. They were really pretty ineffective weapons, serviceable at forty yards—javelin distance—but of little use at a greater range. "As for firing at a man at 200 yards," wrote

a British officer in 1814, "you might just as well fire at the moon." Such was the weapon that began to filter into Japan after Perry's arrival in 1854. But at the same time something rather more effective was emerging, using a rifled barrel to spin the bullet for accuracy and a percussion cap for reliability. The crucial development was in bullet design. The new bullet, named after its French inventor, Claude-Etienne Minié, was conical, with a hollow base that expanded on firing to fit the barrel exactly. The result was a terrific killing device, accurate over a quarter of a mile, which could inflict terrible injuries. It was adapted by the British to create their famous Enfield rifle in 1851, and adapted again as the Springfield rifle for use in the American Civil War, in which it brought battlefield injuries to a new level of awfulness: 200,000 killed, half a million wounded, 90 percent of them by Minié-type bullets. That war ended in April 1865, which was precisely when Saigo was receiving his hero's reception in Kagoshima and thinking about how to effect a reconciliation with Chōshū.

There was at this time a Scottish merchant, Thomas Glover, living in Nagasaki: a small, energetic character with a droopy mustache who had a talent for acting as middleman in deals between Japanese and foreigners, often working in secret to supply domains eager for arms, ambitious merchants and corrupt officials. Nagasaki, with its long landlocked harbor and protective mountains, had become a smuggler's paradise, Japan's window on the West, with its easy links to Shanghai and its freebooting buccaneer traders, Glover among them. In his fine house above the harbor, now a tourist attraction, he kept his Japanese common-law wife Tsuru. One of the three hundred or so foreigners in Nagasaki, he played a special role in preparing Japan for modernity by smuggling a few young and ambitious Japanese to England, where they became eager

students of military, industrial and scientific matters, several returning to help modernize their country.[3] Glover would soon be helping in the purchase of ships, a dry dock and Japan's first steam train. He also had contacts who could help Satsuma in the matter of weapons, specifically the new ones that fired Minié bullets. In 1864, ignoring the shogun's ban on importing such weapons, Satsuma bought 3,000 "Minié-ball" rifles (and also some fine Armstrong guns, which used the same principles as the Minié rifles). And now, at Saigo's suggestion, Glover would help Chōshū. In the summer of 1865 two Chōshū samurai stayed at the Satsuma residence in Nagasaki, where Glover agreed to supply 7,300 of the new rifles and a steamship.

The result, painstakingly achieved over many tense negotiations, was that in early 1866 Satsuma and Chōshū, now well armed, agreed to an alliance. The promises of mutual support were vague, but the alliance and the troops and the rifles would prove useful in less than three years.

The shogunate continued to self-destruct. It planned a second war against Chōshū, ordered domains to provide troops, was ignored, went ahead anyway with its own inadequate forces and suffered humiliating defeats.

Meanwhile, Saigo was in Kagoshima reorganizing and modernizing Satsuma's army into British-style infantry regiments armed not only with muzzle-loading "Minié-ball" Enfields, but also with the first breech-loading Sniders. He now received more support for his belief that the shogunate was doomed from the British, first in the form of the ambassador, Sir Harry

[3] Among them were Inoue Kaoru and Ito Hirobumi, two of the greatest statesmen of their age.

Parkes, who came to Kagoshima for five days in late July 1866 to test an idea that British national interests were best served by dealing with the domains individually, in particular Satsuma. Having had a formal meeting aboard his ship with the Shimazu leaders, Parkes met with Saigo. Since the shogun had forbidden foreign diplomats from developing relations with daimyos, Parkes's presence was both an insult to the shogun and encouragement to Satsuma. Saigo was happy to share his opinions on the hopelessness of the shogunate, and Parkes agreed, adding that Japan really needed a "single national sovereign" if it was to be taken seriously. True, in Saigo's view; not that he yet saw that this would involve violent revolution.

Six months later, while he was in the Satsuma residence in Hyōgō on one of his journeys back and forth to Kyoto, he had his second meeting with a British official, the diplomat Ernest Satow. Satow was a talented and committed Japanologist, Britain's first, indispensable to Parkes as an interpreter, and indispensable to modern historians as well because he kept a daily diary which eventually amounted to forty-seven volumes. He seems already to have known everyone of importance in Japan, despite being only twenty-one. He at once recognized Saigo, because he had come across him on a steamer off Hyōgō just over a year before—"a big burly man . . . who was lying down in one of the berths . . . I noticed that he had the scar of a sword cut on one of his arms." Saigo was wary of whom he met and what he said, so he used a pseudonym and said nothing; Satow, though well aware of who he was, didn't press him. Now Saigo could afford to be more relaxed, laughing heartily when reminded of the earlier meeting. Nevertheless, he was not inclined to small talk, and was smart enough to play up his hesitancy, "so as to sound Satow's true intentions," as he wrote

the next day. Once he was sure of his ground, he opened up. Satow's account of the meeting provides a good summary of the problems of the time:

"After exchanging the usual compliments, I began to feel rather at a loss, the man looked so solid, and would not make conversation. But he had an eye that sparkled like a big black diamond, and his smile when he spoke was so friendly" that gradually the two formed a bond. Talk turned to the weakness of the shogunate and the lack of consultation with the daimyos.

"The *bakufu* [the shogun's government] have got on so badly of late years," said Saigo, "that my prince is of the opinion that they should not be left to ruin the country as they please . . . They expected to have a share of the government. Now they perceive that such is not the intention of the *bakufu*, and they don't intend to be made fools of."

"What is the position with regard to Chōshū? We foreigners cannot comprehend it."

"It is indeed incomprehensible," Saigo replied. "The *bakufu* commenced the war without justification, and they have stopped it equally without reason."

"Is it peace, or what?"

"No. Simply that hostilities have ceased, and the troops have been withdrawn. There the matter rests."

"For us foreigners it is a great puzzle why the *bakufu* attacked Chōshū at all. It was certainly not because he [i.e. the daimyo] had fired on foreign ships. If he really had offended the [Tokugawa] Mikado, surely your prince, with his profound affection for the 'Son of Heaven,' could have lent assistance."

"I believe the *bakufu* hated Chōshū all along," replied Saigo.

At this point Satow summarized the attitude of the British government, and by implication others as well. It was high time that Hyōgō was opened to foreigners, as agreed in the

Sir Ernest Satow, linguist, traveler and diplomat, at age twenty-six. The diaries he kept during his time in Japan (1862–83 and again as minister in 1895–1900) are prime historical sources.

Harris Treaty almost ten years previously. But how could one complain if one did not know who to complain to? The treaty was with the country, not any particular person. There was no intention to interfere, it was a matter of indifference to the British who ruled—emperor, shogun or a confederation of states—but *somebody* or some *body* had to be in charge. "We have serious doubts," said Satow—the failure to open Hyōgō, the murder of Richardson, the impotence of the *bakufu* in punishing his murderers, its inability to extend its authority to Satsuma, warships of friendly nations fired on by Chōshū—and "we had to go and punish him because the *bakufu* could not."

In brief: What on earth was going on?

Saigo's feelings exactly. Something had to be done, and soon.

And then, to cap the chaos, both the shogun and the emperor died. The shogun—a mere twenty-year-old with no heirs—died with no successor chosen, which meant that the death had to be kept secret for weeks, until the emperor appointed the next shogun, the fifteenth—and, as it turned out, the last: Yoshinobu, also known as Keiki, whose earlier bid for the shogunate had failed with such dire consequences for Saigo. Three weeks later, Emperor Komei died. Only thirty-five, he had had smallpox, but seemed to have recovered, so wild rumors spread that he had been poisoned (in fact, he probably had beriberi, a disease caused by a deficiency of the vitamin thiamine). The nation had been unstable enough under his rule, and things were not likely to improve under his successor, Mutsuhito, his age just fifteen, who would rule through a regent.

Perhaps this was the chance to get the daimyos to work together, a first step in reducing the power of the shogun, restoring the power of the emperor and renegotiating treaties with

THE SAMURAI SPIRIT

For over 250 years the upper-class samurai cultivated a very deliberate image: ferocious, exotic and distinctive in battle. This was reflected in their elaborate helmets and armor, and also in the craftsmanship of their swords.

This helmet, with face mask with blackened teeth and bristling mustache, was brought to England by the British collector Charles Wade. The antlers recall the regalia of Honda Tadakatsu, a famous early seventeenth-century general, but its history is unknown.

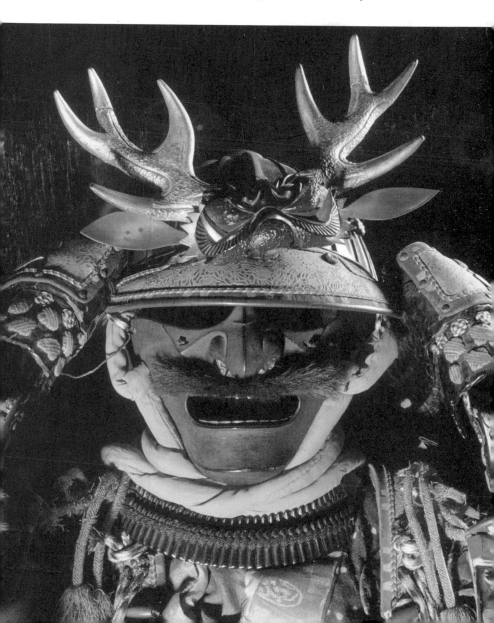

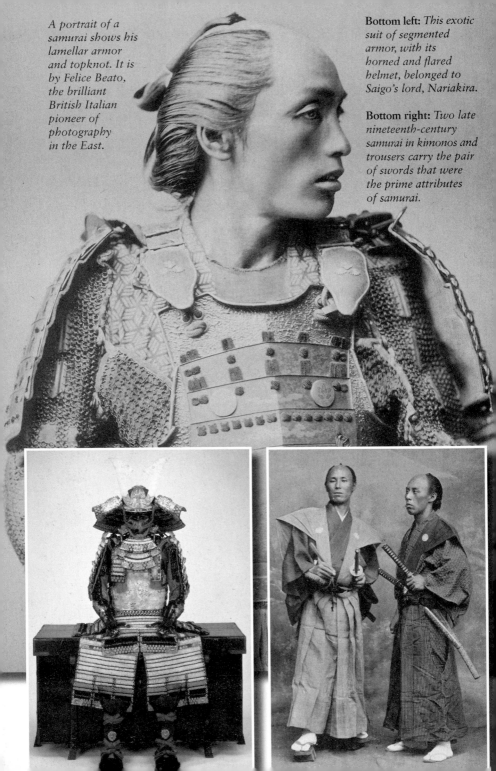

A portrait of a samurai shows his lamellar armor and topknot. It is by Felice Beato, the brilliant British Italian pioneer of photography in the East.

Bottom left: *This exotic suit of segmented armor, with its horned and flared helmet, belonged to Saigo's lord, Nariakira.*

Bottom right: *Two late nineteenth-century samurai in kimonos and trousers carry the pair of swords that were the prime attributes of samurai.*

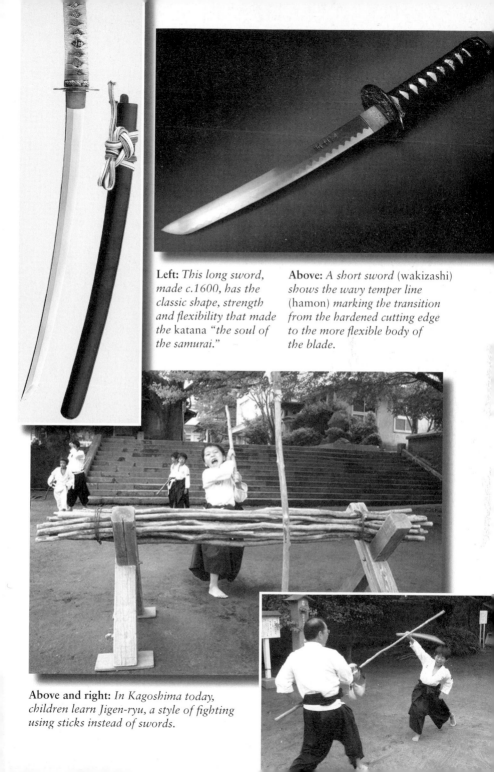

Left: *This long sword, made c.1600, has the classic shape, strength and flexibility that made the* katana *"the soul of the samurai."*

Above: *A short sword (wakizashi) shows the wavy temper line (hamon) marking the transition from the hardened cutting edge to the more flexible body of the blade.*

Above and right: *In Kagoshima today, children learn Jigen-ryu, a style of fighting using sticks instead of swords.*

SAIGO'S WORLD: SATSUMA, KYOTO AND EXILE

These images evoke some of the influences and experiences that marked Saigo's life before he achieved high office.

Left: *Kagoshima's restive volcano, Sakurajima, made the mountains that kept Satsuma isolated from the rest of Japan.*

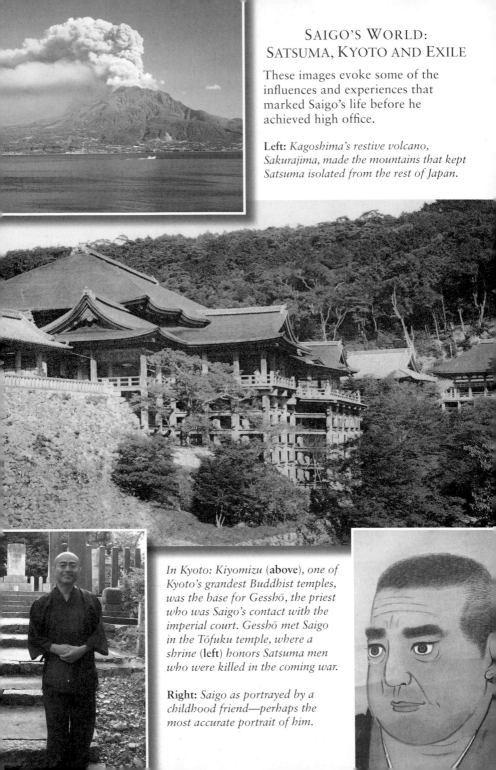

*In Kyoto: Kiyomizu (**above**), one of Kyoto's grandest Buddhist temples, was the base for Gesshō, the priest who was Saigo's contact with the imperial court. Gesshō met Saigo in the Tōfuku temple, where a shrine (**left**) honors Satsuma men who were killed in the coming war.*

Right: *Saigo as portrayed by a childhood friend—perhaps the most accurate portrait of him.*

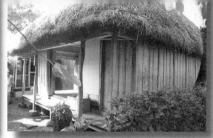

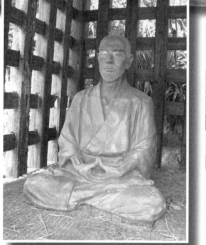

Above left and right: *Exiled in semitropical Amami Ōshima, Saigo made a new life, living in a simple house with his "island wife," Aikana.*

Left: *The island of Saigo's second exile, Okinoerabu, is a flat place of sugarcane fields surrounded by coral cliffs.*

Below: *Condemned to solitary confinement, Saigo spent several weeks in a specially constructed prison cell, recalled by this reconstruction (**right**). A statue of him in meditative pose suggests his stoic response, but looks nothing like him.*

Below left and right: *Sheltered by admiring locals, Saigo was drawn into the island's Ryukyu culture, which included rich costumes and traditional dances performed with astonishing zest today.*

REVOLUTION

During the tumultuous years leading to the restoration of the emperor in 1868, the nation seemed on the point of collapse. In 1862, a merchant, Charles Richardson, was cut down by Hisamitsu's samurai. His murder was seen as an outrage by other nations, especially Britain, and led to a punitive expedition against Satsuma.

Left: *The main Kyoto–Edo coast road, the Tōkaidō, was a succession of villages, inns and official way stations. It is now a highway.*

Below: *This is how the upper class traveled: in a palanquin carried by samurai eager to display their loyalty to their lord and their disdain of almost everyone else.*

Bottom left: *Hisamitsu, the father of Satsuma's daimyo. He was the real power in the province—and an extremely temperamental one. It was he who sent Saigo into exile—and brought him back.*

Bottom right: *Yoshinobu, the last Tokugawa shogun, at twenty-nine. A year later, in the face of pressure in part engineered by Saigo, he resigned. Despite a civil war fought for the shogunate, he had nothing to do with the action. He lived in retirement for another fifty years.*

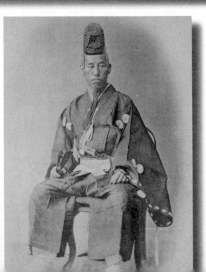

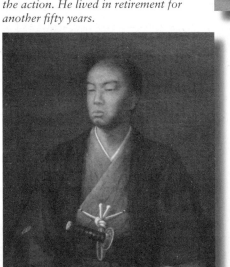

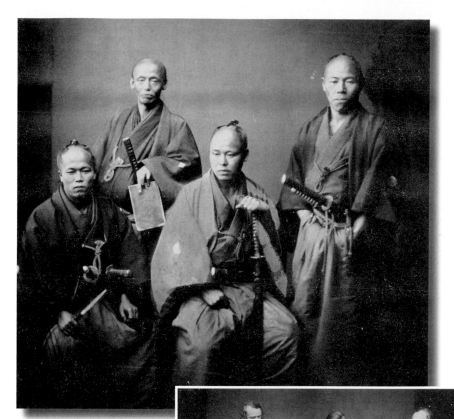

Above: *Envoys from Satsuma in Yokohama, where they arrived late in December 1863 for negotiations with representatives of the foreign powers (**right**), following the Richardson Affair and the bombardment of Kagoshima. Representing Britain were Vice Admiral Kuper (middle, upper row) and Colonel Neale (far right, lower row).*

Bottom: *Richardson's body, cleaned up.*

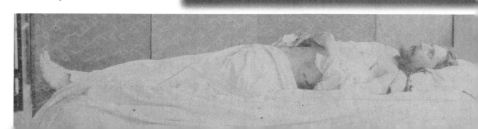

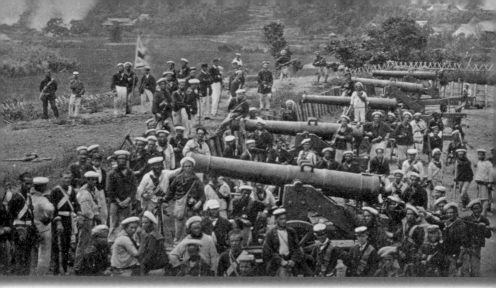

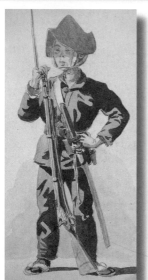

Above: *In another antiforeign incident in 1863, Chōshū fired on Dutch, French and American ships in the straits of Shimonoseki. In September 1864, a joint Western force destroyed some sixty guns. Beato was with the invaders, and took this picture of the British landing party.*

Above: *The Boshin War, 1868: a painting of a shogunate soldier and a photograph of a company show them to be armed with both firearms and swords.*

Right: *The emperor Mutsuhito, posthumously known as Meiji, came to the throne in 1867 at the age of fourteen. He was just fifteen when he proclaimed the end of the shogunate and his own return to full imperial power in 1868. Here he is in Western military dress.*

TO KUMAMOTO—AND DEFEAT

In mid-February 1877 Saigo and his army of keen young followers struggled through snow over these paving stones, slippery even in summer. Hauling a few old-fashioned cannons and poorly clad against the cold, they hoped to take the fortress town of Kumamoto. Their dream slowly turned to nightmare.

Bottom left: The half dozen cannons fired balls, not explosive shells.

Bottom right: The army consisted mainly of samurai armed with swords and dressed in cotton with rope sandals—hardly any protection against the rare snowfall that turned the road to ice and slush.

薩軍兵士
(着 物)

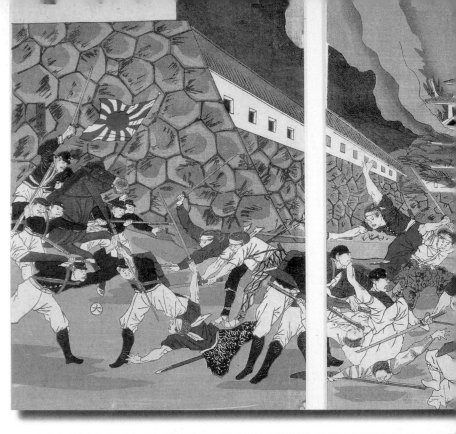

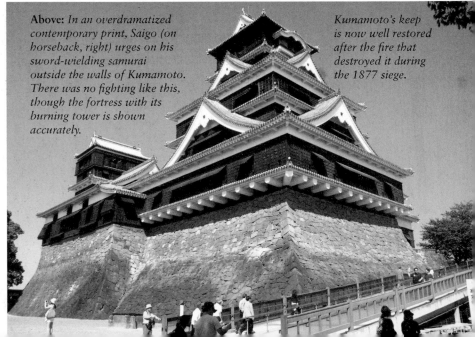

Above: *In an overdramatized contemporary print, Saigo (on horseback, right) urges on his sword-wielding samurai outside the walls of Kumamoto. There was no fighting like this, though the fortress with its burning tower is shown accurately.*

Kumamoto's keep is now well restored after the fire that destroyed it during the 1877 siege.

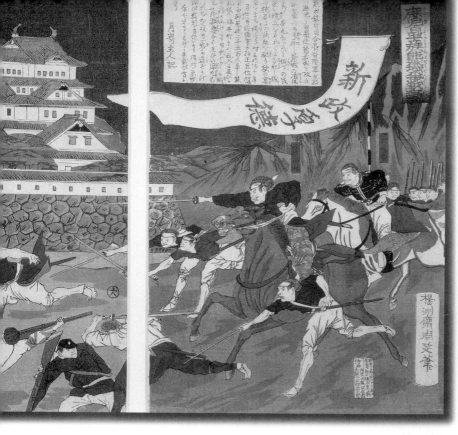

Eighteen kilometers to the north, in Tabaruzaka, the rebels failed to repel imperial forces advancing up the sunken approach road, where each stage of the advance has its marker (**below**). This one is marked "First Slope." Their losses are among the fourteen thousand commemorated on a war memorial (**right**).

ESCAPE, A LAST STAND AND DEATH

Having retreated up Kyushu's east coast, Saigo led a hard core of some six hundred followers in a dramatic escape over Mount Eno. Fighting their way southward, the rebels entered Kagoshima and seized its central hill, Shiroyama. From his HQ in a cave—in effect, a hiding place—Saigo and a small group fled downhill, until Saigo was struck in the leg by a bullet. Unable to go farther, he asked his aide to behead him.

Above left: *Mount Eno, looming over what is now a Saigo Takamori museum.*

Left: *In a museum tableau, Saigo presents options to his advisers.*

Below: *A diary left behind by a rebel soldier.*

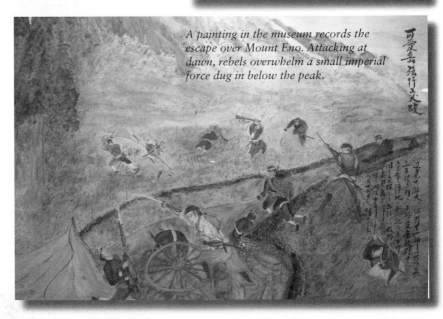

A painting in the museum records the escape over Mount Eno. Attacking at dawn, rebels overwhelm a small imperial force dug in below the peak.

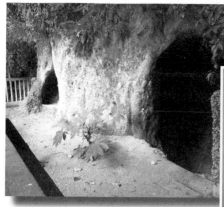

Left: *On Shiroyama, the caves in which Saigo sheltered are now on the tourist trail.*

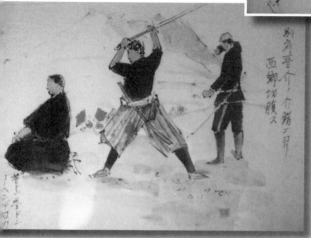

Above: *Sketches kept in another cave nearby show rebels as superfit samurai warriors stripped to their loincloths. In fact, they were soon beaten by overwhelming numbers of imperial troops.*

Left: *Beppu Shinsuke, acting as Saigo's aide* (kaishaku), *raises his sword to cut off his master's head with a single blow.*

Above: *A memorial marks the site of Saigo's death, which it describes as "suicide."*

Right: *Today, Saigo's statue stands in front of Shiroyama, the hill on which he died.*

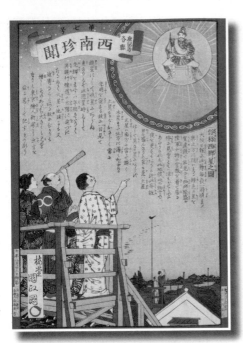

FROM REBEL TO NATIONAL HERO

Though his rebellion had accomplished nothing but death and destruction, Saigo quickly became one of Japan's most admired figures. Today his image is everywhere, on postcards, wall paintings, mugs, T-shirts and tourist trinkets.

Left: *Even before Saigo's death, people claimed he was already in heaven, as a comet, visible through a telescope in full dress uniform.*

*Kagoshima's Nanshu Cemetery (**below**), with its view of Sakurajima, commemorates 2,223 local soldiers who died during Saigo's rebellion, including, of course, Saigo himself. Fresh flowers mark his tomb (**right**).*

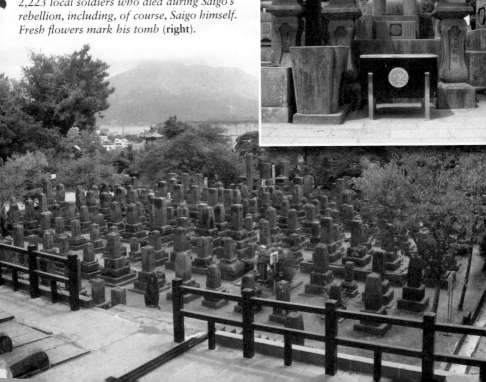

Above: *Saigo's statue in Kagoshima shows him in military uniform, but without medals to indicate his humility. The most famous one in Ueno Park, Tokyo (**above right**), portrays him as a samurai, with his two main attributes, sword and little dog.*

Bottom left: *A miniature statue for tourists.*

Bottom right: *"Saigo in the heavens:" a woodblock print gives him star billing, literally.*

の戦いの西郷死去の後、鹿児島上空に、光り輝く星が突如「西郷星」として世間を騒がせた。

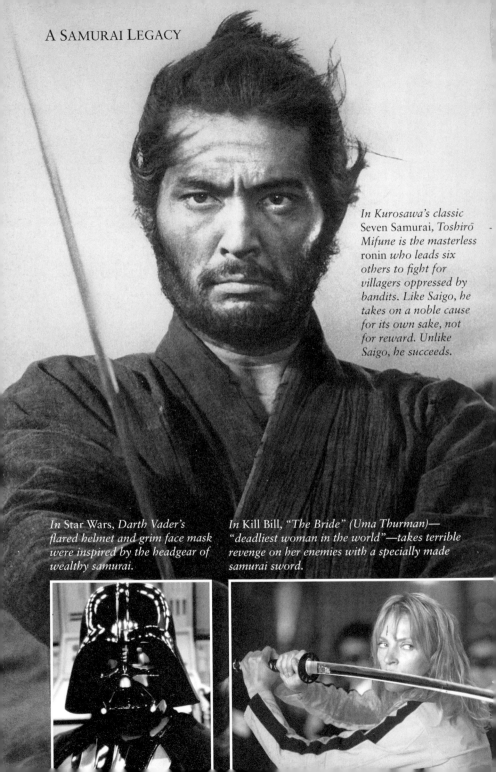

A Samurai Legacy

In Kurosawa's classic Seven Samurai, *Toshirō Mifune is the masterless* ronin *who leads six others to fight for villagers oppressed by bandits. Like Saigo, he takes on a noble cause for its own sake, not for reward. Unlike Saigo, he succeeds.*

In Star Wars, *Darth Vader's flared helmet and grim face mask were inspired by the headgear of wealthy samurai.*

In Kill Bill, *"The Bride" (Uma Thurman)— "deadliest woman in the world"—takes terrible revenge on her enemies with a specially made samurai sword.*

foreign powers. In Kagoshima, Saigo suggested a conference of domain leaders, and found a receptive audience. He gathered seven hundred troops to make an impression in Kyoto, and with his two lords—the daimyo Tadayoshi and his all-powerful father Hisamitsu—set sail for Kyoto, arriving two weeks later in mid-May 1867.

The two important matters to be decided were a pardon for Chōshū, which Saigo had promised, and the opening of Hyōgō to foreigners. But if Hyōgō were opened, it would be controlled by the shogun, which would strengthen his hand: so good-bye to the idea of reform. Somehow, in a long and tense session on June 26, the shogun, Yoshinobu, managed to strong-arm the imperial regent into approving the opening of Hyōgō, leaving open the question of how leniently to treat Chōshū. In effect, the daimyos had been slapped down, Saigo's promise to Chōshū was kicked into the long grass and the shogunate had survived.

Insulted beyond endurance, three leading daimyos—from Satsuma, Chōshū and Tosa—started talking to each other about forming alliances. Two pacts resulted, a new but still vague one between Satsuma and Chōshū and a specific one between Satsuma and Tosa. The draft agreement spoke of revolution: "We must, therefore, reform our political system, restore the reins of government to the Imperial Court, hold a conference of the daimyos, and in concert with one another work for the purpose of lifting the prestige of the nation among the powers of the world." Other domains hinted they would come aboard. Yet it all came to nothing, again. The pact needed approval back in Tosa—but two British sailors were murdered; samurai were accused; warships arrived; the samurai were exonerated. The crisis passed, but resistance had grown and Tosa's officials got cold feet.

Meanwhile, Saigo was plotting with Chōshū to seize power from the shogun, planning attacks with the one thousand Satsuma troops based in Kyoto and another three thousand in Osaka—plans that he was determined to pursue anyway, even without Tosa. Crucially, Saigo needed support from the court, and to this end made good use both of his reputation and of an important aspect of his personality: his lack of ego. He continued to dress in a simple cotton kimono and sandals, which allowed him to move about inconspicuously. Once, according to legend, he was arrested while leaving the palace, because a guard did not believe this shabby figure could be the Great Saigo until a senior court noble identified him.

Now, at last, the decisive blow could be struck. Saigo and Ōkubo drafted a letter to be signed by the imperial court. The minds of the people, it said, had been polluted by Tokugawa rule. The shogun was to blame for all the unrest at home and the threats from abroad. He had to be reduced to the rank of a daimyo. Peace in these circumstances was treason, for great principles could be asserted only by force.

Somehow, the shogun got wind of trouble and took preemptive action, rather brilliantly. In many other cultures, he would have fought back. Instead, he resigned, in a sort of political jujitsu, falling in with his opponents in order to disarm them. His statement is worth quoting as an example of how to minimize conflict by welcoming change:

> Now that foreign intercourse becomes daily more extensive, unless the government is directed from one central authority, the foundations of the state will fall to pieces. If, however, the old order of things be changed, and the administrative authority be restored to the Imperial Court, and if national deliberations be conducted on an extensive scale,

and the Imperial decision be secured, and if the empire be supported by the efforts of the whole people, then the empire will be able to maintain its rank and dignity among the nations of the earth—it is, I believe, my highest duty to realize this ideal by giving up entirely my rule over this land.[4]

At a stroke, the reason for a coup had vanished—except that the imperial court, having accepted the resignation, asked Yoshinobu to stay on as acting shogun until the court could get all the daimyos together to discuss the situation.

But Saigo and his colleagues, principally Ōkubo, were not to be deprived of their coup. On November 14, the ringleaders traveled to Chōshū, where they restated Satsuma's readiness to topple the shogunate by force, then went on to Kagoshima to brief Hisamitsu, whom they wanted to lead troops into Kyoto. This was agreed upon. On December 8, Saigo and the daimyo, Tadayoshi, left with three thousand troops and entered Kyoto ten days later, backed by two thousand more from Chōshū, all gathering ostensibly to "defend the Imperial Court" during the forthcoming conference of daimyos.

The imperial court met and pardoned several loyalist nobles, including the Chōshū daimyo, which is what Saigo had promised. As for dismantling the shogunate, talks continued through the night.

In the morning of January 3, 1868 a leading radical noble, Iwakura Tomomi, drafted a statement proclaiming an imperial restoration, which was agreed to by the top five daimyos. Satsuma troops were ordered to man the gates. This was the moment that came to be known as the Meiji Restoration, the

[4] McClaren, "Japanese Government Documents"; also quoted in Mason and Caiger, *A History of Japan*.

start of the Meiji Era, after the name granted to Mutsuhito after his death. Saigo and Ōkubo, who had helped to engineer all this, made themselves scarce, Saigo commanding the guards, Ōkubo sitting at the back. The young emperor, from behind a screen, read a short edict dissolving Japan's political structure—thus abolishing the shogunate. It is, like Yoshinobu's statement, worth quoting in full just to show how few words it takes to change history, if they are the right words at the right time:

> The Emperor of Japan announces to the sovereigns of all foreign countries and to their subjects that permission has been granted to the shogun Tokugawa Yoshinobu to return the governing power in accordance with his own request. We shall henceforward exercise supreme authority in all the internal and external affairs of the country. Consequently the title of Emperor must be substituted for that of Taikun [Great Lord; Tycoon, as the shogun was usually referred to in English], in which the treaties have been made. Officers are being appointed by us to the conduct of foreign affairs. It is desirable that the representatives of the treaty powers recognize this announcement.

He then declared a new structure, with a collateral prince as president, major daimyos as senators, and samurai and lower courtiers as councilors.

This was a moment that changed history, not just for Japan but for the world: a simple statement drafted in haste by a few dozen people and read out in a few minutes. This time, things really would be different, though how they would play out no one had any idea.

Yoshinobu left for Osaka, where he agreed to surrender

some of his lands, if other daimyos would also surrender some of theirs to help out with imperial expenses.

The daimyos hesitated.

Deadlock. The future of Japan was in the balance. Change was certain, but how exactly was it to come about?

The deadlock was broken by riots in Edo, when some wild Satsuma *ronin* went on the rampage, burning part of Edo Castle, sparking retaliation from anti-Satsuma samurai. Yoshinobu was prepared to lead an army to seize the miscreants and condemn them to death. Battle lines were drawn, the shogun and his allies with roughly 5,500 troops versus Satsuma and its allies with 2,300. Saigo, the senior commander in the latter camp, didn't like the odds. The emperor—the symbol of regeneration, "the jewel" as Saigo called him—was evacuated to Hiroshima, in case of defeat.

As things turned out, the shogunal troops lacked both leadership and morale, and Saigo's had both. They also had their Minié rifles, while many of the opposition still relied on swords. Over three days (January 27 to 30, 1868), the Satsuma gunners, with their Armstrong cannons, pounded the shogunal lines just outside Kyoto. A turning point came when a force of shogunal allies switched sides, giving the Satsuma alliance a victory, and the advantage of what military theory calls "momentum": high spirits, cohesion, focus. That was the beginning of the so-called Boshin War (the Earth-Dragon War, from the Chinese zodiac signs for 1868).

Saigo, as commander, should not have been in the action, but with his usual recklessness insisted on going anyway. He wrote elated letters claiming victory over forces not twice, but five times, even ten times his own. People grasped his hands in the street to thank him, fêting his troops with food and drink, revealing to him for the first time the depth of feeling against

the shogunate. His younger brother Tsugumichi, he said with pride, had a wound on his neck, but would be okay. It was exhilarating to experience action, but at his age (he was just forty), he had had bouts of sickness and thought he was getting too old to fight. "To tell the truth," he wrote in a letter to the man in charge of his family back in Kagoshima, "I can no longer serve like a man, and I am so timid and self-conscious that it's unbearable."

Victory threw up other problems. His agenda—the agenda he had inherited from his former lord Nariakira—had been to work for a council of all the daimyos. But the shogunate had been defeated by only a few of them. And the army: was it to be a mix of domain divisions, or a proper unified imperial army? In early 1868 both existed. And what was his role? He was the highest-ranking samurai in the army, but still a staff officer, lumbered with boring desk work and (in theory) detached from the action. What did all this mean for his future, and the nation's? As Mark Ravina puts it, "one of the founders of the modern Japanese state was deeply ambivalent about his own creation."

The troops of the Satsuma alliance closed in on Edo, meeting little opposition. By early April they were ready to move in for the kill, demanding the surrender of castles, warships and weapons; the execution of officials and the ritual suicide of the ex-shogun Yoshinobu. But Yoshinobu was no longer in command; that position had been taken, strangely, by Saigo's old friend Katsu, for reasons that underlined the conflicting principles being played out. He had opposed the shogunate when it wanted to attack Chōshū, but then fought for it to stop a war he thought was totally unnecessary. Now he contacted Saigo to negotiate peace. He argued that there was neither sense nor morality in a harsh settlement. Yoshinobu was honorable, had

resigned and was prepared to surrender property. To be magnanimous would spread justice throughout the land. Saigo was swayed, and put the case to his superiors.

It worked, briefly. Edo Castle gave up three weeks later, on April 27. Yoshinobu withdrew to a hilltop temple, Kan'ei-ji, in what is now Tokyo's Ueno Park; his officials proved amenable; and weapons were surrendered. There remained only some two thousand obdurate members of a brigade known as the Shōgitai, the League to Demonstrate Righteousness, who had set themselves up as guardians of the Ueno temple, where Yoshinobu was in his self-imposed retirement. Then the peace process stalled. With several guerrilla bands mounting small-scale attacks in the city and the police impotent, anarchy threatened as the league's resistance blocked a definitive settlement. Imperial forces were running short of money, and Edo's merchants made excuses when asked to contribute. Saigo delayed an assault because, with imperial troops deployed in mopping-up operations elsewhere, his forces were outnumbered. Days passed, chaos loomed. "The people are seized with apprehension," Katsu confided to his diary. "Noisy ruffians loot and commit murders—they are unable to wait calmly for the imperial terms of settlement as true *bushi* should. Merchants have closed their doors and impoverished people have lost their means of livelihood. The streets at night are deserted. Is this the sign of the degenerate world?" So it seemed. In a memo to the police chief, he lamented that the castle was overgrown, its towers crumbling, its enclosures dens for beggars. At night, he said, thieves cut down the unfortunate, the aged are left to die in the streets, bands of young men pillage and plunder. The Shōgitai grew in strength daily. The Shōgitai had to be crushed and Edo pacified, or the new government would fall.

When the attack came, in the rainy dawn of July 4,[5] it was almost a disaster. Saigo himself led the assault on the temple's Black Gate, and suffered heavy casualties when troops from Chōshū failed to back him up. Saigo, still a samurai at heart, did not complain: it gave him a chance to glory in the risk. But at some cost. The tide turned only when the Chōshū men attacked the rear of the temple. At the end of the day, Armstrong cannons had reduced the temple to flaming ruins, littered with dead bodies and abandoned by the survivors.

The new regime ordered the Tokugawa family and its retainers—twelve thousand families, one hundred thousand people—out of the city. In midsummer 1868 Edo became the eastern capital—Tokyo—and the era name was officially changed from Keio to Meiji ("Bright Rule"). In October, to mark the new age, the emperor—"the mysterious Presence on whom few are privileged to look and live," as the *Japan Times* put it—was carried past awestruck crowds to the shogun's castle.[6] To ease his passage, the emperor ordained a two-day holiday and the distribution of 2,563 barrels of sake. That raised the city's mood. Locals called it "the wine of renovation." But there was no renaissance yet. By the end of the year another two hundred thousand had fled, and the place "assumed the appearance of a deserted city." A local newspaper, the *Hiogo and Osaka Herald*, commented in labored English that "ravenous, sluggish and dronish usurpers have appropriated to them-

[5] By the Gregorian calendar, as are all dates given here. By the lunar calendar it was Meiji 1, the 15th day of the 5th month, which is sometimes mistakenly given as May 15.

[6] Yoshinobu retired to a quiet life, indulging many hobbies—oil painting, archery, hunting, photography and cycling—and being granted a peerage, dying in 1913 at the age of seventy-six.

selves with grudge the once flourishing Paris of their country, now converted into a den of depredators."

In other parts of the country there were pockets of dissent—firearms going missing, guerrilla bands attacking imperial troops—and in the northeast of Honshu, large-scale resistance. It took until the year's end to achieve complete victory. Saigo himself took three platoons north from Kagoshima in September, arriving in time to find his brother Kichijiro wounded. Four days later, he died of his injuries: a terrible loss, because Kichijiro had been left at home with the day-to-day responsibility for the family. "Just when it was I who should have been the first to die," Saigo wrote, "I let my younger brother go ahead of me" to the front. In victory Saigo showed such restraint that he became something of a hero, even in this recalcitrant region. Indeed, as Ivan Morris puts it, "there can be few violent transformations in history that were accomplished with so little actual bloodshed," an outcome for which Saigo bore much responsibility.

This was the end of the war for Saigo, though in fact it continued for another six months. The ten remaining ships of the Northern Alliance, with three thousand troops and some French advisers, fled farther north, to Hokkaido, intending to create a new, independent state. The Republic of Ezo never received recognition, and surrendered to an overwhelming imperial force at the end of June 1869.

There is a place that commemorates those from Satsuma who fell in the Boshin War. Very suitably, it is in the grounds of the Hokoshui sub-temple where Saigo used to meet Gesshō for their secret talks in Kyoto. You go along a paved path between well-trimmed hedges, climb steps through gently sloping woodland, pass beneath a Shinto-style stone gateway and arrive at a hilltop shrine. A courtyard of flagstones surrounds

six pillars engraved with the 524 names of the fallen. One of the pillars displays a poem with the signature line "Saigo Takamori wrote it," as if the delicate incisions were spray-canned graffiti.

It is a haven of peace, in a nest of maple trees. The shaven-headed monk who told me about Saigo and Gesshō and the teahouse explained that it was peaceful because it was not open to the public, except in November, when people were allowed in to see the maples arrayed in their autumn colors. "This is a famous place, but they don't know much about the monuments. They come for the maples." I wondered how the place survived, without much public access. It was hard, he admitted. "We have fifteen families sponsoring us, but we really need a hundred." He lectured on philosophical subjects, there was the occasional funeral, the temple held tea ceremonies, and so he made enough to keep the temple going. It was his life, a commitment inherited from his father, which he would pass on to his son. And so the shrine would remain, in remembrance of those who fell in the war of the Meiji Restoration, almost forgotten except for those who come to admire the autumnal maples.

It was in the end a very strange sort of revolution, full of paradoxes, as the next few years would show. It had been led by samurai to restore an ancient tradition of imperial rule, yet they sidelined the emperor and legislated themselves out of existence in a sort of collective seppuku. They spoke for their domains, yet centralized the administration. They said they despised foreigners and the outside world, yet embraced the one and could hardly wait to experience the other. Ancient hierarchies would vanish, to be replaced by advancement according to merit. Men who had once proclaimed the virtues of ancient styles of dress soon wore unknotted hair and dress coats, rode

in carriages and flourished umbrellas. That's what it took to put into effect their slogan: "Enrich the country, strengthen the army." Not surprisingly, as time would tell, some would not be able to stand it.

Saigo, it seemed, was not one of those. His task done, he had returned to Kagoshima, to a well-earned rest, recovery from debilitating illness and (so he dreamed) permanent retirement.

13

THE UNHAPPY
REVOLUTIONARY

IN ONE SENSE, THE RESTORATION FULFILLED THE MISSION Saigo had set himself: the emperor back in power, Satsuma developing nicely. But it had taken a toll on him. He felt his age. His joints ached. He had a fever, stomach pains and diarrhea. With no other task before him, and an adequate income for a man of his simple tastes, he retired to recuperate at a hot springs a couple of hours' ride from Kagoshima. There was a river to fish in, a forest to hunt in, several dogs to keep him company—and that would be enough, until, as he wrote, he had a chance to return to his family on Amami Ōshima. So set on retirement was he that he turned down a generous cash bonus and the equivalent of a peerage offered by the imperial court.

It took a visit from Tadayoshi himself to break his resolve. The ex-daimyo, now governor, came in person to ask for his

help in dealing with the local low-ranking samurai. They had had their expectations raised by promises of reform, and then by what looked like some real change: the four leading daimyos had handed over their lands and subjects to the imperial government—which had promptly made them governors of their old domains. The only thing that had changed, apparently, was the title. This was not good enough, and Tadayoshi (though still under his father's thumb) recognized it. "It is obvious," he wrote to Saigo, "that government appointments should be made irrespective of rank."

Saigo didn't actually have to *do* anything, said Tadayoshi, just show his support for reform. Given his reputation—low-born high achiever, ex-minister, commander, wrongfully convicted exile, a virtual saint—that would be enough to calm things. He agreed, and became in effect a nonexecutive director of Satsuma, a presence assuring men of similar lowly origins that there was someone to speak for them in the ranks of the province's government. With hindsight, it is clear that this was where the real trouble began. From this point on, he would find himself ever more deeply mired in conflicting loyalties, to his province and the nation, his lord and the emperor, the samurai as an independent group and the need for national unity, his own inner need for rigidity and a politician's need to compromise. These forces would, in the end, tear him apart, and they were already at work.

Change did follow, mainly initiated by Tadayoshi and his top vassals. Rich samurai had their incomes slashed by over 80 percent, while the stipends of poor samurai increased by over 20 percent—a dramatic change in a province where a few rich families (actually one in five hundred) had previously controlled almost half the income of all samurai. Satsuma ac-

quired a cabinet system, relative equality of class and opportunity, fairer taxes, a modern army. All samurai between eighteen and thirty-five were organized into new military formations, giving Kagoshima some fifteen thousand men under arms, with officers of middle and lower rank being elected by their troops, and most of them retaining their jobs. In other words, as Charles Yates says, Kagoshima had become a military state in a condition of permanent mobilization. It thrived astonishingly well, switching from feudalism to modern capitalism in a few years. This is not to say that all was peace and harmony: the middle-ranking samurai remained resentful at their loss of privileges, a feeling that would burst out in a few years' time and carry Saigo along with it.

Saigo was not happy as a local politician. He was bored by administration, he longed for action, and he mourned the loss of the old days when loyalty to a daimyo gave meaning to life.

Meanwhile, Satsuma's success had raised fears in Tokyo. If Satsuma could succeed on its own, what was the point of the new centralized government? Was Satsuma perhaps planning to break away? Some observers foresaw civil war. Among those in Tokyo's new imperial government who worried about this was Saigo's childhood friend Ōkubo. Having identified the problem, he saw a solution. In February 1871, he and several others came from Tokyo to ask Saigo and Hisamitsu, on behalf of the emperor, to join the central government. One of the delegation was Saigo's younger brother, Tsugumichi, who had been to Europe and was now a lieutenant general in the new imperial army. Another was a senior general, Yamagata Aritomo, Saigo's friend and future nemesis, of whom more shortly. It took three days of tearful pleading to persuade Saigo to come on board, and even then he and Ōkubo could

not agree on the nature of government (a difference that did not bode well for the future of their relationship). Ōkubo wanted a strong, centralized bureaucracy; Saigo a much lighter hand, based on the Confucian ideal of ruling by general principles. Where they were at one was on the need for a national army, and this was the task Saigo agreed to take on, as general, commander of the imperial guard and state councilor, eventually with the unique rank of field marshal.

No one else in the entire country had this degree of moral authority. Imagine Nelson Mandela crossed with the duke of Wellington. He had served time in prison, having been wrongly accused, had reintegrated himself without rancor, and had then become a victorious general and government minister. His presence as a member of the governmental team again had the desired effect. People stopped talking of a possible civil war.

For Ōkubo that was just a start. What was really needed, if the government was serious about becoming militarily independent and powerful, was to get rid of all the old domains and replace them with centrally administered prefectures. There would of course be resistance, not only from the daimyos but also from their samurai retainers. To have backing from Saigo—once a low-ranking samurai of impeccable loyalty, now commander of the imperial guard—would be vital. It took a while, six months, to get Saigo's agreement. Change soon followed. Ōkubo became minister of finance, and Saigo joined a council of four low-born samurai who would oversee the reforms. For Saigo, it was a painful process. On the one hand, it was clear that to create a working central government, to preserve national security and to work with foreign powers, the domains had to go. On the other, he had a personal com-

mitment to Satsuma and its lord. But he had no real option. He chose the lesser of two evils. For the time being, national interests trumped Satsuma's.

On August 29, came a second revolution. The emperor told the ex-daimyos, now governors of their old domains, that all domains were history. Over the next few months boundaries were redrawn, today's prefectures established and new governors put in place, responsible to the imperial government for administering national taxes, laws and education. Almost all of them accepted these stunning changes, with more or less good grace, partly because they were in the midst of a revolution anyway, and partly because they received generous settlements and élite status—each governor was to receive 10 percent of his prefecture's tax incomes for life plus the equivalent of a peerage.

Only one objected: Satsuma's ruler Hisamitsu, still regent for his son, though now as governor rather than daimyo. Hisamitsu was a problem for Saigo. It was he, the regent, who had exiled Saigo, had indeed issued those stern instructions that looked as if they were intended to be fatal; he to whom Saigo was so determinedly loyal. As regent, he had often acted in the place of the real daimyo, his son Tadayoshi. Now it was the son, by this point in his late twenties, who supervised the changes, Hisamitsu, fiftyish, who railed against them, ever more foul-tempered with each passing year. It was certainly hard on him: he was the proud heir to seven hundred years of family rule over Japan's most independent domain, and he ranted about treachery—Saigo's treachery in particular; but there was nothing he could do except fume at Saigo, and nothing that Saigo could do except suffer.

It was time to turn to foreign affairs, to negotiate the revision of the so-called Unequal Treaties with the U.S. and

other Western powers—unequal because they earned almost nothing in customs duties and put foreigners outside Japanese law—and avoid the fate suffered by China at the hands of colonial powers. As a first step there would be a high-level diplomatic mission to America and Europe, led by Iwakura, with Ōkubo as one of the four vice-ambassadors and a huge staff of forty-eight, plus sixty students. The mission's brief was to talk, observe, learn, and gain ideas about how to renegotiate the Unequal Treaties. On no account, though, could its members actually sign new ones. They would be away for a year, during which time the country would be run by a caretaker government, under Sanjo Sanetomi as acting head of state and Saigo as his deputy, which was supposed to do nothing much until the mission returned.

Saigo was not happy doing nothing, and neither were his colleagues. Two areas that needed reform were education and the law. One minister wanted free elementary education, with the building of fifty thousand schools; another a national legal system. But without a modern tax structure the costs of either would be prohibitive. In addition, the new army needed conscripts and modern weapons. And the samurai stipends took up half the government budget. The vice-minister of finance, Inoue Kaoru, proposed replacing the stipends with government bonds, to the fury of the officials on the Iwakura mission. There were arguments, corruption scandals, threats to resign.

One matter Saigo had to sort out was trouble in the imperial guard. Half the guard were from Satsuma, while the commander was from Chōshū; he had a business colleague who provided the supplies and was believed to have squirreled away large sums of cash. The Satsuma men were complaining that all Chōshū men were corrupt. But there was also rivalry in

the Satsuma ranks between town and country samurai. Saigo managed to soothe tempers, but it made him feel, he wrote, as if he were "napping on a powder keg"—a graphic way of describing the pent-up emotions that would erupt five years later.

Saigo, who hated administration anyway, threw up his hands at all this quibbling and bad temper. What he wanted was to live out an exemplary life of virtue, guided by loyalty, piety, humanity and love. If only the leaders would avoid luxury and live simply, ordinary people would do the same, and all would prosper, in every sense. Revere heaven, love mankind—why wasn't that enough? First that, then everything else could follow.

> As to adopting the system of every other country to improve our own way of life, it is necessary first to base our country on a firm foundation, develop public morals and after that consider the merits of foreign countries. If, on the other hand, we blindly follow the foreign, our national policy will decline and our public morals decay beyond rescue.[1]

And then, of course, Saigo had to bear Hisamitsu's bitter tirades. The former daimyo refused a position in Tokyo. He wanted to be made governor of the new Kagoshima prefecture. He railed like an old-fashioned conservative—he was now in his midfifties—against the growing fashion for western dress, against the breakdown of the distinction between samurai and "commoners," against the education of women. No one could understand why he was so cross. Perhaps it was to do with a feeling of impotence at being "merely" the father and re-

[1] Morris, *The Nobility of Failure*, quoting Moriaki Sakamoto's translation of Mushakoji Saneatsu, *Great Saigō*.

gent of the governor; perhaps it was the feeling that Satsuma, once virtually an independent country, was now less than a province. Whatever the reasons for his discontent, it stoked resentment among local samurai, who were increasingly pro-Kagoshima and anti-Tokyo.

Saigo found Hisamitsu's behavior intolerable. He said it felt as though someone were shooting at him with a cannon. Saigo was the emperor's man now, dining with him every couple of weeks, chatting about the issues of the day. The problem called him back to Kagoshima, for six stressful months, but it made no difference. Hisamitsu, his own former lord, continued to undermine him, and in the most underhanded way. When the emperor arrived for a state visit to Kagoshima in July 1872, Hisamitsu slipped a courtier a memo accusing the government of arrogance, yearning for a return to the old days, demanding the resignation of Saigo (and Ōkubo, though he was far away with the Iwakura mission). "The country grows weaker every day," Hisamitsu moaned, because of the evil abuses of the government and the nation's subjection to the western barbarians.

In early 1873, gifts and entreaties from Tokyo won Hisamitsu's grudging agreement to take a position in the capital.

Saigo returned to the capital to resume his three posts: member of the Council of State, commander of the imperial guard and army general.

At this point Japan was in the midst of yet another shattering change. A law had been passed in late 1872 to establish, organize and train a modern, national army. The idea, which had emerged soon after the restoration, was obvious: Japan had vast numbers of peasants who had been deprived of their arms by the Great Sword Hunt of 1587, mainly because they had proved a danger to their rulers when oppressed. For

nearly three hundred years since then they had been kept in their place by their feudal lords and the sword-bearing samurai. But in military terms they were a huge potential resource, as those who had been to Europe or studied European sources knew. The Prussians had just proved how effective a well-trained peasant army could be by winning a stunning victory over France in 1870–1. So now the peasants were to be used, by introducing universal military service. Every man became eligible for three years of service at twenty, creating an army of thirty-one thousand in peacetime, rising to forty-six thousand in war. In addition, peasants would also be in the ranks of the four-thousand-strong imperial guard. The samurai, of course, objected bitterly, because the project threatened their whole ethos, their belief that only they should bear arms. Many of the peasants objected as well, because it deprived families of their most fit young workers and because they feared it would lead to tax increases. But on the other hand a vast number of both peasants and poor samurai hated the old regime, and thousands had happily joined the ranks of Saigo's new imperial army in the 1867–8 war. So from 1873 training went ahead, under French auspices (which accounts for the French look to Japanese uniforms).

The new army was loathed and needed in equal measure, and its central figure was Saigo. Samurai looked to him to focus their distress. On the other hand, Saigo himself saw that a national force was necessary to deal with two crises, both of which foreshadowed war.

The first involved Taiwan. Fifty-four sailors from the Ryukyu Islands—the chain from Okinawa to Amami Ōshima—had been wrecked there when their ship went adrift, and had been murdered by locals. Taiwan, like the Ryukyu Islands, was claimed by China, though it never bothered to do

much about either. Satsuma had been de facto sovereign of the Ryukyus for 250 years, without too much trouble, but now, of course, ultimate ownership was claimed by Japan's new imperial government—a claim that China refused to recognize. So Japanese officials enlarged their claim: if China could not control the Taiwanese, Japan would. In short, both sides were up in arms, literally. A clash seemed inevitable.

The second flash point was Korea. Traditionally owing allegiance to the Chinese emperor, Korea would not recognize another one. Anyway, for Koreans, Japan was farther removed than themselves from China, the true center of the universe, and therefore its people were mere barbarians: the mirror image of the way Japanese thought about Koreans. Traditionally, these radically incompatible views had been kept below the surface, because Korea did not have to deal with an emperor but with the shogun. This distinction provided a sort of diplomatic fig leaf, enabling the relationship to be managed through a local office in Korea run by Japanese from the island of Tsushima. When the shogun went, so did the fig leaf, revealing the new imperial reality. Japan sent three missions to Korea to try to open negotiations, but all were rebuffed. Korea, like China, refused to recognize the new regime in Tokyo—because it was headed by, as it were, a "false" emperor, the only real one being in Beijing. In Tokyo, this was seen as an appalling insult, to which the only proper response was a declaration of war.

Japan desperately needed some steady hands, but there were none to be had, not even among those in America with the Iwakura mission. The mission was itself in confusion, because some of its members wanted to revise the Unequal Treaties, despite having agreed before their departure not to do so. Ōkubo made the journey home from Washington to ask

if the caretakers in Tokyo would say "yes." The answer, to the huge embarrassment of all, was "no." The loss of face blew the delegation apart: several members went off on tours of their own and the last to return home arrived almost two years after they had left.

Saigo's main burden was still Hisamitsu, who turned up in Tokyo on April 23, 1873, accompanied by an entourage of 250 with shaved foreheads and wearing swords. Despite their fearsome looks, the only unpleasantness was Hisamitsu's constant abuse, what Saigo called his "infantile whims." How very different from the good cheer and politeness of the emperor! Saigo admired him more and more—yet another cause of stress, with his loyalties divided between an emperor he loved and a lord he despised. (Actually, this conflict at least would not last long. Hisamitsu would be in office only two years, until 1875, when he was fired and returned to Kagoshima, where he spent another twelve bad-tempered years until his death.)

Another conflict of loyalties arose over Amami Ōshima. In Kagoshima, the samurai, casting around for new sources of income—since most despised trade, business and farming—had homed in on the idea of tapping into the island's sugarcane industry. The old domain monopoly was privatized, allowing company profits to be paid to the samurai shareholders. Saigo approved, because it helped the samurai—but wanted the deal kept quiet, in case the ministry of finance became interested in the possibility of taxing the company. But the company made life even harder for the islanders by paying them less rice. They asked Saigo's former guard on Okinoerabu to intercede for them, which he did, by getting the cane-rice exchange rate improved—thus revealing precisely what Saigo had wanted

hushed up. Exploitation of peasants, followed by lack of transparency, followed by revelation of commercial activity: there was no way, it seemed, to avoid betraying someone if you were a politician.

It was all too much for Saigo's health. He had heart pains caused by arteriosclerosis. What he needed, said the emperor's personal doctor, a German army surgeon named Theodor Hoffmann, was exercise and a low-fat diet. He moved in with his brother in a leafy suburb, where he could walk, hunt rabbits with his dogs and recover. He loved it. He wrote of wishing to leave the "muddy waters" of the city and government and find peace in the "pure waters" of retirement.

Meanwhile, the Korea crisis was blowing up into a storm. The local Korean prefect in Pusan was incensed to discover Japanese businessmen posing as officials from Tsushima, and moreover doing so in western dress. He broke off relations, accusing the Japanese of being lawless. Several members of Japan's imperial council were appalled at this insult, and some were for sending ships and troops instantly, a move that might just have the added benefit of intimidating Russia, which had imperial ambitions in the Far East.

Saigo, though, proposed a diplomatic response, if one can call such a provocative suggestion diplomatic. He said he wanted to undertake a mission to Korea personally. To the cabinet he claimed his intentions were peaceful. "It would not be good at all to send in troops. If doing so should lead to war, it would be contrary to our true intentions, and so the proper thing to do at this point is to send in an emissary . . . We must try to realize our original aim, to establish a firm friendship with Korea."

But privately his aim was rather different. He wanted to bring out the truth about Korea, even if that meant war. To that end he would risk his life, for quite possibly the Koreans would kill him. He did not know their intentions; was not certain that Korea really wished to be insulting; had no gut feeling that either war or peace was more likely—but was prepared to use himself as the catalyst. He adapted the argument he had used when confronting Chōshū: the case was just, it was worth dying for, and if the Koreans killed him this would be the casus belli; the samurai would be angered and forget their grievances, Japan would go to war and win a glorious victory, and he, Saigo, would have made amends as only a samurai could for his many sins—for the death of Gesshō, for his own failure to die, for allowing the abolition of samurai privileges. In brief, he was ready for martyrdom. He wrote to the most outspoken advocate of military action, Itagake Taisuke: "If we send an official emissary over there, I imagine the Koreans still would kill him, and I beg you to send me. I cannot be a fine diplomat like Soejima [Taneomi, the foreign minister], but if it is only a matter of dying, that much I think I can manage. Therefore I hope you will send me."

Was he seeking war or peace? He was prepared for both. What he wanted was to stage a drama to reveal what the Koreans really intended, and the truth would decide policy. If they talked, it was peace; if they assassinated him, war. At a stroke, literally—or not—the matter would be solved. Enough talk! Action was all, if done with integrity. As for himself, he really didn't care if he lived or died—"*only a matter of dying*!" Either way, he would have peace of mind and, as he wrote, "be completely untroubled."

It is still hard to know what to make of all this, for national interest—ill-defined at this point—was mixed up with

personal agendas and power politics. Saigo seemed willing to say different things to different people, depending on what he thought would sway them. But what comes through powerfully is a trait of many leaders: the identification of the national interest with his own ego. He wanted to establish the state's integrity by establishing his own. This was his fixed idea. If it led to peace, fine; if not—well, also fine. It mattered not to him what the long-term consequences might be: his own death; internal and international crisis; war, with perhaps the death of thousands of innocent Japanese and Koreans; perhaps the destabilization of the whole region, with Russia and China being drawn in. What price then his integrity? He was bound upon a wheel of fire, acting for the good (as he saw it) and yet willing, without much reflection, to release a great deal of evil, all because he was determined to present himself as virtue personified.

It was, of course, the short-term good that he emphasized to the council, with a passion that carried the day. In principle, the council backed him, with confirmation pending.

Nothing (except what was yet to come) better reveals what an extraordinary character Saigo was. How to explain this readiness to risk death, as if he were playing Russian roulette with events as the gun? It was perhaps a way of escaping the intolerable paradoxes into which his beliefs and actions had led him. Though steeped in conservatism, he was also in the forefront of change: feudal in his loyalties, he helped abolish feudalism; a samurai who loved the samurai and their traditions, he signed up to legislation that ended their long supremacy; committed to expelling Western barbarians, he accepted the benefits they brought. These were tensions he could not resolve. What he could do was evade them by dying in two noble causes—truth, and either peace or war, with the latter offering

a chance for the young samurai to live out their traditions by conquering Korea.

The extent of his passion, his explosive volatility, the strength of his commitment, his determination to see things through to the end, his obsessive integrity, the depth of his learning—all come together in a poem he wrote in Chinese when he thought he would shortly be off to Korea.

> Summer's brutal heat has passed and autumn's air is clear and crisp;
> Seeking a cool breeze I journey to the capital of Silla [Korea].
> I must show the constancy of Su Wu through the bleakness of the years.
> May I leave behind a name as great as Yan Zhenqing.
> What I wish to tell my descendants, I will teach without words.
>
> *(trans. Ravina)*

The references point to an intimate knowledge of Chinese history back to the second and third centuries BC. Su Wu was a Chinese commander famous for having led an embassy to the "northern barbarians," the Xiongnu, who ruled an empire north of the Great Wall (indeed, part of the Great Wall was built to keep them out). He was taken captive and held as a hostage. He tried to commit suicide, was nursed back to health, and was then tortured, starved and forced to become a shepherd. Finally, after nineteen years, he made it home again. In Chinese history and art, he became a symbol of faithful service in the face of overwhelming odds and a favorite subject in drama, poetry and song. Yan Zhenqing (eighth century) was famous as a city governor loyal to the Tang dynasty and as a calligrapher. And finally, Saigo is aiming for an immortal rep-

utation in endurance, loyalty and artistic merit, not through words or administrative ability but—as ever—through action, his definitive sword-cut through reality's entangling knots.

In the event, the action he took was not at all what he had planned.

The issue of Korea set him at odds with two colleagues, the senior general Yamagata Aritomo and his childhood friend Ōkubo, with whom he had masterminded the restoration. Yamagata, who had seen several European armies at first hand, knew Japan's conscripts were not ready for a war. Ōkubo, who returned home from the Iwakura mission in May 1873, had also seen much of the world, including Germany, and had been very impressed with Germany's chancellor, Otto von Bismarck, who had done for Germany what Ōkubo wanted to do for Japan: he had unified a land of provinces, set an emperor on the throne, avoided war where possible, won a major war (against France), ensured peace internationally by playing off major powers against each other and created a nationwide legal system. All this he had done by pursuing the national interest without passion, pragmatically, compromising when necessary, never allowing old loyalties to get in his way. Indeed, Ōkubo's admiration for the Prussian statesman, and his own attitudes and achievements, earned him the later soubriquet of "Japan's Bismarck." How, then, would a Bismarck deal with Korea? The Koreans were insulting, certainly; but would war with them work for Japan? No, it wouldn't pay off, and it would antagonize Russia. Better to swallow insults and live with shame than have a budget deficit or risk all with Saigo's wild ideas.

The differences came to a head in December, when the ten-strong council was supposed to confirm Saigo's appointment as ambassador to Korea. Five were for him, five against, and

all were near the breaking point, for this was not just about Korea and Saigo, it was about who was going to run the country, and in what direction they would take it.[2]

Next day, Ōkubo came out with powerful arguments against Saigo's mission. What if something serious happened at home when the army was abroad? Anyway, the economy would suffer, and there were debts which, if not paid, would affect negotiations to replace the Unequal Treaties. The only beneficiary of war and more debt would be Russia. Ōkubo said he would resign if overruled. Over the following days, anger exploded yet again on both sides; so much emotion was released that the prime minister collapsed with a ruptured blood vessel in the brain, handing control to Iwakura. Saigo and Ōkubo were each convinced that they knew how to save the nation, and that the other would ruin it. "The biggest coward in Satsuma" was what Saigo called Ōkubo, using the worst possible insult a samurai could hurl; "reckless" was how Ōkubo described Saigo, with a new PM to back him up. On December 12, confirmation of Saigo's mission to Korea was "postponed" indefinitely—in effect, rescinded.

In fury, Saigo resigned (though he kept one of his posts, that of general, which would have implications four years later, when he would be leading an insurrection against his own army). This was not the regime he had hoped for. He had wanted power to remain in the hands of patriotic warrior–administrators, and what he had gotten were wishy-washy, self-serving, compromising politicians, bureaucrats and capitalists. What he had wanted was a federation, and what he

[2] As Hilary Conroy points out in *The Japanese Seizure of Korea*, this was the stuff of high drama, and in fact became so in 1954, when the playwright Yamamoto Yuzo turned it into a three-act play.

got was a centralized nation. Three of his supporters followed him into the wilderness. Then the discontent spread to the imperial guard. A week later, forty-six officers, two of them major-generals, had also resigned, followed by another four hundred members of the imperial guard—10 percent of its total strength—and many, perhaps scores, of country samurai (*goshi*) employed by the city police.

By this time Saigo was on his way to Kagoshima, leaving Ōkubo as Japan's most powerful politician. It was Ōkubo's vision that would prevail, restraining Japan until it was ready to start the march to empire, with consequences that would define its development—and the world's—over the next 70 years.

14

THE ACCIDENTAL REBEL

IF YOU FOLLOW THE ROAD NORTHWARD THEN EASTWARD FROM Kagoshima around Kinko Bay, you pass the thatched hut marking the spot where Saigo "recovered" after his attempted suicide. On one side, steep green hills crowd in upon both road and railway line; on the other lies the bay, its waters crowded with semisubmerged fish baskets, set to catch the yellowtails that sushi eaters love. This was the way Saigo came that winter as 1873 turned to 1874.

The hills fall back, and for a few kilometers you drift inland over fertile soils laid down by the Amori River. Across the river, the old road runs through the little town of Kajiki, where one branch turns to the left into green hills, paralleled now by the motorway to the airport. Another branch continues along the coast toward the village of Hayato. You are in a world far removed from high-rises and expressways. A little stream

runs down from the hills, tumbling between huge, overarching camphor trees. It is this grove that makes the place magical, for camphor trees have for centuries produced timber, culinary leaves, medicines and many sorts of oil. There is a hint of mist and the smell of damp leaves. One giant, even more eminent than the rest, is the subject of myth, spelled out on a notice. Once there were two gods called Isanagi and Isanami, who had a weakly son. The boy had trouble walking, even at the age of three, so the two gods put him in a boat and threw him out of heaven. He landed in the bay out there, and when he came ashore he turned into this camphor tree. The stream runs out to the bay past a single-story thatched house with a veranda running around it. Not far off are the shore, and boats and excellent fishing. Apart from the tarmac, the scene would have been pretty much the same when Saigo came to this house to escape the rigors of government and recover his damaged health.

Except it was winter. The trees, which are evergreens, protected the house from the frost and occasional snow, but he needed the hot springs back up the road in Kajiki. The springs are still in operation, captured by a steamy concrete hall and served by a seedy little hotel, which recalls his presence with several portraits of him on the outside wall, along with some enigmatic lines of verse:

> Compared with the passion in my heart
> The smoke of Mount Sakurajima is thin.

He apparently believed that this was the life he should be living, the very model of the Confucian gentleman-scholar communing with nature. It seems to have made him content,

perhaps a little self-satisfied, as well he might be with all the noncritical adulation he received. His poems proclaim a love of nature worthy of an English Romantic:

> I moor my skiff in the creek of flowering reeds.
> With a fishing pole in hand, I sit on a stepping stone.
> Does anyone know of this high-minded man's other world?
> With my pole I fish in autumn's creek
> For the bright moon and the cool breeze.
>
> *(trans. Ravina)*

Here he was more eager to get out in the woods with his dogs than pine for power or (as some suppose) plan a revolution. But he was a hero, and events would drag him back into the limelight.

Kagoshima's samurai were as determined as ever to protect or regain their traditional status, ignoring directives from Tokyo. Hisamitsu continued to rail against the evils of the new regime. Kagoshima's governor, Ōyama Tsunayoshi, who had known Saigo from childhood, was Hisamitsu's man. The city was bursting with samurai eager to turn back the clock, and these were now joined by several hundred imperial guards who had resigned with Saigo. This was a powder keg of resentful men just ready for a spark.

Something had to be done, and it was widely felt among the restless samurai that Saigo was the man to do it. In fact, for four years he did very little except lend his name to a new system of schools.

He had always been a supporter of education, and had recently been closely involved in a schools project. Immediately after the Boshin War he had been voted an official annual honorarium of 2,000 *koku* (for salaries, like all large units of

currency, were still quoted in bushels of rice and paid in varying combinations of rice and cash[1]), which he donated to help found a school dedicated to the soldiers who fell in the war, with the intention of educating more young men in the same mold. When he left Tokyo, the school closed, but at the same time, the Kagoshima government—through Saigo's friend, Governor Ōyama Tsunayoshi—set up a system of private schools, to which Saigo contributed his salary. These schools had an agenda made clear by the informal names of the first two, the "infantry" and "artillery" schools, set up on the site of the former stables of Tsurumaru Castle at the bottom of Shiroyama, the forested hill at the heart of Kagoshima. As well as Chinese classics, the curriculum included physical fitness, drilling and maneuvers. The two original schools soon spawned a dozen similar ones in Kagoshima and another one hundred in the rest of Satsuma, quickly building up to some seven thousand students in their teens and early twenties, most of them rustics destined to become district magistrates, policemen or village headmen. The schools served to focus the energies of the young, controlling them, but also preparing them for military action. No wonder the government suspected Satsuma of moving toward violent revolution.

Later, when Japan turned to the business of building an empire, these schools and others like them elsewhere came to be seen—especially in America—as forerunners of the "patriotic societies" that fueled Japan's extreme nationalism. It was assumed that Saigo was the shadow lurking behind the private

[1] 1 *koku* = 4.95 bushels, 180 liters or about 150 kilos, or about 330 pounds, supposedly enough rice to feed one person for one year. His honorarium was 30 tons of rice, about $9,000 in modern terms, but clearly costs have changed. In Saigo's day, 2,000 *koku* was enough to feed 2,000 people for a year; you could not do the same today with $9,000.

schools, and sources often refer to them as "Saigo's schools." But this assumption is based on his fame and the fact that the schools' members formed the bulk of Saigo's rebel troops. The connection with Saigo was indirect, through his inspirational but vague educational philosophy, based on Confucian ideals: loyalty, filial piety, benevolence, love. A monument outside one of the school buildings in Kagoshima mentions only some general ideas about cooperation, unity, virtue and progress, which is hardly evidence of a malign nationalist agenda.

Saigo himself spent much more time at a school outside the city which was devoted to the study of agriculture. Here the students cleared land and planted rice and studied military matters and Chinese, pursuing Saigo's ideal of the scholar-samurai, inculcating self-reliance. "These days, I'm a farmer through and through," he wrote in April 1875, "and I am studying earnestly. At first it was rather difficult, but now I can till about two plots a day . . . With no sense of privation and unperturbed by anything, I am at peace."

He was at peace because he was out of the hated business of politics. In his absence the matter of Korea had moved on, in a way that disgusted him. A Japanese ship on a surveying mission off a Korean island was fired on, and replied by destroying the Korean coastal fortress. Ōkubo used this as a pretext for some gunboat diplomacy, sending warships to threaten Korea: either sign a treaty recognizing the new government or it would be war. Korea signed. Saigo thought this was despicable. It was sheer intimidation of a weak power by a stronger one, a shameful act violating "Heaven's principles." It is hard to understand why gunboat diplomacy was worse than actually going to war in revenge for Saigo's death, which was one of the outcomes he had envisaged. In his eyes it just was, because he was a moralist, not an imperialist.

(The Taiwan crisis was solved in an equally high-handed way, with an ill-planned invasion led by—of all people—Saigo's younger brother Tsugumichi. The conscripts did nothing but contract disease and "shoot a few semi-savages," in the words of an otherwise pro-Japanese writer, Frank Brinkley.[2] An American war correspondent, Edward House, sneered: "I do not like to think what the consequences might have been if the Japanese had been met upon the beach, or in the jungles, by a determined enemy . . . The whole business of landing was carried through in the most confused and *laissez-faire* manner imaginable.")

But heaven's principles were not enough to preserve the peace. Old Satsuma wanted independence; new Tokyo wanted a centralized state. Orders came from on high to end the samurai privilege of administering criminal justice, to introduce private ownership of land, to do surveys for a land tax, to open government service to commoners: all were largely ignored by Kagoshima. The two were on a collision course.

Each new regulation from Tokyo inspired a reaction in defense of local feeling. From 1875, the private schools banned their students from studying in Tokyo or overseas, a controversial measure that caused resentment. The following year, new laws struck at the very core of the samurai ethos. First, they banned all samurai except soldiers and police from carrying swords, which was as explosive as a sudden government ban on the right to bear arms would be in America today. Next came a ban on the samurai's topknot hairstyle. Five months later the government ordered them to convert their rice stipends into government bonds. The stipends were like pensions

[2] *A History of the Japanese People* (New York, Encyclopedia Britannica Co., 1914).

Top: Ōkubo Toshimichi, Saigo's great friend—and enemy. Also from Kagoshima, Ōkubo was the leading light in the Meiji Restoration and the new government. *Bottom*: Saigo Tsugumichi, Saigo's younger brother, was commander in the Boshin War. He then traveled in Europe with Yamagata Aritomo, who would drive the elder Saigo to his death. Later, Tsugumichi achieved eminence as privy counselor, admiral and marquis.

paid in kind, both a guarantee that they would not starve and, if sold, a guaranteed cash income. The new bonds paid 5–6 percent annually, and the change meant a drop in income of some 30 percent. Of course, the stipends had been a huge drain on the national finances, and most of the samurai were unproductive, at best supplementing their meager incomes by growing their own food. Now, suddenly, they would have to find jobs, a demand for which they were utterly unprepared. At a few strokes of the pen they had lost identity, status and income. Never without extreme violence has such a large élite been reduced so fast from emotional and financial security to resentment and penury.

The result of the increasing pressure on samurai privileges and aims was outrage and a rash of violent outbreaks in western Kyūshū (and elsewhere). The first occurred in early February 1874. The former justice minister Eto Shinpei, one of those who had resigned with Saigo over the Korea crisis, had returned home to Saga, 175 kilometers north of Kagoshima. He led a few disgruntled samurai to seize a bank, the castle and some government offices, but this miniature uprising was quickly crushed by imperial troops. Eto himself was captured and beheaded along with fifty of his collaborators, his head being exposed as an example to others.

This brutal act did nothing but give heart to another, larger, group near Kumamoto. These were rebels of a different hue: young, xenophobic extremists with bizarre attitudes toward all things Western, avoiding Western clothes, the Western calendar, Western weapons, Western technology—even telegraph lines, which they would walk under only while protecting their heads with white fans. Their manifesto was uncompromising: "Our country differs from all other lands, in that it is the country of the gods . . . Diabolical spirits now

prevailing are bent on abolishing customs which have been cherished and observed since the time of the gods." They were particularly incensed by the presence in Kumamoto of an American military instructor and missionary, Captain Leroy Lansing Janes, who had actually managed to set up a small group of Christian converts. The rebels were known as the League of the Shinpūren, "Divine Wind," from an alternative reading of the signs that spell *kamikaze*, the "divine wind" that had destroyed the Mongol fleet and would give its name to the Second World War suicide bombers. Their leader was a Shinto priest, Otaguro Tomoo, who claimed divine inspiration. On October 24–5, two hundred rebels, wearing armor and wielding swords, made a nighttime attack, killing the commander and the governor in their sleep and cutting down several other senior officials and three hundred ordinary soldiers. They also searched for the American, Captain Janes, but he had wisely left town the day before. Retaliation with guns crushed the uprising the next day, killing over half the rebels. Otaguro himself was badly wounded and asked an aide to behead him. Eighty-five of his followers committed seppuku—the largest case of ritual suicide in peacetime in Japanese history.

By this time a third bunch of rebels, about two hundred, were marching the one hundred kilometers from Akizuki (now part of Fukuoka) to help, unaware that Otaguro and half his force were dead. They were easily scattered by imperial troops. Four leaders committed seppuku, two were beheaded and 150 of their followers were sentenced to hard labor.

All these groups shared the same anti-Western agenda and traditional attitudes toward the use of swords and ritual suicide to avoid dishonor, and all rose in the hope that Satsuma would join them, with Saigo in the lead. All were defeated by conscripts in an imperial army that was quickly gaining ex-

perience and a spirit of its own. All foreshadow the fate of Saigo's uprising, and his own fate.

Saigo himself, however, remained silent. He was sympathetic to the rebels' cause and knew that he could influence events—"no doubt if I were to go into action," he wrote, "it would astonish the entire world"—but said and did nothing to indicate that he supported them.

So events gathered pace without him. An inspector reported to Tokyo about the schools, the unrest, the hostility, the contacts between disaffected leaders and in particular the presence of military hardware built up over recent years by the Shimazu—two armament plants and three ammunition depots. He advised that direct and immediate action was necessary to bring Kagoshima into line with the rest of the country. In January 1877 the government sent imperial troops on a chartered ship to Kagoshima to remove arms and ammunition. It was supposed to be a secret operation, but after the crew sneaked ashore at night they were discovered. About one thousand young men, mainly from the private schools, drove them off empty-handed. Over the next two days, the students broke into several ammunition stores themselves, making off with firearms and tens of thousands of rounds of ammunition, which they proudly paraded through the streets. Kagoshima was in open rebellion.

Saigo had no knowledge of this until after the event, because he was hunting and fishing across the bay, one hundred kilometers away. When he heard, according to folklore, he swore: *Shimatta*! (Damn!), but added that, although he disapproved of the rebels' actions, he was moved by their loyalty and vowed to die with them in battle. In early February he hurried to Kagoshima, where he exploded in anger at the students for their stupidity. Saigo's seventeen-year-old son, Ki-

kujirō, who had been summoned from Amami Ōshima to be educated, later recalled he had never heard anyone shout so loudly—"What a monstrous thing you have done!" But they were from schools to which he had lent his name, they were his students, and when he calmed down he saw it as his duty to support them, even if it meant giving his life. As Ivan Morris says, "it was as if he realized that once again he was being given an opportunity to compass a noble death."

His arrival coincided with the "discovery" of a "plot" to assassinate him—the quotes flagging the extremely dodgy nature of this incident. The main culprit was a shadowy character called Nakahara Hisao, a police corporal. He had come from Tokyo to Kagoshima to do the job, boasted of his mission to a friend and been overheard by a spy, who told his superiors, who told the police, who arrested Nakahara, who confessed all. At first glance it looks pretty damning.

This was the story he told:

In the previous November—"I forget the exact day"—he went to see the Tokyo police chief Kawaji Toshiyoji, who told him that, although there were indications of disquiet in Kagoshima, Saigo's presence was expected to control things. "He added, however, that in case a rising should break out, there was no help for it but for me to confront Saigo and kill him." The following month, he and another twenty police colleagues, traveling separately, went back to Kagoshima intending to infiltrate the private school system and persuade as many students as possible of "the impropriety on the part of loyal subjects of exciting a war on no good pretext," but that "in the event of the rising taking place, Saigo was to be assassinated, and the fact at once telegraphed to Tokyo; that then a combined attack should be made by the navy and army, and the members of the *shigakko* [the private schools] killed

to a man." On January 11, Nakahara arrived in Kagoshima, where three weeks later "the secret plot of assassination was discovered, and I was arrested. Now, in consequence of your examination, I have confessed that by the order of Kawaji I formed a plot to assassinate Saigo."

What truth was there in this? Well, there were other arrests and other confessions. But there were reasons to doubt them, the main one being that the confessions were extracted under torture by police who were pro-Saigo and therefore wanted evidence that would foment rebellion. There was never any evidence of government forces planning to invade Kagoshima *before* Saigo's uprising and kill the private school students. A Tokyo newspaper called it a "sheer fabrication."[3] And later, after the rebellion was crushed, the plotters were found in prison, tried by an imperial court, and acquitted on the charge of plotting against Saigo's life.

But at the time pro-Saigo samurai had good reason for suspicion. Some fifty policemen, originally from Satsuma but now Tokyo based, had slipped into Kagoshima over the previous two months. No one knew their purpose, so it was widely assumed they were spies. Perhaps there were plans for a government clampdown. Whatever the truth, it was enough to persuade students from outlying schools to come into Kagoshima and arm themselves for action, in the belief—which as time passed became certainty—that Tokyo, driven by Saigo's old friend and now treacherous enemy Ōkubo, was planning to assassinate their hero.

The plot, true or false, confirmed Saigo's decision to act. He had seen Nakahara's confession as soon as he arrived in Kagoshima (so the police must have been in a hurry to make sure

[3] Akebono Shimbun, trans. in the *Tokio Times*, May 19, 1877.

he knew about it, since Nakahara had been arrested only three days earlier). The next day, February 7, he had a meeting with his friend Ōyama Tsunayoshi, the city governor. He shook his head over the business of the students seizing the gunpowder. If only he had been there, he might have prevented such a reckless act. "But now the die is cast," he said, "and matters must take their course," the reason being that he had seen the Nakahara confession, and believed it. Kawaji may have ordered the assassination, but the treacherous Ōkubo was behind it. Previously, Saigo would never have rebelled against the government of which he had been a part. But now that government had turned on him. It was no longer his. The emperor had to be protected from Ōkubo and his lot, "the great criminals of the universe" as Saigo called them. That justified action. The idea also fit in with his sense of responsibility toward the students. He could, he believed, control them, turn their violent feelings from negative to positive. And, of course, he once again had a cause in which he could, if necessary, sacrifice his life.

But it shouldn't come to that. He would do as his former lord Nariakira had planned and as Hisamitsu had done successfully: he would lead the rebels to Tokyo, confront the government and "demand an explanation from Ōkubo." Ōyama's role would be to send messengers to all the private schools with copies of the confession and of a statement of Saigo's intentions, which was done a week later.

It would cost. You cannot expect to take several thousand young men away from home for months without feeding them and giving them some pocket money. Ōyama made the arrangements, as he explained in a later statement confessing his role in "establishing a commissariat within the kencho [the prefecture's central office], whence the Satsuma troops were furnished with supplies." He ordered his staff to

raid the prefecture's tax accounts and the funds held to pay salaries and departmental costs. Then he did the same for the subprefecture of Hyūga, the enclave to the east that Saigo had been aiming for when he set off on his ill-fated boat trip with Gesshō. Within just two days these visits to the banks and strong rooms pulled in 120,000 yen. "I then handed the whole sum to Saigo and his party."

The Japanese had recently (on May 10, 1871) decided to adopt a silver dollar coinage under the name of "yen," meaning "a round object." The yen was therefore basically a dollar, defined as 0.78 ounces (24.26 grams) of silver or 1.5 grams of gold. A decline in the value of silver since 1873 had brought the yen down in value: indeed, over the next twenty-five years its worth would be cut by half. But in 1877, 120,000 yen was still almost $120,000, which, even considering the costs of keeping poor samurai and students in food, clothing and ammunition, was a huge sum, perhaps something like $20 million in today's terms. Given the previous raid on official stores of gunpowder, given that most men had a flintlock and a sword or two (some even had rifles), Saigo was all set up for a revolutionary campaign—with one major qualification: that it was not really revolutionary, in that it would not involve any large-scale military action and he was not intending to overthrow the government. A march to Tokyo would be fine; a quick battle could be managed; anything more, and he would quickly run out of cash.

So all was in order. The assassins had been arrested and had confessed to their "wicked design." There were legitimate questions to be asked. Saigo had right—and cash—on his side. And the crowds of young men thronging the streets of Kagoshima felt justified in their resentment, well supplied and eager for action.

15

FAILURE AT KUMAMOTO

WINTERS IN KAGOSHIMA ARE MILD. IT GETS COLD, IT RAINS, and the rain is sometimes messy with the ash from Sakurajima, but it almost never freezes and snow is rare. On February 15, 1877, however, it snowed, heavily, dumping twenty-five centimeters, the best part of a foot, on the roads and hills.

They had been gathering for a week: not just the core of the seven thousand private school students, but thousands of others of the dispossessed and angry from the countryside, until there were twelve thousand of them clogging Kagoshima's streets and overflowing the school buildings. Most, but not all, had guns of some sort, whether breech loaders, muzzle-loading muskets or pistols; a few had rifles; and all, of course, had swords. Dressed in heavy cotton shirts, pantaloons, leggings and rope sandals, they looked more as if they were going to a huge martial arts meeting than preparing for war.

An advance guard of four thousand gathered on the flat

area at the top of Shiroyama and set out northward, as if on a jaunt that would bring the government to its senses without the need for real action.

Two days later, at 6:00 A.M., Saigo—dressed in his imperial army uniform—oversaw the rear guard, artillery units and command group as they gathered on the private school parade ground; two hours later he led them away from Kagoshima through the snow. Since he was a loyal subject leading loyal subjects, he expected little or no resistance, and left no force behind in case of trouble in Kagoshima. In support, they had twenty-eight small cannons, two field guns, thirty mortars and all the ammunition they had raided from the city's arsenals. Much more than samurai in terms of weapons, they were still samurai in spirit: strong, fit and well prepared, full of zest, élan and all sorts of the morale-boosting right stuff, much of it inspired by Saigo's presence as leader. Mark Ravina quotes one forty-three-year-old soldier, Kabayama Sukeami (forty-three— they were not all young bloods!): "I thought that if it was Saigo's doing it just could not be a mistake."

Among the rebel leaders—principally Kirino Toshiaki, supreme swordsman, brigadier-general and now Saigo's number two—there had been a plan to head straight up to Shimonoseki, where they would overwhelm any imperial forces. But that would leave imperial troops behind them in the great fortress of Kumamoto, a threat that might cut them off from their home. Better first deal with Kumamoto, where the garrison would surely take one look at them and surrender. Saigo even sent an optimistic letter to Kumamoto's commander: "I am en route to make an inquiry of the government," he wrote, and politely requested that the fortress be handed over to his command "on the occasion of our passage through the garrison." A week or so later they would cross

the straits and march on to Tokyo. Then what? No one was quite sure, but whatever it was it would be glorious. None saw the contradiction in their cause: they loved the emperor, they were off to beg him to reconsider decisions they considered catastrophic, yet they already knew they would be confronting, if not fighting, the emperor's troops.

So they were not cast down by the snow, which clogged the road leading around the edge of the bay to Kajiki. Feet may have been wet and cold, but spirits were high. At Kajiki, where people knew and adored Saigo, they were greeted with cheering and drumming and the sound of the *shamisen*, the local instrument that resembles a long-necked, three-stringed guitar or lute. They carried their own provisions, and would surely be given more by the grateful people of Kyūshū along the way. Saigo's immense bulk did not sit well on a horse, so he was borne in a palanquin. Horses were loaded with ammunition while the field guns were taken halfway to Kajiki by boat, being landed only where the road veered away from the coast before heading up into the hills.

Today, it's a pretty little road that winds into the forests above Kajiki. A little way up, almost hidden by firs and bamboos, another sort of road branches off. I would have missed it, but Michiko and I had expert guidance in the diminutive form of the extremely cheerful Yamaguchi Morio, in his seventies but lithe and energetic. He led the way onto the paved section, now carefully preserved, of the old road made in the mid-eighteenth century to guarantee that horses and palanquins could climb these steep and somber slopes in all weathers.

"We're thirty kilometers from Kagoshima," I said, "and they were on foot. So it would have taken them, what, two days to get here?"

"One day! Oh yes. But v-v-v-very awful." Morio had

learned his English working for the U.S. Air Force decades before, and he was so eager to spill his information and show off his rusty language that his words tripped over themselves. "The heaviest snowfall in fif-ifty years. Oh yes."

That first night they camped outside Kajiki, drying their leggings and sandals in front of open fires. Then came the climb. I'm not sure whether the stones would have helped or hindered in those conditions. We walked the road in high summer, serenaded by cicadas twittering like birds, but the sun hardly penetrated and the forest held dampness like a sauna. The stones were not flat, but domed like buried pillows, and slick with green moss, turning the road into a surface that resembled a supersize, well-oiled alligator skin. In winter, with the trees dripping meltwater and snow, it would have been treacherous even under rope-soled sandals, and much worse for horses laden with ammunition and dragging cannons.

That was the hardest part of the journey, a few hours of struggle that took most of the second day. At the top, they were on their way to Kumamoto, which, if all went well, they would reach in another two days. Saigo's bulk was transferred to a riverboat at Hitoyoshi, some seventy kilometers short of Kumamoto, from where he floated downriver for a day before setting up his headquarters in Kawashiri, eight kilometers to the south of Kumamoto.

One glance at Kumamoto Castle tells you that this is a place Saigo should never have thought of taking. One of Japan's three greatest fortifications, it is a supreme example of what a castle should be, with nine kilometers of wall, six towers and forty-nine turrets. It was built in the early seventeenth century by a lord who knew exactly what he was about, having fought in Korea, taken many castles and built many others to pro-

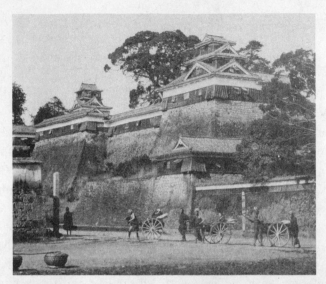

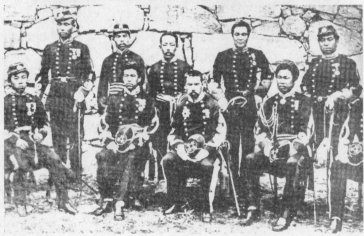

Kumamoto Castle in 1872, five years before Saigo's siege, and some
of the officers who opposed him.

tect his conquests. This was his last masterpiece. Dominated by its wooden towers and a six-story keep—a jewellike mass of gables and roof corners—it stood on a bluff defined by two streams, which, according to folklore, could be dammed to create a moat all the way around. The walls soar upward for 20 metres from curving bases that look like approaching tidal waves. The stones are of andesite, extremely hard, with cornerstones dressed to fit the prowlike curves. The design evolved as the best way to build high walls in an area notorious for earthquakes, for a broad, wavelike base can support a much higher wall than the straight-up-and-down designs of Europe. To attackers, they look alluring, because you can run up them part of the way, as visiting kids do all the time today. But you can't get far; and rocks and logs tossed from the battlements did not drop straight down, as from European castles, but bounced, taking attackers with them. On two sides, the walls rise sheer and forbidding; on the two other sides, where the slopes are less steep, both walls are lower, but the one to the south runs straight for 242 meters along a branch of the Shira River, while the west wall has baffling indentations where attackers can be assaulted from overlooking battlements. If attackers turned besiegers, they had to be prepared for a long wait, because there are within the castle walls 120 wells, and nut trees to provide starvation rations. With good planning, the place could hold out for months.

Not surprisingly, it had never been taken, partly because 250 years of peace descended shortly after it was built. For all that time it was in private hands, until it was taken over by the new Meiji Regime in 1870. Now, seven years later, it was the base for 3,800 extremely nervous imperial conscripts. Few had much training, many of them had friends or relatives among the rebels, and most admired the samurai spirit of Great Saigo.

They were also outnumbered, though they had no idea by how many. If they advanced from the castle and fought in the streets of Kumamoto town, they would be face-to-face with men they knew, with unforeseeable consequences. For the leaders, there was no alternative: they had to stay in the castle, and defend it. This was the nut—formidable on the outside, possibly rotten within—that Saigo intended to crack. No one had a clue as to what the outcome might be. It would all be down to the quality of the defenders. They held the key to Japan's future.

Hindsight, of course, makes all clear. It was a fatal error for the rebels to attack Kumamoto. All the defenders had to do was sit tight until help came, which it would eventually, because the rebels were vastly outnumbered by imperial forces in the rest of the country, and vastly outgunned as well—the imperial government was producing over a million rounds of ammunition a week for their breech-loading rifles. However long the war, they wouldn't run short. But at the time, all were blinded by false emotion: unrealistic fear on the imperial side, unrealistic confidence on the other. No one was certain whether there would be war here and/or elsewhere, whether reinforcements would come to the imperial troops from the north, or from other areas to bolster the rebels, whether the food and ammunition would hold out, whether talks would be held or deals done.

The rebels had already made one fatal error. They—in particular Saigo—had failed to capitalize on their greatest asset, which was the disaffection in other areas. When others rose, when they sent messages asking for help, he remained aloof. If he had committed himself earlier, rather than waiting for the private school students to force his hand, he could have organized a counterrevolution that could have seized the whole island of Kyūshū before the imperial army had time to

respond. Instead, Satsuma was infected by parochialism, which doomed all the southern uprisings to defeat, his own included.

Hindsight might have been our only guide to the next fifty-four days, which is how long the siege lasted. But luckily a lieutenant of artillery, Takehiko Ideishi, was inside the castle and many years later delivered an eyewitness account in a series of lectures, which were taken down in shorthand. His story is selective and confusing, as you might expect from an ordinary soldier recalling events of fifty years before with the help of a few mementos, but it is all we have. What follows is based on his words.

While Saigo's rebels were gathering in Kagoshima, Kumamoto was awash with rumors. Old Man Saigo was raising an army; no, he wasn't; yes, he was, but he wouldn't be taking any part in the conflict. Trouble was coming, that was sure, so no one took any chances. The war minister wrote to the commanding general Tani Tateki: "Kumamoto must, at all costs, be held." The prospect involved "unspeakable anguish" for those inside the castle, because so many officers were from Satsuma and the soldiers didn't care much for the new central government. The chief of staff, Karayama Shiki, was a friend of Saigo, and the only action the conscripts had seen had been against the *Shinpūren* rebels last October. "Therefore there was extreme anxiety about the outcome of pitting these demoralized troops against those strong rebel soldiers who were full of resentment and willing to fight to the death."

As it happened, Karayama set his friendship with Saigo aside, the officers showed themselves willing to share the privations of the men, and shared danger strengthened morale. Shared pleasure, too: on February 13 and 14, a Great Memorial Day Celebration commemorated those who had fallen in

other uprisings, with bystanders packing the streets to watch sumo wrestlers and a fireworks display. But inside the fortress soldiers were digging trenches and storing provisions, driven on by reports that Satsuma mutineers were approaching— with or without Saigo, no one knew.

In the middle of the morning on February 19, 1876, for reasons never explained, a fire broke out in the castle's main storehouse, which housed most of the provisions and stood right above a stone-built ammunition magazine. "In the time it takes me to say 'This is terrible!'" said Takehiko, "the fire spread in every direction and it was impossible to do anything." There was no way to bring water up from below. After a few minutes of horrified inaction, a staff officer named Kodama yelled for the troops to open the magazine underneath the blaze and save the ammunition. With the flames engulfing the keep, throwing out embers that set fire to the city below, troops—Takehiko among them—risked opening the door and started to carry out the ammunition, terrified that the tower would collapse on top of them. "The bodies of all of us who were working were in the jaws of death. Would it be death? Or life? Fortunately, the tower which should have fallen towards us, by some quirk of circumstances, fell inward with a great rumble, like a thousand thunderclaps heard at once. Truly it was an indescribable piece of luck." The provisions were gone, but at least the ammunition was saved.

In the square beside the smoking wreck of the keep, a tent was put up to act as the commander's HQ. That very afternoon, three messengers arrived from Saigo and were received in the tent. They brought his letter, written back in Kagoshima, requesting permission to be allowed to proceed to Tokyo. Perhaps he still hoped that all would be well, that his good intentions would be enough to pave the way to Tokyo. If so, the

reply from the chief of staff, Karayama, would have disillu-
sioned him. Karayama told the messengers that "if Satsuma
broke the laws of the land, and if by chance they carried arms,
formed units, and by force tried to secure passage through the
garrison, they must be prepared to be killed without mercy."
The next day, Tokyo published the official response to Saigo's
plans. He might think he was on a legally justified expedition
to question the government, but the government disagreed.
Saigo's men were "unlawfully bearing arms against the Impe-
rial authority," and so "His Majesty the Mikado has ordered
an expedition sent to chastise them." Reinforcements would
leave the next day (the twentieth) and arrive in Hakata Bay,
one hundred kilometers to the north, in a few days. If anyone
still doubted it, they could doubt no longer: this was civil war.

Also on the twentieth, the castle received another boost.
Totally unexpectedly, some six hundred police entered to
strengthen the defense, just as the first rebel troops, perhaps
some of Saigo's supporters from the countryside, began to
arrive in town, warily eyeing the townsmen carrying swords
and guns who were also patrolling the streets. "Enemy jostled
enemy in the very heart of the city, but there wasn't even a
single exchange of blows. Recalling it now, it was certainly
a curious situation," because the new arrivals were arrogant
men, certain that the imperial troops were mere peasant con-
scripts who, with no samurai traditions to make them fighters,
would simply flee or be cut to pieces with no trouble at all.

Saigo's force—three times the number of defenders—arrived
en masse on the twenty-first and attacked at dawn the fol-
lowing day with constant barrages of rifle fire, now from one
side, now from another. The chief of staff Karayama and regi-
mental commander Yokura were among those shot and killed.
Despite the officers' worries, the conscripted imperial troops

performed admirably. "The smoke from our artillery covered the castle inside and outside. You couldn't tell one place from another . . . It was like darkness at noon. Above ground level, there was a semi-darkness because of the smoke, and from time to time the sun became invisible." Officers and men fell to Satsuma bullets. "As for myself," wrote Takehiko, "I thought first of the words of a wise old man, 'No matter what happens in war, the most important thing is tranquillity.'"

Where was Saigo? Still no one knew, until a strange incident that afternoon. With typical samurai bravado, a Satsuma soldier waving a red flag led a body of rebels up the gentle western slope toward one of the gates. "Don't let him advance!" came shouts from inside. "Shoot him down!" There was a rattle of shots, and the man fell. After nightfall, the defenders crept out, recovered the body, and found on it a diary—many soldiers kept diaries—recording the events of the previous week, revealing that Saigo was at the head of the rebel troops, but for the last two days had been based a few kilometres to the south in Nihongi.

Letters written by Saigo at this time to the commander of the imperial forces, Prince Arisugawa, show him outraged by the unfairness of life. Here he was, the target of a planned assassination, a samurai loyal to the emperor, whose only wish was to "question" the government in the form of his old friend Ōkubo, and the emperor's own forces were opposing him, forcing him into the position of rebel—he, who was more loyal than anyone!

Still no one in the castle knew much about the rebel army. The only way to discover more was to sneak spies out in the hope that they could find out something useful and get back alive to report it. Several managed to leave, but none re-

turned, presumed dead. About two of them there was no need to presume—their severed heads were tossed over the castle walls. One Shishido, a man with a reputation for bravery, politely agreed to try his luck: "Since you have gone to so much trouble, unworthy as I am, I humbly accept." He was disguised in workman's clothing and his exposed skin was covered with soot, as if he was someone who had been searching for possessions in one of the burned-out town houses. A week after setting out, he returned safely with a complete report of where the Satsuma rebels were deployed and the welcome news that "the rebels have no artillery"—other than their medieval guns that fired cannonballs—and imperial troops would be attempting to break through and rescue the castle in a few days.

By March 1, when the siege had been going on for a week, it was becoming obvious that if there was no rescue, they would starve. Officers calculated that there were nineteen days of supplies left. The defenders, who had been eating white rice, started to prepare brown rice, which had to be pounded to remove the husks. In quiet moments, the castle rang to the thump of the pestles in mortars.

Despite the distant sound of artillery and rifle fire, no breakthrough came. Occasionally, arrows came whizzing over the wall with letters attached designed to undermine morale— "What are you going to do, cut off in there? . . . Quick surrender is the best policy! . . . The Imperial Army is collapsing!"—to which the conscripts replied by firing arrow-borne messages of their own and hanging up huge posters proclaiming Saigo's crimes and their own outrage: "—However, we will have mercy on you, you band of ignorant outlaws, and if you repent of your previous crimes, throw away your weapons and return to proper allegiance, your crimes will be forgiven."

*

Not all Saigo's troops—now some 20,000 of them, as more samurai poured in from the countryside—settled into the siege. Some 6,000 headed north, hauling six cannons, with good supplies of powder and ammunition, to confront the imperial reinforcements that were on their way to relieve Kumamoto. They fought and won a couple of skirmishes on their way, but had little idea of what they were taking on. The imperial army had 46,000 men and rising, each with a rifle and something like 1,500 rounds of ammunition. In addition, they could call on 45 so-called mountain guns, 20 field guns (German, made by Krupp), mortars, an Armstrong and 2 Gatlings. The force led by Prince Arisugawa had already left Hyōgo in four ships and on February 22, landed in the great natural harbor of Fukuoka—Hakata Bay, for which the Mongols had aimed in their disastrous invasions seven hundred years before.

With the troops came another figure who was to have a crucial impact on coming events—Prince Arisugawa's campaign commander, Yamagata Aritomo. As soon as Saigo knew this, he would have realized what he was up against: the whole imperial army, which—by one of the many ironies of his uprising—he had helped create. He and Yamagata went back a long way; they were old enemies, old friends, and now enemies again. Yamagata came from Chōshū, Satsuma's long-standing rival and sometime ally. Like Saigo, he was a middle-ranking samurai by birth; like Saigo, he had worked his way up, becoming Chōshū's representative in Kyoto. It was he whom Saigo had approached when he and Ōkubo were pressing to reform the shogunate in 1867; for him that Saigo had engineered a meeting with Satsuma's lord Hisamitsu to lay the foundations of the Satsuma-Chōshū alliance. Yamagata was one of those who had been to Europe, seen what the West had

to offer, admired Prussian militarism, also studied the French, English and Russian military systems, and pushed through the law requiring universal conscription (in conjunction with Saigo's younger brother—another irony). He was among those who in 1871 came to Saigo in Kagoshima to persuade him to rejoin the government in Tokyo. He was one of the geniuses of the restoration, and would remain a force in national affairs, as field marshal, chief of the general staff, prime minister (twice) and president of the privy council, until his death in 1922. He was also a very good garden designer. Right now, this brilliant autocrat was intent on destroying his old sparring partner, and like him—both being samurai—would never give up. Saigo versus Yamagata was going to be a long slug fest that would end only when one of them was dead.

The newly landed imperial troops set off to march the one hundred kilometers south, which would take them three or four days. They had to be stopped; and, since there was only one main road south, the place to block them was from a hilltop eighteen kilometers to the north of Kumamoto: Tabaruzaka, a natural fortress from where cannons could bombard the road below and troops launch assaults. If this could be held, and the imperial force driven back, then Saigo had a chance of starving Kumamoto into surrender; if not, all hope would vanish.

Tabaruzaka—the Slope of Tabaru—is today proud of its place in the history of Saigo's rebellion. A farmhouse with carefully preserved shell scars stands among trees beside a memorial to the fallen and a museum, with a commanding view of the surrounding hills, fields and woods. The curator, Mr. Nagaiyama, a fit ex-soldier type in a sleeveless jacket and peaked cap, explained.

Imagine up on the hilltop the six thousand rebels—growing

steadily up to ten thousand as supporters streamed in—with their six cannon, not really much use because they had a range of only about two kilometers and fired only balls, not explosive shells. Winter was over, but the spring rains had started. Saigo's troops were in cotton and wool, with rope sandals that broke apart in mud, and swords and old-fashioned flintlock muskets that would not fire if wet. Over there—Mr. Nagaiyama pointed over the valley—was the pass from the north, beyond it a plateau. That's where the advancing imperial force set up their own cannon, and look, over there, that camphor tree, you see how it spreads out? It has no central branches. That's because a shell landed right on it, and blew its heart out. What could the troops up here do in defense? Only remove the sole obvious target, the farmhouse. So they burned it, leaving only the shell-scarred walls. What could they do in reply, with just small cannons and cannonballs? Nothing. It's more than two kilometers across that valley. The imperial guns were out of range.

But while the Satsuma men were up here, they would be a danger. They had to be removed. So the major battle was along the steep, narrow, tree-lined road, some of it more of a ditch with high banks of earth, leading to the top of the hill. It is said that the road was dug out when Kumamoto was built so that defenders could line its banks to ambush enemies. True or not, this is exactly what the rebels did, taking cover behind the trees, hunkering down in dugouts. The road today follows the same course as it did then, winding upward for 1.5 kilometers in a series of high-banked bends overhung with bamboo and a variety of other trees. Even on a hot summer's day, like the one on which I walked it, the road is a haunted place, with splashes of sunlight making the shadowy depths as grim as a grave.

And that, for seventeen days, is what it became. The imperial force was equal to the rebels in numbers: ten thousand of them, in uniforms and leather boots, with breech-loading rifles and good supplies of food and ammunition. They approached along tracks which are still there, running alongside paddy fields, over a little arched bridge that spans a stream, then on up into the killing field, which on that first day of the assault, March 4, was made dismal by continuous rain. Survivors said later they feared the rain more than the imperial troops.

The hill divides into three separate sections, each some four hundred to five hundred meters long, each one marked now by a heavy metal plaque: First Slope, Second Slope, Third Slope. Each had to be taken and then secured by an advance that averaged eighty-eight meters a day, every meter being marked (on average) by nine corpses. Not that this was a continuous fight. There were advances and retreats, days of no action except sniping and artillery fire, followed by intense, close-quarter action, often involving sword fights. Day by day the imperial troops closed in around the hill. Then, early on March 20, as a night of yet more rain turned to a damp and foggy dawn, cannons and rifles announced an assault that, after another four hours of fighting, drove the rebels off the summit.

In very few actions in modern warfare have so many been killed in such a time in such a small area. So thickly did the bullets fly that a few collided and fused in midair, which seems impossible until you see the odd-shaped lumps in the museum. Someone has calculated that the two sides exchanged three hundred thousand bullets every day, leaving the soft banks and forest floor so riddled with lead that today's schoolchildren like to collect them. Was that possible? I wondered. Yes, it is, assuming that most of the shots were from imperial guns. Several thousand men were fighting for those eighty-eight daily

meters, packed almost shoulder to shoulder, and each was firing scores, perhaps hundreds of times a day.

Climbing Tabaruzaka is like a pilgrimage: past the shield-like plaques that mark each of the three stages, past a memorial to an imperial officer who fell here, around the final bend with its view over cherry trees to the tree-covered plateau at the top, and finally to the memorial that records the appalling death toll—a roll call of fourteen thousand names carved in black stone (though the list includes the names of those who died in nearby actions as well). "And," said Mr. Nagaiyama, "5,307 of these names are those of soldiers from Satsuma." Which leaves some 9,000 dead on the imperial side, many of whom are buried along with their Satsuma enemies in six cemeteries scattered around the area. In death, the enemies lie side by side.

If these numbers are accurate,[1] they rank with the worst in the history of warfare for single battles. As the English-language weekly the *Tokio Times* put it rather melodramatically: "The fighting was more severe than any recorded in former times, and the blood of the killed and wounded flowed in torrents sufficient to float rice mortars, and the dead bodies were heaped mountain-high." It is hard to compare like with like, for battles vary in size and time scale. But let's try, by reducing the figures to deaths per day as a proportion of total combatants. At Gettysburg, one of the most destructive of American Civil War battles, 5,500 died in action over three days, and a further 4,000 of their wounds, out of a total of 150,000 soldiers. That's a death toll of 2 percent of combat-

[1] Another estimate of deaths is four thousand per side, eight thousand in all, out of twenty thousand combatants (see James Buck, "The Satsuma Rebellion of 1877"). But to see the names written out is persuasive. Next time, I'd better count them.

ants per day. Or take the Somme (300,000 dead, 1.5 million combatants, 4.5 months, from July 1 to mid-November 1916): despite its notorious horrors and the catastrophic casualty rate on the first day, its total death toll works out at a surprisingly low 0.15 percent per day. On Tabaruzaka, some 40 percent of those who took part died, over seventeen days. That's a daily death toll of 2.3 percent. If measured on a scale of intensity, Tabaruzaka was among the deadliest battles in history.

Back in Kumamoto, on March 12, the castle's defenders had no idea of the crucial nature of the battle then halfway through its bloody course. With the food supply dwindling to desperate levels, the police chief took fourteen or fifteen of his men to raid rebel positions to the west of the city. When they were some 30 metres from the Satsuma lines the rebels opened fire, which brought hundreds of defenders rushing out to support the police. The ensuing battle lasted two days, ending when the imperial troops overran the Satsuma emplacements, with the loss of eighty dead on the imperial side and at least seventy-three rebels: those were the bodies left scattered over the battlesite, but there may have been more. As Takehiko reflected, "I don't know how many corpses they carried off to the rear. Later we buried those corpses in a common grave and put up a grave-marker reading 'Grave of 73 Rebels.'" After that the rebels kept their distance, and the only contacts were yells, either insults—"Crazy fool! What made you into a rebel?"—or queries about friends and relatives—"Is so-and-so over there with you?"

As it became ever clearer that the castle was not going to fall, someone on the rebel side picked up on the idea of flooding the surrounding area by damming the two streams on either side of the castle. Saigo agreed. But it was an act that cut

both ways. It trapped the defenders inside the castle, condemning them in the long run to surrender or die of hunger; meals were reduced to two a day, and became nothing but tofu and wheat gluten. It also prevented the rebels from mounting any more attacks, making it clear that they had abandoned hope of taking the castle by force.

Never mind. Spirits were still high, because the whole countryside was in a ferment for Saigo. In scores of villages, peasants feared new taxes to pay for education, land surveys and conscription. Saigo made no appeal to them, but his vague plan to "question" the emperor allowed them to ascribe to him any motive that suited them. At one village, for instance, a rebel returning from the siege of Kumamoto told his neighbors that if Saigo came no one would have to pay taxes. A few days later, the threat of violence forced local officials to flee. Samurai groups from all over Kyūshū marched across the country to join their hero, hoping that the new regime in Tokyo might fall. Someone in some newspaper office devised a slogan, "A New Government, Rich in Virtue," and soon newspapers everywhere had attached the slogan to Saigo, even claiming that it was on his battle flags. Though never coordinated into a revolutionary force, these outbursts of unrest and expressions of discontent were enough to make Tokyo very nervous.

The spirit of Saigo and his troops comes through clearly in a letter sent by the rebel force to a member of the imperial government, Kawamura Sumiyoshi, vice-minister for the navy, who had asked them to surrender, saying: "It can never be justifiable for a subject to take up arms against his ruler." On the contrary, came the reply, you are wrong, we are right; you are illegal, we are legal; we are sane and you are crazy. It is a letter that shows exactly why the rebels felt so self-righteous, and why they could never, ever surrender:

Saigo Takamori, when residing in Kagoshima, held the rank of general-in-chief of the army. He is thus a high officer of the throne. But Okubo, Kawaji, and others, in direct violation of the laws of the nation, attempted or caused to be attempted his assassination. This is the entire cause of the present civil war. Yet the government takes no notice of those who thus violated its laws . . . Under such circumstances, it is useless to look for any tranquillity in the empire. These were the causes that induced Saigo Takamori to set out from Kagoshima to obtain redress from the government, but . . . he was opposed by the Imperial troops, his rank and titles were taken from him. This was not done by the consent of the Emperor, but by those who wished to conceal their own crimes and deceive the Mikado. We are therefore much angered, and have determined to destroy these corrupt officials, and to disperse the infernal clouds which surround the Emperor and the Imperial throne . . . You say you will petition the government to extend its clemency toward us if we will surrender. This is ridiculous. We are fighting for justice, and in a just cause we care not what our fate may prove. Your Excellency further says that we may recover our honour. This we cannot understand. Surely the cause of justice is honourable. How then have we lost our honour? So greatly do we differ from the views expressed by your Excellency that we think your Excellency must be out of your mind, or speaking under the influence of nightmare . . . You had better come to Kumamoto and ask our pardon.[2]

[2] This letter is quoted in full in Mounsey, *The Satsuma Rebellion*, without a source.

In the castle, with no attacks expected or planned, bore-
dom would have set in had not some conscripts decided to
put on a show. There were, after all, nearly four thousand of
them, and it didn't take long to discover a few who were will-
ing to act. Someone managed to get hold of a *shamisen*, the
long-necked guitarlike instrument with three strings. Someone
else was voted in as master of ceremonies and fitted out in
an old-time costume made of paper. Every evening, they put
on a show. The MC's appearance would bring a storm of ap-
plause and cheerful teasing—"Master of ceremonies! Do a
good job! Let's hear it!"—which he would cut through with
a cry: "Hear ye! Hear ye!" Then "Ladies and gentlemen!" he
would begin, to more laughter, given the lack of ladies: "I have
the pleasure to announce—" and there would follow the name
of some ballad or well-known drama, and with a roll of drums
the evening's entertainment would begin. (Outside, beyond the
walls and the floodwaters, rebel forces heard, and wondered,
and became depressed. The sound of a *shamisen*, and singing,
and laughter—it could only mean that somehow the imperial
forces had managed to smuggle geishas into the castle.)

When the siege started, the officers had calculated that pro-
visions would last for nineteen days. Those nineteen days, and
more, had now gone, and inside the castle they were surviving
on millet, boiled or turned into gruel—and the occasional
horse. Takehiko again:

> This is a vulgar story, but the gruel was a greenish-blue
> which looked just like nightingale droppings and was thus
> rather amusing. And for the sick, we butchered the flesh of
> horses killed by enemy rifle and artillery fire, made soup
> from the bones and made them drink it . . . Whenever a
> horse was felled by enemy fire, someone would holler, "Hey!

Today we got a trophy! Divide it up and bring me some!"
From each unit, men came to the scene, a staff officer wit-
nessed the proceedings, and there was a great commotion as
the horse was butchered.

Now it was April. Tabaruzaka was taken, and imperial
forces on their way to relieve the castle. Another two brigades
had landed forty kilometers to the south, and were moving
north, taking town after town: Miyanohara, Ogawa, Matsu-
bashi, Uto, Kawashiri—all minor centers of samurai resistance.
Of all this, the defenders knew nothing. Despite "chewing dirt
and eating pebbles," no one considered surrender; all accepted
the need to fight to the death if necessary. Every day that
passed disproved the samurai belief that only samurai knew
how to fight. Sometimes the sound of gunfire could be heard
at a distance—surely, the conscripts told each other, a sign that
rescue was near.

Impending starvation inspired a high-risk strategy, possibly
suicidal—"to break through the encirclement, to sink or swim,
to live or die." There seemed no choice. The men who took the
risk might die; but if they stayed, they might die anyway—of
starvation—and the meager rations they consumed wouldn't
be available to keep others alive.

The breakout squad was to make its bid just before dawn
on April 8. The night before there was an emotional meeting
with the chosen men, who were given some precious rice, a few
greens from the castle's vegetable plot and some horse meat,
three horses being killed and butchered for the occasion. Then,
at 4:00 A.M., an advance party of police slipped out through
the main castle gate, followed by the main force, a few dozen
in strength. The idea was to ford the flooded Shira River, seize
a bridge, head southeast for three kilometers and make a base

in a temple (the Suizen, now a park, with a fine carp pond and popular teahouse), where they were to light a beacon fire to signal success.

As they approached the bridge, they saw it was guarded by rebels huddled around a campfire and decided on a bold approach, assuming that the rebels would think they were some of their own. So a few called out from the darkness, asking if all was quiet. Sure is, came the reply, nothing happening around here. Back down the line went the whispered message: Now is the time! The enemy is unprepared! So the attack that followed, just as dawn was breaking, worked perfectly: not a shot fired, several rebels killed, the bridge taken, the temple occupied.

In the castle, officers and conscripts watched in suspense as night turned to a misty dawn, wondering if the whole venture had ended in death and failure. "To our minds, one day seemed like a thousand autumns. While we were concentrating—staring—in the direction of that area, a single column of smoke arose through a gap that opened in the morning mist. Seeing this, the castle was in an uproar. 'They've done it! The army is safe!' Our men went mad with joy."

Not far beyond, 10 kilometers to the south, the party from the castle linked up with their rescuers. And relief came, from a village which had been a base for local rebel troops—746 bags of rice, 100 small arms and 3,000 rounds of ammunition, carried by horses and men back into the city through rebel forces, which briefly resealed the gap. By now, imperial troops were approaching from the south, finally breaking through at dusk on April 14, when the commander of the first imperial troop "came up to the dismount bridge, and cried loudly, 'We've come! We're here! We've driven all those fellows out!' . . . Now the Will of Heaven unfolded in our favor and

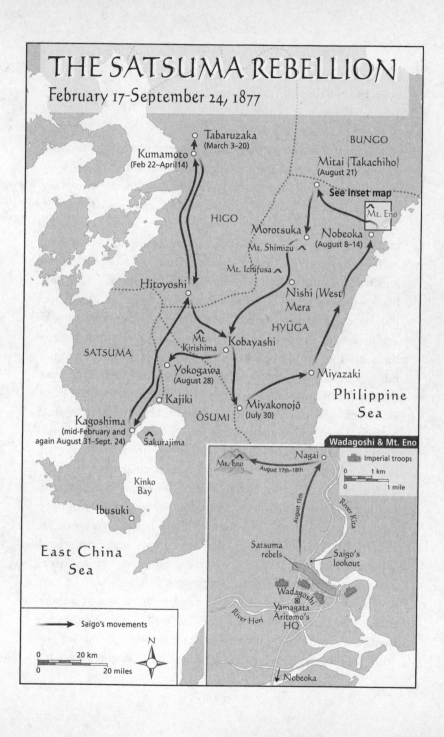

THE SATSUMA REBELLION

February 17–September 24, 1877

Tabaruzaka
(March 3–20)

Kumamoto
(Feb 22–April 14)

BUNGO

Mitai (Takachiho)
(August 21)

See inset map

Mt. Eno

HIGO

Morotsuka

Nobeoka
(August 8–14)

Mt. Shimizu

Mt. Ichifusa

Hitoyoshi

Nishi (West)
Mera

HYŪGA

SATSUMA

Mt.
Kirishima

Kobayashi

Yokogawa
(August 28)

Miyazaki

Kajiki

ŌSUMI

Miyakonojō
(July 30)

Philippine
Sea

Kagoshima
(mid-February and
again August 31–Sept. 24)

Sakurajima

Wadagoshi & Mt. Eno

Nagai

Imperial troops

Mt. Eno

August 17th–18th

0 1 km

0 1 mile

River Kita

August 15th

Satsuma
rebels

Saigo's
lookout

Kinko
Bay

Ibusuki

East China
Sea

Wadagoshi

Yamagata
Aritomo's
HQ

River Hori

Nobeoka

Saigo's movements

N

0 20 km

0 20 miles

once again we could see the light of day"—after 54 days under
siege and the death of 186 defenders—which, compared with
Tabaruzaka, is hardly a death toll at all.

Tabaruzaka was the turning point. As the surviving Satsuma
troops began to trail back to rejoin Saigo, who had been di-
recting the assault from a hill overlooking the castle, certain
truths had been revealed. It had been a close-run thing for
Meiji, because almost the entire peacetime force of 31,000,
plus 15,000 reserves, plus several thousand armed police,
militia, marines and cadets—some 65,000 in all, well armed
and well supplied—had been committed to the fray, a num-
ber vastly in excess of Saigo's ragtag, underfed, underarmed
but extremely spirited forces. The imperial army was still an
undertrained, ill-coordinated, small-scale force compared to
the army that would build Japan's empire in decades to come,
but it was massive superiority, not some new spirit, that won
the day. Until now, almost everyone had accepted that samurai
alone could be soldiers, that no others had the right or ability
to bear arms, which should, of course, be swords. Moreover,
samurai tradition held that all fighting was local, in defense of
one's lord and one's domain. Now it was clear that ordinary
men could fight, and that they would do so for a new entity,
the nation. Imperial forces, from the top down to ordinary
conscripts, took heart. The oligarchs who had seized power in
the emperor's name—among them, of course, Saigo's ex-friend
Ōkubo—could wield that power nationally, and no local force,
certainly no traditional force, could stand in their way.

The sad truth was that the Way of the Warrior was a thing
of the past, and had been for the last nine years. All that re-
mained was for the warrior—in this case Saigo—to see the
truth, and surrender. But he could not, would not do so, for

that would betray the trust of his followers and deny his life's essence, his identity, his ideals. He was not, he said, fighting for victory, but for the "chance to die for principle." This was not a vision with much appeal; but his example was enough.

There would be no surrender, only a slow retreat in the face of overwhelming odds, until no further retreat was possible.

16

RETREAT

IT IS EXTREMELY HARD TO FORCE SURRENDER UPON AN ENEMY who (a) is an excellent leader; (b) has an impregnable belief in his own rectitude; and (c) is prepared to die for his cause. That was the case with Saigo, and it was infectious. After two major defeats, he showed no flickers of self-criticism, or regret, or defeatism. Instead, he masterminded a slow seventy-kilometer retreat, regrouping, fighting off assaults, and finally, after a week, reestablishing a base at Hitoyoshi, about halfway back the way he had come. He knew the place well, because it was from here that he had taken a boat down the Kuma River on his way north in the snows of February.

By now it was early summer, and the surrounding steep hills were lush with new growth. For three weeks, until mid-May, he stayed there, hoping for more help from other disaffected areas, while his army blocked the river valley with a series of stockades. No help came. Imperial troops took the stockades

one by one. It was time to retreat again. Some of the rebels were beginning to fret about their food and cash. A few of Saigo's men, now well down from the original twelve thousand, opted to make for home, and some three hundred others chose to surrender to take advantage of an offer of amnesty. The rest, following Saigo's still confident lead, trailed south, along winding mountain roads, with the imperial troops in pursuit.

They might have headed back to Kagoshima, but that was now in imperial hands, as they soon discovered. A squadron of imperial ships had arrived at the end of April, with seven thousand troops and eight field guns. The place was, of course, entirely undefended, and in terrible shape. The rich had fled, the poor had looted stores and houses. It took just a couple of weeks for the new arrivals to surround Kagoshima with gun batteries, stockades and rifle pits. By the time the bulk of Saigo's army approached at the end of May, it was too late to reclaim the city. Intense attacks over the next few weeks killed twenty-two imperial troops and wounded two hundred, but made no lasting impact, and the rebels withdrew into the hills of central Kyūshū. Pro-government newspapers in Tokyo hopefully claimed that the rebels would soon fall before the superior power of the government armies.

Some hope. There was still no thought of surrender. Far from it: this was ideal country for guerrilla warfare, thanks to the one-hundred-meter layer of ash dumped by Sakurajima and twenty-two thousand years of rain. As you can see today if you take the train to the east coast of Kyūshū, it is all steep green hills and twisting little valleys, with the occasional gray scar where an earth slide has exposed the underlying soil. This, the Yakushima National Forest, is as wrinkled as a duvet after a restless night. Streams wander the valley floor, smoothing out

A "banknote"—actually an IOU backed by nothing more than wishful thinking—printed by Saigo when he was retreating cross-country in the summer of 1877.

the rich soil, making space for farmhouses and paddy fields beneath the towering forests of cedars and bamboo. Geography often makes history, and it certainly did here, in the summer of 1877, because there was no way that imperial troops from far away, faint in the muggy heat, with baggage trains and cannons and heavy uniforms and leather boots that gave them blisters, could catch locals in rope sandals with friends everywhere. The rebels did whatever they could. They planted pointed bamboos along trails and in front of their positions. They rolled barrels of gunpowder on to enemy positions. On one occasion, they staged a successful ambush by placing a man in the barrel and rolling it downhill toward an imperial outpost; when the man stepped out, the unsuspecting imperial troops rushed forward, swords drawn, only to be mown down by fire from above.

On the other hand, the rebels could not win, and their cash was gone, and friends were harder to find as time went on, because all they had now were promissory notes with Saigo's name printed on them. That was all well and good while Saigo looked like he was winning. But when erstwhile supporters started raising eyebrows at these worthless bits of paper, the rebel guerrillas had to do what special forces often do: steal provisions from those who could ill afford to lose them, even snatching metal tools to melt down into bullets. In late July an imperial assault overran the latest rebel base, Myakonojō, and that was the end of the brief guerrilla war in the mountains. Saigo led his rebels eastward.

The hills give way to a wide open plain, and then, fifteen kilometers farther on, a flat coastline with gray volcanic sand and the town of Miyazaki, where Saigo now based himself, hoping for reinforcements from disaffected samurai from the north. He even had some of his promissory notes printed here,

so there was still hope. But no help came. The imperial troops, strengthened by another ten thousand new arrivals, gathered for yet another assault, which would surely be the last. Once again, Tokyo's papers predicted an imminent rebel collapse, imminent government victory.

No, not yet. The rebels, now down to 3,500 and outnumbered many times over, backed away up the coast along a corridor between sea and hills, taking and then surrendering every town along the way—Sadawara, Takanabe, Hososhima, Nobeoka. Out in the open, they had few weapons to fight with, and didn't know what to do with those they had. Expecting an attack from the sea, they mounted brass cannons at two harbor mouths, Hososhima and Nobeoka. They even tried making wooden cannons—hollow pieces of wood bound with bamboo hoops—but if these amateurish devices fired at all they either had a very short range or burst apart.

Just north of Nobeoka, however, the landscape gave them a chance to confront their tormentors. You cross a river, the Hori, and ahead is a nose of flat land beyond which, only two kilometers away, is another river, the Kita. But even if you were up high you couldn't see that far, because there are hills in the way, blocking Saigo's escape route northward. The hills gave the rebels a slim chance of slowing down their pursuers, allowing yet another escape, yet another chance for Saigo's loyal remnants to scatter and wage guerrilla war and perhaps link up with whatever dissident forces waited for them in the neighboring domain. So now you can drive up a winding road onto a forested ridge thirty meters or so above the surrounding countryside, where the trees are broken by a little monument. The spot is called Wadagoshi, which is also the name of the battle that took place below. This was where Saigo and his number two, Kirino, stood to look over the plain and watch

events unfold. The odds were frightening—3,500 against 50,000; at least, that's what it says on the plaque, though other sources speak of 35,000 or 40,000 on the imperial side. On a mound just under two kilometers to the southwest—which on Google Earth stands out as a clear patch of green among suburban roads—was Saigo's nemesis, General Yamagata.

It was obvious as soon as the sun rose on August 15 that the rebels didn't have a hope. The imperial troops, armed with cannons and breechloaders, were crowding in on both sides along the ridge on which Saigo's men stood, and down on the plain. The rebels held just this little saddle of rising ground, an easy target for the imperial guns, which opened up soon after sunrise and fired for several hours. All the rebels could do in response was pick off the occasional target with their flintlocks, shooting some two hundred imperial troops for the loss of one hundred of their own (if the plaque at the site is to be believed).

My guide put a generous speech into Saigo's mouth, acknowledging the martial spirit of his enemies. Turning to Kirino, he said: "You told me those peasants [meaning the imperial troops] can't do anything. But my private school men are in difficulty fighting against them. That means that Japan will be all right in their hands. If that is the case, I can die in peace."

At 2:00 P.M. Saigo ordered that Wadagoshi, too, be abandoned. Many of the troops surrendered; many were captured; and a hard core retreated upriver, seeking refuge in the hills and ravines that tumbled almost to the riverside.

By chance, on the evening of this day, August 15, 1877, an American steamship captain named John Hubbard, who worked for the Mitsubishi Steamship Company, arrived in Nobeoka. In one of his letters to his wife back in Yokohama,

he described what he saw.[1] For two days, he was kept aboard by incessant firing. "From our steamer we could see the smoke of both sides, and trace the lines among the hills and valleys as the rebels fell back and the Imperialists advanced." Then on the nineteenth, he went inland, traveling with colleagues by rowboat up the Kita River.

As soon as we entered the river we saw boats coming with rebel prisoners who were being put on a small island in the river. As we passed close to many of these boats we saw what a hard looking lot they were and plainly showed the fatigue they had undergone during the last six months, while being hunted from place to place. We learned that in the last two days' fight 5,200 prisoners had been taken [a vast exaggeration: Saigo had only 3,500 fighting for him]. But Saigo and Kirino, with the other leaders and about 5,000 samurai had broken out of the magic circle, as they have done so often before.

After pulling up the river for two miles, we landed [on the east bank] and walked across the country, constantly meeting Imperial soldiers and rebel prisoners, and wounded of both sides. We reached the village after a three-mile walk and found every house occupied by soldiers. In one we were shown a large quantity of arms that had been captured the day before. There were old Springfield muskets, Spencer and Remington rifles, but among the most numerous of the fire-arms were the old-fashioned match-locks. The swords were in a pile at least ten feet from the ground and were all sizes and lengths, and appeared to have had some very

[1] Extracts were published by Hubbard's granddaughter, Elizabeth Nock, in 1948.

rough usage. Going through the village we came to a river with quite a strong current. Here was a pontoon bridge of boats . . . quite strongly built, and that day a constant stream of soldiers was crossing in both directions, amongst them many wounded. We saw numbers of dead bodies floating away at sea, all of which seemed to be rebels. Soldiers were stationed on the bridge to prevent the bodies getting foul of the boats and bridge. While crossing [to the west bank] we counted nine dead rebels. Another two-mile walk brought us to the battleground [of 15–17 August], but the only indications of the recent fight were the marks of bullets on the trees here and there; the fields were ploughed up by large balls and a few houses burned to the ground.

Hubbard and his party then stopped for a picnic, and took a walk where charming views made up for the distasteful scenes they had just witnessed. Having made their way back to the pontoon bridge, they hired a boat, sailed back downriver to find their own vessel, and rowed across to the island where the prisoners were being kept.

We found them a sorry looking lot, mostly lying under the trees, listless and black with dirt. Their clothes were of all sorts, sizes, and descriptions. Hats seemed to be the main uniform; of the greatest variety and the worst looking that one could imagine; there were even black and white felts of all shapes. Before we were finished our inspection my attention was called to two fellows in black frock coats, no pants, but tall black top hats. None of the prisoners were tied and all were very lightly guarded—we thought about one soldier to fifty men. The poor fellows looked too used up to ever attempt to escape.

The letter was dated August 22, and all had been quiet for the last three days. Obviously, the imperial troops were off into the mountains, hunting the rebels, "but I fancy it will take some time to find them, and they will probably turn up in some place where they are not expected." He was right. But no one could possibly have guessed that by the time Hubbard had finished his letter, Saigo had already slipped clear yet again in perhaps the most audacious escapade of this doomed campaign.

Saigo had known how weak his position was at Wadagoshi; so, even before the battle, he had made arrangements for a further retreat, to a ravine four kilometers to the north where there was a village named Nagai. To the east was the river, fast flowing, with neither bridges nor boats. To the west were the forested flanks of a precipitous ridge and a peak, Mount Eno. Here an advance guard somehow persuaded the villagers to make a house and rooms available for senior officers, set up a hospital and bring in food. On the evening of the fifteenth, Saigo, Kirino and perhaps two thousand of the surviving rebels arrived. The imperial troops began to close in on them again. Anyone but Saigo would have said this really was the end.

What happened next is not in many books, but it is well known in these parts because there is, as usual with sites connected with Saigo, a museum. A signpost in a familiar shape—big eyes, kimono, dog—points you off the main road, under a bridge to a courtyard, a ticket office and three neat single-story houses with wooden walls and gray-tiled roofs. This is the Saigo Takamori Lodging Place Museum, looked after by its resident keeper. Kodama Gosei is in his fifties, with a suntanned face—because he's out a lot in his immaculate

garden—and mournful eyes. He reminded me of a Labrador I knew once, friendly, appealing and eager to reveal what would have remained hidden.

"So when they came Saigo found lodging at this house, the main one by the courtyard. Kirino stayed over *there*, with everyone else scattered through the village, under trees, resting wherever they could. There was no space for even an ant to penetrate."

It was clear to Saigo that there was no chance of winning, either in a pitched battle or by guerrilla warfare. The following afternoon, as enemy forces crept into position for the final showdown, he made a symbolic gesture, bringing his general's uniform into the yard—yes, right there, said Mr. Kodama, just between the ticket office and his house—and burning it, along with some documents, as if admitting finally that he could no longer play the loyalist. There would be no reconciliation. His army was beaten, and it was time for a choice.

This was not just his decision. There was a council of war, which has been re-created in a life-size tableau in the very room where the council met. You slide open the screen door and join the meeting—Saigo, kimono open to the top of his enormous belly, kneeling in front of the Satsuma logo and his old slogan "Revere Heaven, Love Mankind"; Kirino standing to summarize the dire position; and five others kneeling around the low table. One of them is Saigo's aide Beppu Shinsuke, whom he had perhaps already asked to act as his right-hand man when the time came for seppuku. All are dressed as samurai, of course. It is a timeless scene. There is nothing to say this is 1877 as opposed to 1600.

So, said Mr. Kodama, a decision was made, and Saigo addressed a public meeting.

"The only choice is death in some form. There are three ways to die: the first is to commit seppuku; the second is to die in battle; the third is to surrender and die in prison."

To which one senior officer, speaking for the majority who were samurai from other domains, not from Satsuma, replied that death by seppuku or on the field of battle would be to choose between two kinds of death, and both of them anonymous. The purpose of seppuku or battlefield death was to save honor, but that could only be achieved if the death was verified. In the present case, this would be impossible: families, in particular, would never know how their sons or husbands had died. Perhaps not even the names would be recorded. There would be no dishonor, but there would be no honor either. Better to surrender and save hundreds of useless deaths. Most accepted this reasoning, and decided that they could surrender.

That left a hard core of some six hundred private school students from Kagoshima, whose loyalty to Saigo was rock solid. If Saigo was going to go out in a blaze of glory, so were they. To those who wished to fight on, he had just the sort of message they wanted to hear. "This is no place to die," he said (supposedly, for there is much folklore in the accounts). There was, perhaps, a way out. Not along the river northward, or back southward, or into the surrounding hills, but taking the one route that looked impossible, that no one in their right mind would choose, that Yamagata and his officers would never, in their wildest nightmares, think of—straight up the slope behind the village, over the top of Mount Eno.

It was not that Mount Eno was inaccessible. It is only 727 meters high, a two-hour climb for a fit young soldier—or a fit priest, for, as Mr. Kodama said, it was a sacred mountain. "No women were allowed up there. Buddhist priests of the

Shugendo sect used to tie their feet together and hang upside down up there." (That's what he said, and it may be true. Shugendo was an ancient form of esoteric Buddhism which tested adherents' courage and devotion with rigorous rituals.) "There's a path all the way up."

That meant that what the imperial troops were doing on Mount Eno was no secret to the locals. Approaching along trails from the other side, they had dug themselves in just below the crest of the ridge. Saigo was proposing a surprise attack, which had to be made on the eighteenth, to pre-empt the imperial attack due on the nineteenth. If successful, there would then be an escape over the mountains with the aim of heading back to Kagoshima, where they would either—with élan and a great deal of luck—regain control of the city, or (far more likely) die in the attempt. How exactly they were to do this was an open question. After the breakthrough, they would regroup thirty or so kilometers farther westward, at the town of Takachiho, and there decide on a plan of action.

Surprising the imperial forces meant attacking while they were still asleep. So, late on August 17, about 10:00 P.M., according to Mr. Kodama, Saigo's troops were ready. These were interesting times, to say the least, and some of those looking death in the face took care to record their thoughts in diaries, some of which they left behind with other possessions that were later found and placed in the museum. Mr. Kodama retrieved from a showcase four diaries written with brushes on rice paper. There had been five, but he had loaned one to someone and never got it back. No, he replied to my eager question, there was nothing personal here. It was all quite bland: "12,050 bullets shot," wrote Sergeant Kirota Minesuke, thereby ensuring that his name would receive at least some sort of recognition. "This morning the soldiers advanced . . . rain,

again." Saigo left a few things behind, each a symbol of some aspect of his life—a bugle made in London (was he thinking of adopting British army traditions?), a camping pillow so tiny it looks like a sausage, a compass, one of those promissory notes printed in Miyazaki, a brush and ink tray—indeed, he was writing even now, as suggested by a poem discovered while I was researching this book.

It was, of course, in Chinese, four lines, seven characters per line, and it was found in the papers of a doctor named Taisuke Yamazaki, who apparently copied it when attending Saigo in his final hours in Kagoshima. If it is Saigo's (and this was much disputed), it could well have been composed in some quiet moment in Nagai, as he wondered whether he had always done right, decided he hadn't, and accepted his coming death—with trepidation:

All the roads to Higo and Bungo[2] are blocked.
Let's return home to our grave. I unwillingly backed [the restoration], for nothing.
Now when I look back on my life, I see merits and demerits.
How can I face my lord [Nariakira] in the Underworld?

It was about 10:00 P.M. on August 17 (not that anyone had a watch or a clock), with no light at all under the trees. None of the rebel students came from the area, so a local woodcutter had been persuaded to act as a guide. Leaving about one hundred injured behind, the five hundred of them, walking silently in their rope sandals, set off up the narrow path in single file, banned from smoking and talking, following little swatches of

[2] Higo was the old name for Kumamoto prefecture, and Bungo was Oita, the prefecture to the north, from which he was expecting help.

cloth tied to trees by those in front. Some sources claim that Saigo had to be carried in a litter because he was too ill to walk (on which more later), but more likely he, too, was walking this narrow, slow climb. A line of five hundred men, some perhaps with matchlocks, but everyone with a sword or two, would have stretched out for almost a kilometer. It would have taken something like four hours for the leaders to get near the imperial troops sleeping in their hastily dug trenches, and surely much longer for all five hundred to settle within striking distance.

Shortly before dawn, when the eastern sky was beginning to glow and the imperial troops were still asleep, the rebels attacked. A painting in the museum shows the scene: the rebels in cotton jackets, pantaloons and sandals wielding swords against rifle-bearing imperial troops in their uniforms. A cannon lies on its side in an emplacement, ready to be set up for the bombardment planned for later that day. It was a perfect breakout—the imperial contingent quickly killed and scattered, the rebels streaming over and around the top of Mount Eno.

17

THE LONG ROAD TO DEATH

THE BACK COUNTRY OF KYŪSHŪ IN SUMMER IS HOT, GREEN and wrinkly. The slab of territory across which Saigo's rebels now started is basically 2,600 square kilometers with hardly any flat land to speak of. There are some 50 mountains of over 1,000 meters, not high, but each with its foothills and ranges and valleys, where rivers rush between steep forests down to the coastal lowlands. The rebels did not know this, because there was yet no master plan, but they had 75 or so kilometers as the crow flies to cross before they were out of the higher hills and into lower ones. But they were not flying. Twists and turns doubled the distance, ups and downs tripled it. Where did they go exactly? Some of the places were recorded, but as for the back ways, no one knows now, because when today's roads were cut and paved no one used the back ways any more, and mushroom pickers and charcoal burners

were not enough to keep them clear. It was hot, very hot. And then there were the wasps and the adders. All these inconveniences were recorded by the British writer Alan Booth, who climbed Mount Eno in 1986. And the flies: "They fed in my armpits, swam in my sweat, flew into my mouth and died in my hair."

An anecdote about Saigo on this epic retreat was told to one of his biographers—this must have been in about 1950—by an old peasant named Kawakami Takeshi, who as a little boy was walking with a man named Maki when they saw Saigo coming toward them, wearing a sword and a cap:

Maki stopped me suddenly and said, "Wait a minute, boy."

"What is the matter?" I asked, turning back.

"You must get out of the way, for the Master is coming along."

We two got out of the way to the left hand side. Saigo the Great was walking along quietly, with a cap on [from one of the private schools], and wearing a sword at his side. He seemed as if he were hunting at ease over a peaceful field, forgetting the presence of the enemy. When I thought that this accounted for the stately mien and magnanimity of the greatest hero the world had ever seen, I could not help revering him.

"How great a man the Master is!"

"Yes, he is a god."

Then Saigo drew level, they bowed, and Saigo acknowledged their bows. That was the core of Kawakami's memory. A man who was a samurai, a former top general and minister, who should have been weighed down by defeat and impending

death, acknowledged the bows of two peasants. For the boy, it was a wonder beyond imagining.[1]

Later, the two saw Saigo again, this time in a different mood:

> I have never forgotten the image of Saigo the Great then. He was squatting with his elbows on his knees, the hilt of his sword thrust forward, his left shoulder a little higher than his right, his lips tightly pursed, his eyes glaring fiercely at the men who were following him down the track. The terrible glare must have been a reproof for their tardiness. A wild animal crouching to spring on its prey could not have looked more ferocious.

A small digression on Saigo's health, which was by some accounts poor. In these two memories, he was both walking and squatting, which is not something a sick person does easily. True, there had been bouts of ill health, but no hint of anything debilitating or life threatening. Yet other accounts speak of him being carried in a "palanquin," presumably nothing more than a wooden litter or stretcher. Another anecdote in the same biography describes how, nervous about crossing a shaky rope-and-wood bridge over a river in his palanquin, he climbed off it, took off his overcoat and crawled across. Many pathological conditions have been claimed for Saigo, including filariasis (a mosquito-borne disease, possibly picked up in Amami Ōshima or Okinoerabu, that swells remote bits of the body), a hernia or a fever; but there's no evidence to confirm that he had any of them.

[1] The quote is from Morris, *The Nobility of Failure*. The tale is retold by Alan Booth in *Looking for the Lost*. Both took it from Saigo's biographer, the dramatist, novelist and poet Mushakoji (or Mushanokoji) Saneatsu (1885–1976).

The best indication of what was wrong was the official autopsy after his death, which reported "dropsy of the scrotum." In other words, he was suffering from an excess of fluid in the hydrocele, the sac that surrounds each testicle; it was this that caused the swelling. Sometimes, the excess is the result of disease, which does not seem to be the case with Saigo. It is usually painless, but may cause discomfort, especially if a lot of walking is involved. Hence, we must assume, the litter. In the village of Akadani, an old man told Alan Booth:

> My grandfather's brother [Sakada Bunkichi] would have been sixteen or seventeen at the time, and some of Saigo's men stopped at the house [in the nearby hamlet of Miyanohara] and asked him if he would help carry the palanquin. Saigo's testicles were swollen something terrible and he couldn't walk. He was sitting waiting in the grounds of the temple. My grandfather's brother helped carry him as far as the next temple at Sakamoto, another four kilometers down the road, where he was planning to spend the night. Saigo wanted to pay him for his trouble, but he had no money, so instead gave him a pouch made of rabbit-skin that he used for carrying his tobacco. It was in such a filthy state after all the months of fighting and scrambling up and down mountains that my grandfather's brother threw it away.

That was a bit farther on. We left the rebels moving west, into the mountains, along back roads and trails. They were not just trying to travel in secret. They had to head for their rendezvous, Takachiho, because this ancient and much revered little town had bridges over the rushing headwaters of the Gokase River. Of course, Yamagata knew that, too, and had sent a force—well fed, well armed and with no need to remain hidden—upriver to cut them off. It was important to get

there in time, before Saigo did something dramatic: not that there was evidence that he would, but he could. Takachiho, then known as Mitai, is one of two places that claim to be where the grandchild of the sun goddess landed, bringing from heaven the imperial regalia—mirror, sword, jewels—that have been the emperor's symbols of power since time immemorial (coincidentally, Saigo would be passing the other Takachiho later in his grand tour of Kyūshū). The sun goddess herself disappeared into a nearby cave, plunging the world into darkness until another goddess lured her out with a lewd and comic dance, inspiring traditional dances that are today one of the town's main tourist attractions—if you can get there, which even today is quite a challenge. Once, the place had over five hundred shrines, and it still has a dozen temples. What Saigo might do to make some political gain out of all this sacredness and symbolism was anyone's guess. It would certainly be a dramatic place to stage a final shoot-out. Yamagata's orders were simply to break him, kill him, capture him—anything to stop him in his tracks, and it was for this reason that he had taken troops away from Kagoshima and was now pursuing Saigo in such overwhelming numbers, with contingents dropped off from ships at three coastal towns ready to march across the country and cut him off.

It took both forces three days to reach Takachiho. They met on August 21, just outside the town. The rebels could not hope for victory, but fell back along a 7-kilometer gorge of sheer gray cliffs carved by the Gokase River through lava.[2] There

[2] The lava came not from Sakurajima but from another far more massive volcano, Mount Aso, thirty kilometers to the north. Aso, the largest volcano in Japan, is one of the largest in the world. An eruption some three hundred thousand years ago created a caldera up to twenty-five kilometers across, even bigger than Sakurajima.

was nothing to do now but go on running, back home to Ka-goshima, and there find death in whatever glory might still be possible. In the village they found time to seize 7,280 yen in cash and 2,500 bales of rice—which sounds far too much for 300 men (or was it 500? Sources vary, but see my note on page 269) to carry into the mountains—before heading off south-west, following a river valley, back east to the spaghetti loops winding up and over the Iiboshi Pass, then at last southward, where the road winds back on itself as it descends ridges to the river. Sakamoto, Morotsuka, around the flanks of Mount Shimizu, over another pass, down the Matae-no-haru River . . .

"The Satsuma men came down from the pass through Matae-no-haru, along the same road you took today," a seventy-year-old named Tsushida told Alan Booth. "Whenever they passed a house or a hut, the people who lived there came out and gave them shōchū [a local alcoholic drink] and pickled plums and anything else they could spare . . . But when the government troops came through later in the evening, they turned their backs on them and ignored them. Partly it was because they admired Saigo so much, and partly because they felt sorry for his followers, who were just boys.

"By the time Saigo and his men reached [the village of] Mikado," Tsushida went on, "they had started to come under sniper fire from the advance parties who had raced across the pass and spread out along the route, so they took cover among the buildings that are scattered through this valley. At the house on the right, from about four o'clock till about eight o'clock on the evening of the 24th, Saigo himself rested and had something to eat. That's puzzled the members of our local historical society for years, you know. One minute Saigo's under rifle fire, and the next he's sitting having a snack . . . It's just possible that a temporary truce was arranged, for even

Saigo's enemies had the greatest admiration for him. Three Satsuma men died in the skirmish. You can see their graves here in the village."

That evening, there occurred an incident that highlights the strange nature of this war, and of Saigo himself. As the imperial troops advanced, Saigo's men took to the surrounding woods. At dusk most of the village houses were requisitioned by imperial officers to sleep in. When darkness fell the rebels emerged to rejoin Saigo, and discovered as they passed a temple that an imperial medical officer was billeted there without sentries. So they seized him, dragged him to Saigo, and asked if they should behead him. They were, of course, only kids, teenagers or in their early twenties: hotheaded, unthinking, eager to prove their spirit, even in these appalling circumstances. Saigo reproached them gently, sent them off, and invited the medical officer to sit down and share some *shōchū*. Wars, he observed, were hard on all; he wished the officer well; hoped he would soon be home safe with his family; and sent him off back to his temple billet.

At one o'clock in the morning, in rain, Saigo and his band were off again. Down to Shiromi, cross-country, over pass after pass, westward to Mera, Murato, Suki—tiny places that don't exist on any map that I have found. Anyway, at this point the sources become vague about Saigo's route. Was it due south over the switchback Omata Pass, or over the ridges farther west, across the prefectural border into Kumamoto? It hardly matters. It was August 27, Saigo had been fleeing for nine days, and the worst of the mountain crossing was over. On the twenty-eighth he reached Kobayashi, a proper town at last, just in time to scare off a tired contingent of imperial troops advancing from the coast a day's march away. As if this were a major victory, he was joined by some three hundred

more troops—rejoined, actually, because they were some of those who had thinned Saigo's ranks by returning home while he was fleeing this way after the siege of Kumamoto a few months earlier; or so one otherwise reliable source claims.[3] Kagoshima was sixty fast kilometers ahead, and spirits had revived yet again.

Ever since Tabaruzaka five months before, Saigo had been staging hairsbreadth escapes or been one step ahead of Yamagata. Now, in this final push, speed was as essential as ever. The same imperial troops they had just scared off were heading back to Kagoshima to reinforce its poor defenses, skirting the great volcanic wilderness of Kirishima—twenty-three mountains, ten crater lakes, numerous hot springs, and the other Takachiho, which (with somewhat better credentials) also claims to be the mountain where the sun goddess's grandson descended to earth with the imperial regalia. Now tourists crowd into these two hundred square kilometers, because they form Japan's oldest and perhaps most glorious national park. For Saigo, it would have been a death trap. So he and his little band also skirted it to the north, and then swung south, through Yoshimitsu and Yokogawa, where the highway now runs up past the airport. He might then have rejoined the coast road, the one he had taken many times through Kajiki, the one that leads past the spot where he "recovered" after failing to

[3] The source is a photocopy of a map of Saigo's flight from Mount Eno to Kobayashi. I have no idea when or by whom it was originally published, but the copy was made for me by Tsuyoshi Takayanagi, head of the memorial museum by the Nanshu Cemetery and a Saigo expert. Its information about dates and places is accurate, so I tend to trust this snippet. It makes sense of many disparities in the numbers at the beginning and end of the flight through Kyūshū: five hundred fleeing from Mount Eno, plus three hundred who rejoined, which declined to the six hundred arriving on Shiroyama.

drown himself; but the coast was dangerous, because it was within range of Yamagata's warships, which either had already arrived or would do so shortly.

So he and his ragtag army, now settled at about six hundred, the toughest of the tough, used to living off the land, eager to die well, arrived just outside Kagoshima on the last day of August. The next day Saigo walked—or was carried, who knows which—along the ridge-top road above Kajiki, ten kilometers inland, to the village of Kamo, where he spent that night safe from Yamagata's shells.

18

SAIGO'S LAST STAND

THE NEXT DAY, AVOIDING THE SCRAPPY IMPERIAL DEFENSES, Saigo joined his followers heading for the steep and forested knoll of Shiroyama—Fortress Hill—which dominates Kagoshima. Some attacked imperial troops who had occupied one of the private schools at the bottom of the hill and managed to remove four pieces of artillery before the enemy launched a counterattack and forced them out again; you can still see the hundreds of bullet holes that scar the stone walls. But there was as yet no large-scale opposition to the returning rebels. Saigo had left no protection when he marched out six and a half months before, gambling everything on his march to Tokyo; and Yamagata had made the same mistake, gambling everything on catching Saigo in Tabaruzaka, or Miyazaki, or Nobeoka, or Kobayashi. So now the rebels could take their swords and their four cannons and their fifty firearms and their pathetic little store of ammunition and climb unhindered

up Shiroyama's forested flanks. Death was likely, but not yet inevitable. They could still dream. If they could make themselves impregnable, they could perhaps still break out and regain control of Satsuma, still stand in the way of change for long enough to question the government about its decisions. Perhaps there were some who really believed this. If so, they did not know what awful odds they would soon be facing.

Brigade after brigade of imperial troops flowed back into Kagoshima: two that same day, two more on the next two days, and a fifth by sea on September 8. That made some thirty-five thousand troops available to forge a ring of steel around Shiroyama. But there had been almost such a ring around the rebels before they escaped over Mount Eno, and Yamagata was not taking any more chances. His attitude exemplified a Japanese proverb: once burned by hot soup, one blows on sushi. He had been burned too often over the last few months.

On Shiroyama the rebels dug in, making trenches—with spades provided by the few locals who lived on the hill—and building palisades of bamboo from the surrounding woods. There were, according to one estimate, a mere 281 of them, together with 80 noncombatant bearers; perhaps 600, if my map is right; no one knows for sure. They were divided among ten defensive positions on the top of the hill, with 26 designated as a bodyguard for Saigo. They had no ammunition for their field guns, and very little for the rifles, which they tried to make good by setting up a furnace to make their own bullets, using the metal from incoming shells and from small Buddhist images made of tin and copper. They had no medicines at all; on a few occasions when wounded limbs had to be amputated, the job was done with an ordinary carpenter's saw. And they were almost out of food. Two days after occupying the hill, 70

of them tried raiding the government grain store near the private school, but it was too late: imperial troops were already in position and over half of the raiders died, the rest climbing back up empty-handed.

Today, it's an easy climb up a winding road to a parking lot, even easier if you take one of the well-preserved old-fashioned buses that make the run to the top. On clear days there's a great view of the town, the bay and the volcano. The square where the rebels gathered that snowy February is still an open space among the camphor trees, its grass worn away by countless walking feet.

Back up there in September they could see the five warships riding at anchor in the bay, see the smoke from the guns as they began to bombard the hill and the surrounding area, see the repetition of what had happened when the British ships had done the same thing fourteen years before. Fires broke out among the suburban wooden houses. Shells ruined the two schools at the foot of Shiroyama. Those on the hill were well shielded from rifle fire by trees, though any who were spotted instantly drew a fusillade. But there was no defense from the shelling, which, by the twelfth, was coming not just from the ships but from artillery placed all around the mountain.

And still the noose tightened. Yamagata issued instructions: Yes, the hill was now surrounded, but there was to be no rush for a final assault. Better to be safe than sorry. If Saigo's men did attack, and if they threatened to break through, the adjacent unit was to open fire indiscriminately, even if it meant shooting down their own fellow warriors. It was an order that indicated a fear of Saigo's samurai out of all proportion to the threat. Having a 100 to 1 advantage was not enough. There had to be no scintilla of a possibility of escape. To this end, Yamagata ordered an impassable obstacle course of astonish-

ing complexity, given the minimal opposition. It was described by John Hubbard, the captain who had witnessed much of the fighting around Nobeoka and Mount Eno. He sailed back into Kagoshima on September 21, and saw the barriers the following day. First a double bamboo fence two meters high in a crisscross pattern, forming a row of diamond shapes. This was backed by boards studded with nails; then a ditch one meter deep and almost four meters wide; then squares of bamboo strips, six meters across and raised half a meter from the ground, so that if a man stepped on them, his foot would go through and the splinters would tear at his legs; then another six-meter ditch, this one filled with small branches; and finally a breastwork of earth and earth-filled bags, two meters wide at the base and half a meter at the top, behind which the soldiers sheltered and watched. All in all, it was extraordinary proof of the fear inspired by Saigo, his followers and their suicidal escapades.

Hubbard described the scene to his wife after going ashore with two other captains:

> We walked for three hours over the ground once occupied by the pretty city of Kagoshima. Before the war there were many thousands of houses; now there are hardly fifty left . . . I walked among the ruins, failing to recognize a single locality I before knew so well. About two-thirds of the grounds formerly occupied by the city is in possession of the Imperialists, and the other third the Rebels hold. This third is at the base of a steep hill, a mile in width, with hills on three sides and the city of Kagoshima in front. It is entirely surrounded by the Imperialists who have constructed such strong breastworks that it seems impossible for the Rebels to escape . . . They will probably hold out until their provi-

sions are ended, and then give up or kill themselves. The Imperialists evidently do not mean to leave their entrenchments and attack them, as that would involve the loss of many lives. They keep watch behind these breastworks, and if a Rebel shows himself he is at once fired on. They keep firing cannon and throwing shells on the hill night and day, but the Rebels have not fired a single shot for the last week. It is thought their ammunition is expended.

Up on the hill, Saigo's aides became nervous for his safety. It would not do for him, as a samurai commander, to be taken out by a random shell or bullet. It happens that on the slopes below the summit of Shiroyama are several almost sheer cliffs of exposed lava, which is soft enough to be eroded by rainwater into shallow caves, soft enough also to be cut away further to make shelters. On September 19, after over two weeks of bombardment, a couple of these caves, overlooking an open area but well shielded by trees springing from the cliff above, became Saigo's headquarters.

A few minutes' walk from the top brings you down to the little square, where there is now a gift shop and a gallery cut through the volcanic rock. An oversize statue of Saigo guards the entrance to the gallery, which is lined with watercolors showing the course of the battle. Exit through the shop, with its shelves of Saigo kitsch—statuettes, Saigo-shaped biscuits, mugs, portraits—and you are at the caves themselves. There are ten altogether, the two in which Saigo was based being fenced off like a side chapel in a cathedral. One, only a meter and a half high, is just about big enough for two men to sleep in. The other is higher, almost Saigo's height, but no deeper. They are not places where you would wish to spend any time, let alone five days.

On the twenty-second, two of Saigo's aides approached him to ask if they might see if his life could be saved. Probably not, Saigo told them, unless a peace could be negotiated, but he was happy to let them try. Waving a white flag they ventured downhill, leaving Saigo to issue a statement, which offered no hope of survival, but much of salvation:

> Kono Shorichiro and Yamanoda Ichinosuke have just been sent to the enemy camp to inform them of the complete determination of our force to fight until death and perfectly to fulfil the true relationship of sovereign and subject in this great undertaking of ours. We have no intention to meet death in a court of law. We shall make this mountain our pillow. Now exert yourselves to the utmost. Resolve to act so that no shame shall be reflected on posterity.

At the imperial lines, the two were promptly arrested and held as deserters. The next day a senior officer took them to see Yamagata, who told them there would be no negotiation. Or it may not have been Yamagata, for as usual sources vary. Perhaps it was the local commander, Kamura, as our fast-talking guide Morio said. Whichever it was, he sent back an uncompromising message: Either surrender by five o'clock this evening, or we begin the final assault first thing tomorrow morning. Only one of the officers returned with the reply. The other, Kono Shorichiro, was kept as a hostage, and survived to play a significant role in the restoration of Saigo's reputation.

Whether Yamagata, Saigo's one-time friend, issued the ultimatum himself or not, he was as trapped by his grim duty as Saigo was by his misplaced idealism. He suffered, so it was said later, the proof being that with the returning messenger he sent Saigo a long and moving letter, pleading with him to sur-

render and live. "Yamagata Aritomo, your old friend," he begins, "has the honour of writing to you, Saigo Takamori Kun [old friend]." You must now see how absurd your rebellion is. You have surely been blinded to the course of history by your loyalty to your clansmen. Perhaps also you have been in the hands of those who wish to use you for their own ends. It was quite understandable that you should wish to question those in authority in Tokyo. It could all have been done legally. But it became a revolt. This was totally without sense. You fight only for your men, they fight only for you, and both lack a real reason for fighting the imperial forces. Why therefore this continued bloodshed? Why not admit it was not you who made this rebellion and end the hostilities immediately? "I shall be very happy if you will enter a little into my feelings," he concluded. "I have written this, repressing my tears, though writing cannot express all that is in my mind."

If this is true—and almost everything that is said about personal details during the last stand must be subject to doubt—it made no impression on Saigo. All he supposedly said was: "There's no need to answer this."

The decision seemed to fill him and his closest aides with a sort of exaltation, as if they were martyrs on the way to glory. While the desultory shelling continued into the night, he and a dozen colleagues gathered for a party—

"A *party*?" I thought I must have misheard Morio's uncertain English. He didn't get much practice, and he was so anxious to explain that he was hard to understand.

"Party, ye-e-es, a good-bye party. Someone had a *biwa* [a sort of short-necked lute] and he told his retainers play *biwa*, and do a sword dance, and drink sake, party cups! Party cups!" (I think he meant "toasts.") "And say good-bye to the world in poetry."

If I were a drop of dew, I would take shelter on a leaf-tip,
But, being a man, I have no place in this whole world.

At precisely 3:00 A.M. the guns ceased. Under a moon two days from full, silence fell across the trees and the grubby shelters and the caves and those who knew their time had almost come. For an hour the calm lasted, until dawn began to lighten the sky. Captain Hubbard, on his ship out in the bay, had heard the bombardment, the sudden silence, and then, at 4:00 A.M., "the popping of rifles," marked by flashes on the still-dark flanks of the hill. The imperial troops were going over the top, flushing out the rebels before they had a chance to use their swords. "As the sun rose we saw the hill was covered with Imperial soldiers and could watch them as they made their way into the hollows and valleys and hunted out the Rebels. The firing was all on one side as the Rebels had no more ammunition."

Two hours later, it was almost over. Some sources say only forty men remained alive, but there's some evidence for one hundred, as we shall see. If so, four hundred had died, at least 65 percent, perhaps 80 percent, of Saigo's men. Outside the cave, listening as the sound of firing died away, Saigo's group of aides decided they had to move before they were hunted down and shot or captured. What they were planning to do when they met imperial troops, as they were bound to, we have no idea. Probably their intention was to die a noble death, swords in hand, charging guns. It's not far down the slope from the cave, a few hundred meters of road winding down the valley of a seasonal stream, the Iwasaki. Some sources say they carried their master on a litter, some that he walked, sheltered in so far as this was possible by his four retainers: Beppu Shinsuke (his elected second), Kirino Toshiaki, and two others. About

the only thing that is certain is his dress, because it was still on him when his body was found: a light, yellow-striped, unlined kimono with a man's white sash and dark blue leggings, very suitable for a traditional death. From the slight evidence, the chances are that he was walking, in a group, slowly because of his bulk, and exhaustion and swollen testicles.

What happened a few minutes into the descent, I guess, was that shots rang out from above, the evidence being that Saigo himself was hit, just outside a fine residence belonging to the Shimazu family, who had owned the whole place up until the 1868 restoration. The wound—as is known from the report made after his death—ran "from the right hip to the left femur," that is, the thigh bone. This is a strange angle for a wound. His right hip must have been turned to face up-hill. Perhaps he was looking back over his right shoulder, half turned, to see where the shots were coming from when the bullet entered from above him, passing through the flesh at the back of the thigh right through without hitting the bone, out the other side, and into his left thigh, striking his left thigh bone. It was a terrible wound, which would have brought him down, leaving him unable to walk, and more crucially unable to complete the act of seppuku that he would have chosen to end his life, for when his corpse was examined later, there was no cut to the belly.

All he had time for was to say something like, "Shinsuke, right about here ought to be good enough. Please do the honor of beheading me," or "I think this is as far as I go," or "This place is as good as any." All three sound good. Since there would be no seppuku, these words serve in its place to cast Saigo in a heroic mold, which suggests they are mythical. Who heard? Who reported? There are other, less noble, versions— that he was shot on his litter, that Beppu carried him farther

down the slope (but why? and how—a man of Saigo's size?), that he actually did commit seppuku, that he was quite simply shot dead, after which Beppu did the honors on his corpse (again unlikely; it's hard to behead a corpse on the ground). Did he, as some allege, ask the direction of the imperial palace, so he could face it? Unlikely, I think. He himself would know its direction, had known it from childhood: northeast. There was the sun glinting through trees telling him the direction. Anyway, we are in the territory of myth creation and hagiography, because there is no evidence but the leg wound, which hints at the probable truth—that he could go no farther because he would soon be unconscious from the pain and loss of blood, that he wanted it over as soon as possible, that all he could do was kneel, not ceremoniously because of his wounded legs, but on hands and knees, and present his neck.

Beppu raised his sword, and with one stroke severed the head from the body.

Another aide, Kichizaemon, then took the head toward a nearby house and hid it in a ditch to prevent the enemy getting their hands on it. Some accounts say he buried it, but how do you bury a head without a spade, when there are bullets flying and death is close? And anyway, who survived to say what happened? The only certainty is that the head was lost for a while. Quite likely in the horror of the moment, with shots coming from the hill above and nothing more for Beppu and the others to do but die a good death, the head simply rolled downhill into the ditch.

Today, the road leads down, with many bends, between high wooded banks and neat houses, to a busy junction with a highway emerging from a tunnel right under the hill. Once over the crossroads, ahead is a railway bridge. That was where the imperial army was, said Morio. Yes, yes, yes. Two hundred

and fifty meters away. On the left is the memorial, "The Site of Saigo Takamori's Suicide," four steps up to a small raised platform with a plinth.

I stood and wondered about the word "suicide." It has interesting philosophical implications. Everyone calls his death a suicide, which struck me as stretching a point, if you come at it with a Western viewpoint. We Westerners distinguish between killing yourself, getting help to kill yourself and getting someone else to kill you. But this is Japan. A beheading is the second half of seppuku, the first half of which is certainly suicidal, since no one survives disembowelment. You behead someone as an act of mercy, because it saves him from a death that is both painful and inevitable; it also, of course, confers dignity. So, from the Japanese point of view, a ritual beheading *implies* suicide. It need not actually *be* suicide. Indeed, traditionally it was enough for the performer of seppuku to reach for his sword, or even a fan that symbolized a sword, to prompt the beheader to swing his. Saigo intended suicide, so suicide it became.

There on the hillside, the master was dead and the end was in sight, for on the slope below there were imperial soldiers pointing their rifles uphill. Beppu and Kirino, standing beside the stream of blood, saw their only choice was to die as they had lived, as samurai. One of them, or somehow both, cried out—"Saigo is dead! All who die with him, rally here!"—raised their swords and ran downhill toward the rifles, falling seconds later in a hail of bullets. (Naturally, a hail of rifle bullets was not quite dramatic enough for some sources, which claim that they fell under a typhoon of bullets from Gatling guns, hand-cranked forerunners of the machine gun. True, the imperial army had a couple. But there is no evidence of their use at this place and time.)

A few survivors in trees and gullies had time to commit seppuku, and the rest were captured. By eight o'clock it was all over.

Hubbard was among the first to see the results. "After breakfast"—his wife would surely have liked to know he was looking after himself—

> in company with three others, I went on shore. After landing we heard that the bodies of Saigo and others had been brought in and were lying on a hill close to the breastworks. Hundreds of soldiers and coolies were going up the hill. We joined the crowd and were soon at the top. When we arrived there we found eight bodies laid out in two rows. The first was Saigo. He was a large powerful looking man, his skin almost white. His clothing had been taken off and he lay there naked.[1] It was a few seconds before I realized his head was cut off. Next to Saigo lay Kirino, then Murata. Saigo's was the only headless body, but the others were a fearful sight to look at. Their heads were dreadfully cut up.[2]

What of the head? It had to be found, not because it was proof of death—the body was proof enough of that—but because the head was the essential element in the traditional rituals of death on the battlefield. It took a brief search to find it, because it was not close to the body. Since the head of a samu-

[1] No mention of the enlarged testicles, which, even if Hubbard had noticed such a detail in such circumstances, would no doubt have been too much to include in a letter to his wife.

[2] ". . . and it was obvious that they killed each other," he concludes. But that is not an obvious conclusion. There was no evidence of seppuku or ritual beheading. More likely the wounds were from bullets and enemy swords.

rai had so much significance in history, the story of Saigo's head quite quickly attracted an accumulation of myths, as if it were a Japanese equivalent of a saintly relic in a Christian cathedral. But the conscripts and their officers were products of a new post-samurai era; they had no need of rituals. Hubbard, whose account is not well known in Japan because it is so lacking in reverence, was there. While he and his companions were looking at the bodies, Hubbard wrote to his wife, "Saigo's head was brought in and placed by his body. It was a remarkable looking head and anyone would have said at once that he must have been the leader." No rituals, no weeping, no speeches. Just a matter-of-fact matching up of head and torso.

Then at some point there was a formal identification and the few comments that passed for an autopsy: "Saigo Takamori. Clothing [which must have been removed and laid nearby]: light yellow-striped unlined kimono. Dark blue leggings. Wounds: head separated from body. Bullet wound from right hip passing through to left femur. Old sword wound in right ulna. Dropsy of the scrotum."

"Such a ghastly sight," continues Hubbard, "we could not long look upon, so we made our way down the hill," passing lines of noncombatants bringing in dead rebels by the score. On the way back to the boat,

> we branched off a little and went to a large enclosure where there were about a hundred prisoners [that's the evidence for the number of survivors]. They were a hard looking set; many of them quite young while others were old and grey-headed. All looked very sorrowful and dejected. One of the officers there told us they were all samurai and would probably lose their heads too. We wandered around amongst

them till noon, and after a rest [apparently changing their minds about going back to the boat] started off for the hill where the Satsuma leaders and others had met their end. We found the dead were being put in their graves, and this, no doubt, is the closing act of the Satsuma Rebellion.

19

TRANSFIGURATION

SAIGO'S TRANSFORMATION TO SEMIDIVINITY STARTED EVEN before his death. In the summer of 1877 a comet appeared, which a regional newspaper said framed an image of Saigo, if you looked through a telescope. In fact the comet, named after its German discoverer Ludwig d'Arrest twenty-six years earlier, is entirely unexceptional, returning every six and a half years as a tiny fuzzy blob; a telescope makes it a slightly larger fuzzy blob, but a blob in which, it seems, Saigo enthusiasts could read their dreams, rather as psychiatric patients see patterns in inkblots. The report sparked a fad, and people all over Japan started looking for Saigo in the heavens. Some climbed onto roofs for a better look; there were even reports of roofs collapsing and causing injuries. Mars was also in the news, because it was close to earth right then (as a result, its two tiny moons, Phobos and Deimos, were spotted in the very month of Saigo's death). A newspaper reported that he had become

Mars, his loyal companion Kirino his satellite. In September the American zoologist and orientalist Edward Morse, in Japan to research brachiopods, reported on the popularity of Saigo-as-Mars prints: "Many of the people believe he is Mars, which is now shining with unusual brilliancy." That their hero should live on as a heavenly body was not too far-fetched for people who believed that ghosts were as real as their own bodies. If such a hero had died, he would continue to exist in spirit and would surely return to wreak havoc on his enemies.

Officially, of course, immediately after his death Saigo was vilified as a rebel and failed general, the imperial army lauded as brilliant and the government as wise. He had after all encompassed the death of many thousands and caused the government almost to bankrupt itself. "The only consequence," said an editorial in *Hochi Shimbun*, "has been a vast destruction of life and property and large expenditures of money on both sides. Excepting these sad ends, nothing has been attained . . . Are not all the people of our country rejoiced to hear such good news as this?" The rebel leader's destruction was "a universal triumph."

But just two weeks after his death the balance was beginning to shift, with press analyses beginning to present him as less villainous, more heroic. The newspaper *Nichi Nichi Shimbun* did its best to serve both opinions. "When we consider his great works we ought to respect him for his heroism; honor him for his wisdom; and love him for his patriotic actions; but also award such punishment as our pen can inflict for revolting. Who will blame us for praising what is worthy and assailing what is evil?"

Once the scales had tipped, it didn't take long for Saigo the rebel and outcast to become Saigo the Great again: loyal, courageous, fearless, incorruptible. Even when most reviled he

had his supporters, one of the most powerful being Japan's leading expert on the West, Fukuzawa Yukichi. He had been to San Francisco in 1860, was part of the first embassy to Europe (1862), spoke Dutch and English, and wrote the best-selling, ten-volume *Things Western* and the hugely popular *Encouragement of Learning* in praise of Western-style education. Writing only a month after the end of the rebellion in 1877, he complained bitterly about the way Saigo, once the national idol, was now cast as "the great traitor." It was iniquitous, he said, and the government's "dark, unjust policies" were to be blamed for driving him to his death.

In Kagoshima Saigo's rehabilitation was swift, thanks mainly to the hostage, Kono, who had tried and failed to win a reprieve for his master. After the rebellion he was jailed for ten years, but released after two, because there were enough in Tokyo's government who felt that Saigo's memory was being wronged. That was when the memorial to Saigo's birthplace was set up, proclaiming him a model for coming generations. Kono set to work on something rather more substantial. He obtained permission for a cemetery, not simply for Saigo but for all the soldiers from Satsuma who had died. Donations quickly raised enough money for the land, and government money bought the memorials, 755 of them. In 1880, just three years after Saigo had been cast into outer darkness, he was back in favor, his tomb the central element in the Nanshu Cemetery, after the name he adopted when exiled.

The guide spoke so fast and so loudly and so unstoppably that Michiko didn't have a chance to translate everything, so I never understood how the 2,023 dead were properly remembered with only 755 memorials, but it doesn't matter. You come not to count but to feel. The stones have little stylistic merit, for they are no more than boxlike blocks. But they stand

in rows, as if on parade, and they impress by their massed presence, set off by a superb view of the bay and the volcano. Each stone is named—here are Beppu, and Saigo's brother Kohei, and Kirino—and the largest, Saigo's, adorned with vases of fresh flowers. One of the stones commemorates the youngest to die on Shiroyama, a boy of fourteen years and six months, no older than many who come every Sunday to the flat area of gray volcanic gravel below to practice their Jigen-ryū fighting. It is as if they are performing for their ancestral relatives, most of whom died too young to father children of their own. As I had tracked Saigo back and forth across Kyūshū I had been amazed, often, and intrigued, but this was the first and only time I found myself moved.

In 1880, as part of the new Meiji constitution, Saigo received an official pardon and had his former rank restored, "as if," in the words of Ivan Morris, "the rulers of the country had realized, somewhat belatedly, that they had a fully fledged hero on their hands and must rise to the occasion by granting him the proper honours." His followers had always worshipped him; now it was universally acknowledged that he deserved respect. His status as a national treasure was confirmed by deferential mentions in school textbooks. He had achieved a unique and paradoxical position, in Mark Ravina's words, as "revered rebel and loyal traitor."

Revered, respected yes, and more: adored. There were songs, anonymous poems—

> Now my sword is broken, and my steed has fallen dead,
> The autumn wind will bury my bones
> Here in the hills of my native town.

—and then the legends started, mainly concerning his death. The truth, that he had been badly wounded, and was be-

headed, was simply not good enough. Saigo did not commit seppuku, as we know from Hubbard and the official autopsy, yet illustrations of the event soon had him doing exactly that. They veered back into reality with the beheading by Beppu, and then out of it again. Traditionally, the head of a fallen hero had to be honored by the opposing commander, so soon other versions of what happened to Saigo's began to circulate. One became accepted as gospel. According to this account, the head is delivered to Yamagata. He receives it with due reverence. Reenacting the ritual supposedly performed on many a medieval battlefield, he cleans it—no: *cleanses* it—in pure water. Stroking it, he says wistfully, through tears, "Saigo, your face has not changed. Perhaps three days have passed since your hair was cut." Then facing his assembled men, he utters a peroration: "How peaceful is his face! Truly Okina ["the old man"] was among the greatest of men. No one knew me better than he; no one knew him better than I. That I have not slept for one hundred days is due solely to him, yet now he is lost to us. This is, indeed, the lingering regret of one thousand autumns." Then he tenderly places Saigo's head on the corpse as a steady rain begins to fall, *cleansing* Shiroyama of its blood and gore, but not of its memories. It's a tale that must be told with the right vocabulary and the right actions, the Japanese equivalent of an Arthurian romance. It serves its emotional purpose, it fortifies the listeners and readers, but historically it's rubbish. Yamagata was not even present when the head was placed, unceremoniously, by the body.

Saigo even became a character in a children's nursery rhyme, a girls' song sung to the rhythm of a bouncing ball. My guide in Kyoto had learned it from her mother, though "children nowadays don't know the old nursery songs any more." She sang it for me under a spreading tree in the Imperial Gardens:

a strange story of a girl of seventeen with flowers and incense in her hand, a girl who is (by implication) pregnant. Like many nursery rhymes, it's mostly nonsense, with roots in a historical event distorted by folk memory and constant repetition. The narrator, sitting on a bridge, asks: "Where are you going, my pretty maid?" and she replies something like the following, except that in Japanese it is in thirteen highly rhythmical lines:

I am the daughter of Saigo Takamori, from Kagoshima in Kyūshū, and I am going to the grave of my father, who committed seppuku in March of the 10th year of Meiji [1877; but why March, not September?]. When I sit by the grave and pray, a tear comes to my eye. If this child is a boy, I'll send him to university and make him study English, and he will have a nightingale on his arm, and the nightingale will make a *ho-ho-kekyo* noise, and that's the end of this song.

Or perhaps he had survived to flee to an Indian island or China or Russia, and would soon return in a sort of second coming to send the Meiji regime packing, lead an invasion of Korea and save the nation. Indeed, in 1891 there was a brief, crazy rumor that he would reappear on a Russian warship bringing the crown prince, Nikolai, on a state visit.

The myth machine works on today, with the toys and trinkets and tourist kitsch portraits that you see in any gift shop, and many statues. The most famous is the one in Tokyo's Ueno Park, among the few remnants of the great Kan'ei-ji temple whose destruction he authorized. He is not in uniform, but dressed as a simple samurai, a summer kimono wrapped around his solid belly. Holding his dog by a lead, he leans forward, resolutely, hand on sword, ready for anything the world can throw at him. In Kagoshima, they chose a different image:

his statue here, with Shiroyama as its backdrop, shows him as a maker of modern Japan, in army uniform to show his authority, but without his medals to show his humility. The statues are not only at sites associated with him. There's a big new one at Kagoshima's airport, which I would not be surprised to see renamed after him one day.

Why the adoration? Certainly not because of his success, for his historical significance stemmed from his failures. In so far as he was successful—as part of the revolution that brought about the restoration—he was one of several leaders, with less political skill than some and less military skill than others. Only when he struck out on his own did he do something truly original, and that was to heap on his nation death and destruction and waste. In many ways, he achieved precisely the opposite of what he wanted. Before, there had been much opposition to the new regime and three other uprisings with which he had been in sympathy. Now, as a result of his own rebellion, no one would ever again take up arms against the central government. Violence would be in the hands of individual assassins, opposition in the hands of politicians. The domains and prefectures, whose independence he valued, had come together not as a loose federation of states but as a nation. He had assumed that samurai would continue to monopolize both the armed forces and the administration, yet the samurai had vanished and the army—the army he helped create—was one of conscripts. Its victory under Yamagata sealed the end of the samurai as a force in Japanese history. Saigo's domain, Satsuma, had been the proudest and sturdiest in defense of its independence—which made it all the more extraordinary that the drive both for and against reform should have come from Satsuma, and that the driving forces for both should have been

childhood friends, Ōkubo and Saigo, who lived within walking distance of each other.

Irony and paradox don't guarantee a hero's reputation. That comes from Saigo's peculiar character, and his essential appeal. Inside this giant of a man, with his vast shoulders and belly and bull neck and pop eyes, there was a nature that was passionate, visionary, generous, highly moral, utterly uninterested in wealth, selfless and totally committed to whatever cause and whatever friendships he attached himself to. He was at ease with his equals, and gentle with his inferiors. In Ivan Morris's words, he had "a simple, almost childlike enjoyment of the moment and an immediate, earthy humour." Of course, of those who adored him, few knew his darker side, his obsessive loyalty unto death, the willful, crazy readiness to risk self-destruction, like a gambler betting on Russian roulette. Yet those who knew this aspect of his character loved him, too. He may not have been much into domesticity, but there is no hint that he behaved badly to the few women in his life, or that they resented him. What was there not to love?

Well, from the point of view of his colleagues, quite a lot, because he was all ideals and no practicality. Often, his ideals came up against the limits of the possible, at which point he would court rejection or simply pull away, leaving the messy business of administration to others. So he appealed to some as a potential savior, to others as the one who retained a sense of morality. He allowed himself to be persuaded to join the government, then condemned it as the "meeting-place of robbers."

For a man who was catapulted into the mainstream of politics, he was unique in one respect, a characteristic so marked it needs several terms to emphasize it: his austerity, his asceticism, his frugality, his active dislike of luxury. A samurai was expected to display abstinence as a sign that his life was de-

voted to higher things, but Saigo was spartan beyond the call of samurai duty. Even as a high official, he lived like a monk, with no luxuries, refusing to draw his salary for months on end. Often, he gave away whatever he could. As a government minister, he lived in a room that cost three yen a month—the equivalent of $3.00, which today is something like $450— quite a contrast to the way government employees lived then, let alone now. He always wore a simple country kimono, never the frock coats and top hats that became fashionable after 1868. It takes an extraordinary character not only to wear a monk's clothing in the imperial palace, but then to remove his clogs and go barefoot, courting arrest as an intruder.

There's no denying that his austerity was part of him. But it was also a deliberate provocation. At times, he sounded like a Confucian version of a Puritan preacher scourging his congregation. In 1870 a patriotic samurai committed seppuku in front of the national council building in protest at the corruption of the new regime, a deed of which Saigo approved, beginning his obituary: "Many of the government officials, addicted to dissipation and debauchery, are living in such extravagance that they fall into error." Sharing the suffering of the poor, he spoke for them. In death, he remained a symbol of unstained purity.

There were many other strands in Saigo's complex appeal, for he was so varied and contradictory a character that he served as a man for all men and all seasons. Some loved him for being part of the samurai tradition; some for his confrontation with Korea; some for his role in creating the new regime, some for his opposition to it; some for his support of Western technology, some for the way he rejected any dealings with the West (for he was one of the few major players who never visited the West, nor expressed any interest in doing so); some

because he was a conservative, or a socialist, or a democrat, or a nationalist, or anything that anyone could wish.

Or even a closet Christian, as suggested by Japan's most famous Christian, Uchimura Kanzo (1861–1930). A misfit from childhood, Uchimura studied English, converted, married, divorced and fled to the U.S. for a year to avoid the embarrassment of the failed marriage. Shocked by the laxness and ignorance of Americans, he returned and became a writer—in English, in order to explain both his own troubled self and Japan to foreigners. Translated into Japanese, his books made him famous. *How I Became a Christian* portrays the difficulties of a convert's life. *Japan and the Japanese* consists of five biographies of men he considered examples of high moral rectitude, the equals of any Western leader. One of them was Saigo, who had helped Japan to modernize. Uchimura portrays him as humble, direct, selflessly making Japan a moral entity as Luther did Germany, Cromwell England and Washington America. His only weakness was letting subordinates talk him into rebellion. What Uchimura was after was respect in Western eyes, and Saigo was a device to achieve it, as were the books themselves, written in high Victorian style. Saigo's biography begins by aping *Rule Britannia*: "When Nippon first, at Heaven's command, arose from the azure main, this was the charge to the land: 'Niphonia, keep within thy gates. Mingle not with the world till I call thee forth.' So she remained for two thousand years and more, her seas unplowed by the fleets of the nations, and her shores free from their defilement." God ordained it, and it was good. But times changed, and that, too, was ordained. Perry, the instrument of change, was "one of the greatest friends of humanity the world has ever seen." Great Saigo, too, was God's instrument. His reliance on the Chinese philosopher Wang Yangming proves it. Wang's philosophy was

covert Christianity, which meant that Saigo's was, too. "Shall we deny to our hero a voice direct from Heaven's splendour as he roamed over his favourite mountains? . . . Did not a 'still small voice' often tell him in the silence of the cryptomeria forest, that he was sent to this earth with a mission?" His mission was to unite the nation and lead it in imperial conquest, "that Japan might be a compeer with the Great Powers of Europe . . . a career assigned from the beginning of the world." Saigo was thwarted by a duplicitous government. Peace was mere effeminacy, indecisiveness, injustice. That he became a rebel was lamentable, but it was not his fault. His sensibility was too keen; he, "the strongest of men was almost helpless before the suppliant entreaty of the needy." Yet in the end he exemplified the virtues of a Christian monk: humble, caring nothing for possessions, selfless, generous-hearted and righteous. "What conceptions he had of Heaven . . . we have no means of knowing. But that he knew it to be all powerful, unchangeable, and *very* merciful, and its Laws to be all-binding, unassailable, and very beneficent, his words and actions abundantly testify." Uchimura doesn't quite say so, but the implied conclusion is pretty clear: Saigo was a Japanese Jesus, perfect in spirit, crucified thanks to his own virtues and the blindness of his enemies.

So far, so good. But in the late nineteenth and early twentieth centuries he also became the symbol of more ominous views. He was, after all, the embodiment of Japan's ideals: loyalty to the emperor and devotion to duty, both proven by his glorious, self-sacrificial death. Now, as one who had advocated the invasion of Korea, he became an inspiration for those so-called pioneer patriots who argued that Japan had an imperial mission to fulfill. She would become the bulwark against a hostile China and a Russia eager to seize Japanese territory

and (after 1917) spread the plague of Bolshevism. Manchuria was increasingly Japan's bridgehead, a base for colonists and for traders. From there, China would be absorbed, and the Europeans driven from their enclaves. In the 1930s, Japan took over Manchuria and established what was planned to be the original Great East Asian Co-prosperity Sphere. It didn't work out, because Japanese tanks and planes were stopped by the Russians and the Mongols in 1938, at a place called Khalkhin Gol in eastern Mongolia. This, the second greatest tank battle of all time, is very little known in the West, but hugely significant, because it turned the Japanese imperial gaze away from inner Asia toward Southeast Asia and the Pacific, a change of tack that in December 1941 led to Pearl Harbor. By then, Saigo was no more than a wraith in the Japanese war machine, but his ideals were still those of Japanese officers: reverence for the emperor, disdain for foreigners, self-sacrifice in battle.

And it goes on, with ramifications that were not at all malign, not even particularly Japanese, simply human. The legends—especially the story of Yamagata weeping over Saigo's head—were convincing because they were so *right*, so befitting the arc of Saigo's epic: a deserving young man with the right spirit moves from insignificance and poverty to fame and influence, undergoes a Christlike rejection and a sort of crucifixion, and, because he has been true to his ideals, is finally restored to glory. In the postwar years and again in the austerity years of the 1990s, Saigo's story contained the welcome message that there was dignity to be found in defeat.

A hero he remains, as opposed to Ōkubo, his childhood friend and then enemy, whose end was also dramatic, if a lot faster. Ōkubo was in power only briefly after Saigo's death, until a spring morning six months after the end of the rebellion, when

seven samurai set upon him while he was walking near the imperial palace and killed him. They were objecting to the revolution of which he was the driving force, but they were too late. Industrialization and militarization continued at a frantic pace for the next twenty years, culminating in Japan's victory over the Russian fleet in 1905. In a sense, the unified nation and that victory were Ōkubo's true memorial. A great man, certainly, a visionary, a political genius; but never beloved, as Saigo was. With his carefully cultivated muttonchop whiskers and his Western clothes, he played formality to Saigo's impracticality, compromise to Saigo's rigid idealism, cold to Saigo's warmth.

What was it about Saigo? His story reveals many reasons for his appeal. Forget the legendary Saigo: there is enough in the real Saigo to make him a storybook tragic hero. First, he is a highflier. Aristotle said the hero had to be a royal to generate respect, but nowadays we find it more impressive to see someone start low and achieve greatness. Second, he is a man of many admirable virtues—generosity, courage, stoicism, intelligence and ambition, among others. Third, though virtuous, he is flawed, for he is unbending in his virtue, willing not only to die but also to impose death on others. Fourth, because he is unbending, he is doomed to confront those who are more flexible, more practical, more compromising. So (fifth), there is no way out for him but death, which he chooses freely. There is no external fate that has it in for him; his fate is his own powerful, flawed character. And he dies as if onstage or in film, in high drama. He could not be a tragic hero if, for example, he just fell into a river or had a heart attack.

Last—and this is what explains his unique position in Japan—he is not an American-style superhero, defeating villains and saving the world. It is not even possible to imagine in

what way a Satsuma victory in 1877 would have saved anyone from anything. Turning back the clock, keeping the samurai in power, casting out foreigners? That sounds as much like failure as success. Anyway, it was impossible. He was doomed to fail, and that's the point. There is a sort of glory in death facing fearful odds; but in the West, we prefer heroes who face fearful odds *and win*. If they happen to lose, they become tragic, but they lose by miscalculation or bad luck. In Japan, they like heroes who know they are going to die, and therefore make sure they do so. Saigo is an extreme form of this, in that he willed his own destruction several times over, succeeding only after several failures. He might have said, like a Romantic poet, "I have been half in love with easeful Death." But Keats's dreamed-of death was a sort of drink- and laudanum-induced haze; no heroism there. Saigo dreamed not of an easeful death, but of a hard one: a death of action, gore and glory that came not from the cause but the fact of self-sacrifice. He was indeed the last of the samurai, in that his death on Shiroyama ended the dream of a samurai revival. But in another sense a spirit such as his cannot be killed. Its peculiar uselessness ensured his survival, and the survival of the samurai ethos, at the heart of Japanese culture.

It was this that made him the spiritual ancestor of the kamikaze pilots of the Second World War, who, like Saigo, acted out of loyalty to their emperor, knowing not only that they were going to die, but also that their gesture was entirely impractical. It would not save the nation in reality; but it would do so in spirit, by expressing the self-destructive courage, the nobility of failure, that was so much part of the Japanese character.

ACKNOWLEDGMENTS

My research would have been impossible without the committed and expert help of Yamasaki Michiko (IS Interpreters Systems) in Kagoshima; general thanks also to Taka Oshikiri, SOAS, for help on translation; Colin Young, swordsman; Alan Cummings and Angus Lockyer, SOAS.

Many thanks to the following for their help:

In Kyoto: Noriko Ansell.

In Kagoshima: Fukuda Kenji, Museum of Meiji Restoration; Matsuo Chitoshi, Shokoshuseikan Museum (Shimazu History Museum); Kukita Masayuki, Kagoshima Prefectural Museum of Culture Reimeikan; Narasako Hidemitsu, director general, Kagoshima Prefectural Visitors Bureau and his wonderful staff, including Matsunaga Yukichi, Higashi Kiyotaka and Morita Mikiko; Takayanagi Tsuyoshi, Saigo Nanshu Memorial Museum; Yamaguchi Morio, guide; and Saigo Takafumi, artist, potter and president of the Saigo Takamori Dedication Organization.

In Amami Oshima: Yasuda Soichiro, Hisaoka Manabu, Sakita Mitsunobu and Ryu Shoichiro, all of the Saigo Nanshu Memorial Association.

In Okinoerabu: Oyama Yasuhiro, Saoda Tomio, Minami

ACKNOWLEDGMENTS

Sanekatsu, Take Yoshiharu and Nagao Futoshi, all of the Saigo Nanshu Memorial Association.

In Kumamoto: Kuskabe Kazuhide, guide.

In Miyazaki: Kodama Gosei, Saigo Takamori Lodging Place Museum.

As ever, Felicity Bryan and all at her agency, Gillian Somerscales, for superb editing, and all at Transworld: Doug Young, Simon Thorogood, Sheila Lee and Philip Lord.

BIBLIOGRAPHY

The best detailed biographies of Saigo in English are those of Ravina and Yates. Both have extensive bibliographies. The remaining works in this list are my other main sources.

Adamson, Christopher. "Tribute, Turf, Honor and the American Street Gang: Patterns of Continuity and Change since 1820." *Theoretical Criminology*, February 1998, 2 (1).

Booth, Alan. *Looking for the Lost: Journeys through a Vanishing Japan*. New York: Kodansha, 1996.

Bottomley, Ian and Anthony Hopson. *Arms and Armor of the Samurai*. New York: Crescent Books, 1988.

Buck, James H. "The Satsuma Rebellion of 1877: From Kagoshima through the Siege of Kumamoto Castle." *Monumenta Nipponica*, vol. 28, no. 4 (Winter 1973).

Conlan, Thomas C. (trans. and interpretive essay). *In Little*

Need of Divine Intervention: Scrolls of the Mongol Invasions of Japan. Ithaca, NY: Cornell University Press, 2001.

Conroy, Hilary. *The Japanese Seizure of Korea, 1868–1910: A Study of Realism and Idealism in International Relations*. Philadelphia: University of Pennsylvania Press, 1960.

Dore, R. P. *Education in Tokugawa Japan*. Berkeley: University of California Press, 1965.

Fairbank, John K., ed. *Cambridge History of China*, vol. 10: *Late Ch'ing, 1800–1911*. Cambridge: Cambridge University Press, 1978.

Freeman-Mitford, Algernon, Lord Redesdale. *Tales of Old Japan*. Los Angeles: Aegypan Press, 2009.

Harris, Victor and Nobuo Ogasawara. *Swords of the Samurai*. London: British Museum, 1990.

Hawks, Francis. *Narrative of the Expedition of an American Squadron to the China Seas and Japan under the command of Commodore M. C. Perry*. New York: D. Appleton & Co.; London: Trubner & Co., 1856.

Horowitz, Ruth and Gary Schwartz. "Honor, Normative Ambiguity and Gang Violence." *American Sociological Review*, vol. 39, no. 2 (April 1974).

Ihara Saikaku. *The Great Mirror of Male Love* (trans. Paul Schalow). Stanford, Calif.: Stanford University Press, 1990.

———. *Tales of Samurai Honor*. Tokyo: Monumenta Nipponica, 1991.

Ikegami Eiko. *The Taming of the Samurai: Honorific Individualism and the Making of Modern Japan*. Cambridge, Mass.: Harvard University Press, 1995.

Inazo Nitobe. *Bushido: The Soul of Japan*. Tokyo: Kodansha, 2002. (First publ. 1900.)

Katsu Kokichi. *Musui's Story: The Autobiography of a*

Tokugawa Samurai (trans. and ed. Teruko Craig). Tucson: University of Arizona Press, 1988.

McCullough, Helen Craig, trans. and ed. *The Taiheiki: A Chronicle of Medieval Japan.* New York: Charles Tuttle/ Columbia University Press, 1959.

McLaren, W., ed. "Japanese Government Documents." *Transactions of the Asiatic Society of Japan*, vol. 42 (1914).

Makato Sugawara. *Lives of Master Swordsmen.* Tokyo: East Publications, 1996.

Marius B. Jansen, ed. *Cambridge History of Japan*, vol. 5: *The Nineteenth Century.* Cambridge: Cambridge University Press, 1989.

Mason, R. H. P. and J. G. Caiger. *A History of Japan* (rev. ed.). North Clarendon, VT: Charles E. Tuttle, 1997.

Mathers, E. Powys, trans. *Eastern Love*, vol. 7: *Comrade Loves of the Samurai by Saikaku Ebara and Songs of the Geishas*, limited ed. London: John Rodker, 1928.

Morris, Ivan. *The Nobility of Failure: Tragic Heroes in the History of Japan.* London: Secker & Warburg, 1975. (Contains an excellent chapter on Saigo.)

Mounsey, Augustus. *The Satsuma Rebellion: An Episode of Modern Japanese History.* London: John Murray, 1879.

Mushakoji Saneatsu. *Great Saigō: The Life of Saigō Takamori*, trans. and adapted by Moriaki Sakamoto. Tokyo: Kaitakusha, 1942. (Extremely rare. The only copy I found listed is in the Australian National Library.)

Myamoto Musashi. *The Book of Five Rings* (trans. William Scott Wilson). Tokyo, New York and London: Kodansha, 2001.

Nock, Elizabeth Tripler. "The Satsuma Rebellion of 1877: Letters of John Capen Hubbard." *Far Eastern Quarterly*, vol. 7, no. 4 (August 1948), pp. 368–75.

Ravina, Mark. *The Last Samurai: The Life and Battles of Saigo Takamori*. Hoboken, NJ: Wiley, 2004.

Roberts, John. *The New Penguin History of the World*, rev. ed. London: Penguin, 2004.

Safilios-Rothschild, Constantina. "'Honour' Crimes in Contemporary Greece." *British Journal of Sociology*, vol. 20, no. 2 (June 1969).

Satow, Sir Ernest. *A Diplomat in Japan*. San Diego, Calif.: Stone Bridge Press, 2006. (First pub. London: Seeley, Service & Co., 1921.)

Shigeno Yasutsugu. *Saigo Nanshu Itsuwa*. Tokyo: Shōyū Kurabu, 1998.

Shinichi Miyazawa. *Englishmen and Satsuma*, limited ed. Kagoshima: Takishobou-Shuppan, 1988.

Sinclaire, Clive. *Samurai: The Weapons and Spirit of the Japanese Warrior*. Guildford, Conn.: Lyons Press, 2004.

Takehiko Ideishi. *The True Story of the Siege of Kumamoto Castle*, trans. James Buck. New York: Vantage Press, 1976.

Turnbull, Stephen. *The Lone Samurai and the Martial Arts*. London: Arms and Armour Press, 1990.

———. *The Samurai Sourcebook*. London: Arms and Armour Press, 1998.

Yamakawa Kikue. *Women of the Mito Domain: Recollections of Samurai Family Life (trans. Kate Wildman Nakai)*. Tokyo: University of Tokyo Press, c. 1992.

Yamamoto Tsunetomo. *Hagakure: The Book of the Samurai (trans. William Scott Wilson)*. Tokyo, New York and London: Kodansha, 2009.

Yates, Charles L. *Saigo Takamori: The Man behind the Myth*. London: Kegan Paul, 1995.

PHOTO CREDITS

Photos not listed here have been taken by the author.

In the Text

8 Engraved portrait of Saigo Takemori by Edoardo Chiossone, *c.* 1883.

48 *Top*: daguerreotype of Shimazu Nariakira in formal attire by Ichiki Shiro, September 17, 1857: Shoko Shuseikan, Kagoshima; *bottom*: Shuseikan, Kagoshima, 1872: National Science Museum, Tokyo.

70 *Top*: *Portrait of a North American*, Japanese woodblock print of Admiral Matthew Perry, *c.* 1854; *bottom*: Admiral Matthew Perry, photo by Matthew Brady, 1854–8: both Library of Congress Prints and Photographs Division, Washington, D.C.

90 *Top*: engraved view of Edo, 1863–4, from *Zhivopisnaia Iaponiia*, 1870, a Russian translation of *Le Japon illustré*, 1870, by Aimé Humbert; *bottom*: "View of Yedo," lithograph by Hanhart, from *Japan, the Amoor, and the* Pacific by H. A. Tilley, 1861: both SSPL via Getty Images.

113 Takasugi Shinsaku, a samurai from Chosu, photo from

Vues et moeurs d'Indonésie et Japon, c. 1860: Bibliothèque nationale de France, Of 34Pet.Fol.G139256.

159 *Top*: detail of "The Bombardment of Kagoshima," engraving from *The Illustrated London News*, November 7, 1863; *bottom*: map of the bombardment of Kagoshima, 1863: Print Collector/HIP/TopFoto.

168 Kaishu Katsu, photograph: JTB/Photoshot.

177 Ernest Satow in 1869, photo from *A Diplomat in Japan* by Ernest Satow, 1921.

214 *Top*: Toshimi Okubu, postcard: Alamy; *bottom*: Saigo Tsugumichi in 1872, photo by Frederick F. Gutekunst.

226 *Top*: Kumamoto Castle in 1872, photo: Nagasaki University Library; *bottom*: officers of the garrison who fought Saigo's troops in 1877, photo from *Ancient photographs of the Bakumatsu and Meiji periods*.

250 Saigo banknote, 1877: Japan Currency Museum, Tokyo.

Photo Insert

Images listed clockwise from top left:

1 Samurai helmet and face mask, Green Room, Snowshill Manor: Andreas von Einsiedel © The National Trust Photolibrary/Alamy.

2–3 Samurai in traditional armor, hand-colored photograph by Felice Beato, 1860s: Bibliothèque nationale de France, Dep Eo 97(1) fol.a; samurai sword, *c.* 1600: Mary Evans/Interfoto; short samurai sword: © Oleksiy Maksymenko/Alamy; two men in traditional samurai costume, 1880s: © RMN (musée Guimet, Paris)/droits réservés armor used by Shimazu Nariakira, late Edo period, Tokyo Fuji Art Museum, Tokyo: Getty Images/The Bridgeman Art Library.

4–5 Kagoshima volcano, Kagoshima: Gyro Photography/ amanaimagesRF/Photolibrary; Kiyomizu-dera temple, Kyoto, photo *c.* 1900: Getty Images.

6–7 View of the Tokaido, 1867–8, photo by Felice Beato: Getty Images; daimyo and his retainers preparing to go to Edo, *c.* 1867, hand-colored photo by Felice Beato: © RMN (musée Guimet, Paris)/droits réservés; Satsuma's envoys, 1863–6, hand-colored photo by Felice Beato: Royal Photographic Society/Science and Society; meeting of Western diplomats, 1863–4, left to right: Captain Benjamin Jaurès, Captain Dew, Robert Pruyn U.S. minister to Japan, Vice Admiral Augustus Leopold Kuper, Col. Edward St. John Neale, Gustave Duchesne, Prince de Bellecourt, French diplomat, photograph by Felice Beato from an album in the British Museum, Asia Department, 2006, 0218,0.34: © The Trustees of the British Museum; Charles Richardson's corpse, 1862, photo attributed to W. Saunders: Pacific Press Service; Tokugawa Yoshinobu, 1863–8, hand-colored photo by Felice Beato: © Alinari Archives/Corbis; portrait of Shimazu Hisamitsu by Harada Naojiro: Shoko Shuseikan, Kagoshima.

8 British naval landing party at Shimonoseki, September 6, 1864, photo by Felice Beato: Nagasaki University Library; Emperor Mutsuhitsu, 8 October 1873: © RMN (musée Guimet, Paris)/droits reservés; shogunate soldiers before 1868, from *Bakufu panorama kan*, by Yoshino; shogunate soldier, Osaka, 29 April 1867, from *Hakodate Bakumatsu and Restoration* by Jules Brunet, *c.* 1867.

10–11 *Battling with the Kagoshima samurai at Kumamoto Castle, February 22, 1877*, woodblock print by Yoshu

INDEX

INDEX

INDEX

About the author

Read on

Insights,
Interviews
& More . . .

Meet John Man

© by Franck Pelagatti

JOHN MAN is a British historian and travel writer with a special interest in Asia. A graduate of Oxford who also studied at the University of London's School of Oriental and African Studies, Man has written acclaimed biographies, including *Genghis Khan*, *Attila the Hun*, and *Kublai Khan*, as well as *Alpha Beta*, on the history of the alphabet; *The Gutenberg Revolution*, on the invention of printing; and *Ninja*, on the infamous stealth assassins of Japan. He lives in England.

An Excerpt from *Ninja*, John Man's Previous Book

Origins

Make yourself resolute with the idea that you will win whenever you go on a mission, and you can win even if it is not so realistic.

Ninja instructional poem

JAPAN'S "SHADOW WARRIORS" rose to fame at a particular time, roughly 1400–1600, in a particular region, and in particular circumstances. But they did not spring into existence fully formed. To find their roots, look far away and long ago, to China, almost eight hundred years earlier.

In the early seventh century, Tang dynasty emperors emerged as rulers of a powerful empire and a great culture. The Japanese, precariously united under their own ambitious emperors, wanted to know its secrets. Court officials, students, teachers, monks, and artists visited, were vastly impressed, and returned with the "new learning," which was in effect all the main elements of Chinese civilization—Confucianism, medicines, textiles, weaving, dyeing, the five-stringed lute, masks, board games, and whole libraries of books on scripture, history, philosophy, and literature, all in Chinese.

One thing China knew a lot about was war. For centuries, it was armed conflict that divided the nation, yet it was war—and ultimately conquest—that, in 221 BC, brought peace and unity. China's military wisdom had been summarized some hundred years earlier (or more, no one ▶

knows for sure) by the great military theoretician Sun Zi (Sun Tzu in the old Wade-Giles orthography). His *Art of War* was already one of the great classics. Sun Zi was a professional through and through. He spelled out the "five fundamentals"—politics, weather, terrain, command, and management—and went on to analyze details such as the cost of entertaining envoys and the price of glue. He was not concerned with glory; he was interested in fast and total victory, for as he said, "There has never been a protracted war which benefited a country." Only by quick victory can more war be avoided. Today's generals study him. Politicians ignore him at their peril. George Bush might have had second thoughts about invading Iraq, let alone boasting of "mission accomplished," had he pondered one of Sun Zi's aphorisms: "To win victory is easy; to preserve its fruits, difficult." The lessons were clear: Don't engage unless sure of victory; Avoid risks; Better to overawe your opponent than to fight. But if you have to fight, do it my way! Learn the rules of military leadership, logistics, maneuvering, terrain, and, in particular—he saves this for last—deception.

It is the final chapter that interests us in our pursuit of the ninja's origins:

> All warfare is based on deception. Therefore when capable of attacking, feign incapacity; when active in moving troops, feign inactivity. When near the enemy, make it seem that you are far away; when far away, make it seem that you are near. Hold out baits to lure the enemy. Strike the enemy when he is in disorder. Prepare against the enemy when he is secure at all points. Avoid the enemy for the time being when he is stronger.

Only in this way can you gain the essential—speedy victory.

Of all the weapons vital for a speedy victory, the most vital is information. "The reason a brilliant sovereign and a wise general conquer the enemy . . . is their foreknowledge of the enemy situation. This 'foreknowledge' cannot be elicited from spirits, nor from gods, nor by analogy with past events, nor by astrologic calculation. It must be obtained from men," namely, spies.

There are five types of spies, he says: native, internal, double, doomed, and surviving. In brief, your own people, the enemy's people, double agents, expendables, and ninja-like spies who can penetrate enemy lines, do their job, and return. All these men are vital for victory. None should be closer to the commander, and none more highly rewarded, and "of all matters none is more confidential

than . . . spy operations." He who is not sage, wise, humane, and just cannot handle them, "and he who is not delicate and subtle cannot get the truth out of them. Delicate, indeed! Truly delicate," for if plans are divulged prematurely, the agent and all those to whom he spoke must be put to death.

An example of what Sun Zi was talking about occurred when Zheng of Qin, the future first emperor, was halfway through unifying what would in 221 BC become the heart of modern China. The first emperor, brilliant, ambitious, and utterly ruthless, was the target of several assassination attempts. Like many heads of state today, he took care to protect himself at all times. When traveling he was particularly vulnerable, as we know from an archaeological find made near his grave site close to Xian, and also near the tomb's greatest treasure, the several thousand life-size soldiers that make up the Terra-cotta Army.

In 1980 archaeologists working at the western end of the tomb mound found a pit divided into five sections, in one of which were the remains of a wood-lined container, crushed beneath the fallen earth. Inside lay what have become the crown jewels of the Terra-cotta Army Museum: two four-horse, two-wheeled carriages, in bronze, half life-size, complete with their horses and drivers. The carriages had been smashed into fragments, but after eight years' work they were restored to full working order, perfect down to every rein and harness and free-spinning axle flag.

One chariot is an outrider, with a driver standing on a canopied platform. The other is the emperor's. It has a front section for a charioteer and a second, enclosed section for the emperor, with a roof of silk or leather waterproofed with grease. In the windows there is mosquito netting—all this rendered in bronze, of course—and, on the side windows, a little sliding panel so the emperor could see out, get air in, and issue orders without his august person being seen.

But Zheng's chariot is not exactly a tank. It had to be relatively lightweight for easy movement and was therefore vulnerable to heavy-duty arrows or swords, such as might be carried by would-be assassins. The solution, as Sun Zi knew, was deception, which meant exactly the same solution as adopted by many a head of state today: decoy vehicles. The emperor traveled in any one of several identical carriages. At least one assassination attempt failed because the assailant attacked the wrong carriage. Possibly, another four decoy carriages remain to be found, so that a would-be assassin had only a one-in-five chance of attacking the right carriage. ▶

So to get at Emperor Zheng, a conventional approach would be useless. What was needed, in effect, was a ninja.

In what became one of the best-known incidents in Chinese history, Emperor Zheng conspirators against Zheng employed a proto-ninja for the job. The episode has become a popular subject for film and TV dramatization (most effectively in the 1998 epic *The Emperor and the Assassin,* directed by Chen Kaige). The source is the grand historian Sima Qian, whose account, written a century after the event but based (he says) on eyewitness accounts, is as vivid as a film synopsis.

One of Emperor Zheng's generals, Fan Yuqi, defected, and is now under the protection of the prince of Yan, a rival province. Zheng has offered a reward of a city plus 250 kilos of gold for his head. The emperor's troops are massing on Yan's border, and the only way to stop Zheng's meteoric rise is to find an assassin to kill him. A young adventurer named Jing Ke is chosen for the task. He is a man with nerves of steel and high intelligence, who likes "to read books and practice swordsmanship"—in brief, the essence of the true ninja. He refuses to quarrel; if offended, he simply walks away. Jing Ke is too smart to agree at once, but his reluctance is overcome when he is made a minister and given a mansion.

Knowing he has no chance of getting close to Zheng without a good excuse, he approaches the renegade Qin general, Fan, with an extraordinary suggestion: If he could have the general's own head, he will go to Zheng offering Yan's surrender, with Fan's head as a sign of good faith. He will also have a map of Yan territory. These two items will gain him access. Inside the rolled-up map he plans to conceal a poisoned dagger, with which he will stab Zheng. The general finds this an excellent idea—"Day and night I gnash my teeth and eat out my heart trying to think of some plan. Now you have shown me the way!" So saying, he obligingly cuts his own throat.

Head and map gain Jing Ke and an accomplice entry into the court and an audience with the king. At this moment the accomplice has an attack of nerves, leaving Jing Ke to go on alone. Watched by a crowd of courtiers, Jing Ke unrolls his map, seizes the dagger, grabs the king by the sleeve, and strikes. The king leaps back, tearing off his sleeve, and Jing Ke's lunge misses its mark. Zheng flees with the assassin in pursuit, while the unarmed courtiers stand back, appalled, watching their lord and master dodging around a pillar, trying in vain to untangle his long ceremonial sword from his robes. A doctor has the presence of mind to hit Jing Ke with his medicine bag, which gives the king a moment's grace.

Even as Jing Ke comes at him again, the king manages to untangle his sword, draw it, and wound Jing Ke in the leg. Jing Ke hurls the poisoned dagger, misses, and falls back as the king strikes at him, wounding him again. Jing Ke, seeing he has failed, leans against the pillar, then squats down, alternately laughing hysterically and cursing the king. The crowd moves in and finishes him off.

Would it be fair to call Jing Ke a forerunner of the ninjas? Hardly. True, he gained entry to the emperor by means of a trick. But the plot demanded that he operate in public and be prepared to die. Ninjas moved in secret and planned for survival. If there are lessons in this story, they are that rulers should be more careful and that secret agents should up their game. There's no point in half a ninja.

The incident, along with much of China's recorded history, became familiar to the Japanese from their embassies. Scholars knew about the first emperor and were familiar with the "Five Classics," among them Sun Zi's *Art of War*, known in Japan as *Shonshi*, a Japanese version of "Sun Zi." In theory, therefore, they knew about Sun Zi's admiration for the dark, covert arts of deception and spying. In addition, a number of wealthy Chinese fled the war-torn mainland in the early Middle Ages (tenth through twelfth centuries), many traveling through the Japanese heartland to the court and some settling along the way, emphasizing to their Japanese hosts the importance of Chinese culture, including the techniques of covert warfare. The famous Takeda family, which rose to prominence in the sixteenth century, owned at least six of the Chinese classics, including those by Sun Zi, Confucius, and Sima Qian (the grand historian who told the story of Jing Ke), suggesting that key ingredients of *ninjutsu*, the "art of invisibility," are Chinese in origin.

In fact, the idea of deception also has well-established Japanese roots, as two stories reveal. They appear in Japan's most ancient surviving book, the *Kojiki* (*Record of Ancient Things*). The *Kojiki* was one of two works produced for Emperor Temmu, who in AD 682 commanded his princes and nobles to "commit to writing a chronicle of the emperors and also of matters of high antiquity." Produced for the court thirty years later, the *Kojiki*'s amalgam of written and oral tales purports to explain the origin of the nation, from the beginning of heaven and earth, "when the land was young, resembling floating oil and drifting like a jellyfish." From three gods sprang the islands of Japan and eight million—"eight hundred myriad"—other gods, among them Amaterasu, the sun goddess, ancestor of the royal family. In a slurry of myth, song, legend, pseudo-history, and history, the 149 ▶

brief chapters reveal how, over twelve hundred years, thirty-four emperors imposed their wills on rival clans as Japan's divinely ordained ruling family.

Two stories tell of a young hero called Wo-usu, later renamed Prince Yamato the Brave, who still wore his hair up on his forehead in the style of a teenager. He was (supposedly) the younger son of the twelfth emperor, Keikō of Yamato, which in the second century AD was one of the five provinces of central Honshu, the heartland of the almost unified nation. The words in quotes are from the original as translated by Donald Philippi.

The Wiles of Prince Yamato

Emperor Keikō tells the elder of his two sons, whose name is Opo-usu, to bring him two beautiful sisters to marry. Instead Opo-usu marries the sisters himself. Then, in embarrassment, he avoids coming to eat morning and evening meals with his father.

The emperor tells the younger son, Wo-usu, to summon his brother.

Five days later, Opo-usu has not appeared.

"Why has your elder brother not come for such a long time?" says the emperor. "Is it perhaps that you have not yet admonished him?"

"I have already entreated him," replies Wo-usu.

"In what manner did you entreat him?"

"Early in the morning when he went into the privy, I waited and captured him, grasped him and crushed him, then pulled off his limbs and, wrapping them in a straw mat, threw them away."

Wo-usu's ruthlessness strikes the emperor as a pretty rough punishment for skipping a few meals. He instantly finds a mission that will suit his son's "fearless, wild disposition."

"Toward the west," he says, meaning the southern part of Japan's southern island, Kyūshū, "there are two Kumaso-takeru"—*kumaso* being a word for the aboriginals of that part of untamed Kyūshū and *takeru* meaning "brave." If this were an English fairy tale, these aboriginal chieftains would be ogres, and Wo-usu a Japanese Jack of the beanstalk. Anyway, says the emperor, "they are unsubmissive, disrespectful people. Therefore, go and kill them."

Before departure, Wo-usu's aunt, who in other versions of the story is a high priestess of the sun goddess, gives him two items of

clothing suitable for a woman, an "upper garment" and a skirt.
Why? Because very soon they will become vital to the story, and
he has to get them from somewhere. Armed with a small sword,
which he tucks into his shirt, he sets off.

When Wo-usu arrives at his destination, he finds the ogre
brothers inside a newly built pit house, for in olden days
aboriginals often lived in houses hollowed out of the ground.
There is much noise, for the ogres are preparing a feast to
celebrate the completion of the house. Wo-usu waits, walking
around until the feast day. Then he dons a ninja-like disguise.
He combs his hair down in the style of a young girl, puts on the
robe and skirt given him by his aunt, hides his sword under his
costume, mingles with the women, and enters.

The two ogres take one look at this vision of loveliness and
command the "maiden" to sit between them.

When the feast is at its height, Wo-usu draws his sword, seizes
the elder ogre by the collar, and plunges the sword into his chest.

The younger ogre, seeing this, takes fright and flees, with
Wo-usu in pursuit. At the foot of the stairs leading out of the
pit house, Wo-usu catches up with his victim, seizes him by
the shoulder, and stabs him in the rectum.

"Do not move the sword," says the ogre. "I have something
to say." At this the action, as if in a dream, comes to a dead halt,
giving the ogre, to whom it has now occurred that the "maiden"
is no maiden, time to ask, "Who are you, my lord?"

Wo-usu launches into a long explanation of his origins,
naming his father the emperor. Hearing that "you [ogres] were
unsubmissive and disrespectful," he says, "he dispatched me to
kill you."

Then the ogre, still ignoring the sword up his backside, says
politely, "Indeed, this must be true. For in the west there are no
brave mighty men besides us. But in the land of Yamato there is
a man exceeding the two of us in bravery. Because of this I will
present you with a name. May you be known from now on as
Yamato the Brave."

Then, at last, Wo-usu, now Yamato-takeru, Yamato the Brave,
killed his long-suffering victim, "slicing him up like a ripe
melon."

In the next chapter, Yamato the Brave comes to an old province
in southwestern Honshu, intending to kill the ruler, Idumo the
Brave, otherwise known as Many-Clouds-Rising. To do this, he ▶

uses two deceptions. First, he pretends to be Idumo's friend, then he makes an imitation wooden sword.

The two "friends" go to a river to bathe.

Yamato comes out first, and says, as a friend might, "Let us exchange swords!" Idumo agrees, and straps on Yamato's wooden sword.

At this Yamato issues a challenge, but of course Idumo can do nothing with the imitation sword and falls an easy victim to Yamato, who exults in his unsporting victory with a song:

> *The Many-Clouds-Rising*
> *Idumo the Brave*
> *Wears a sword*
> *With many vines wrapped round it*
> *But no blade inside, alas!*

Ninja: The Word Explained

English-speakers are often puzzled that the word *ninja* is sometimes rendered *shinobi*. How can two such different words in English be the same in Japanese? Here's how:

From the seventh century, Japanese took on Chinese culture as the foundation of their own. This included writing with Chinese signs, despite the fact that there is no connection between the two languages. This script, kanji, is used in combination with two other scripts, both of which are syllabic. The two syllabic scripts are relatively easy to learn, but in practice they are not much use without knowing several hundred kanji signs as well. It's a struggle and, frankly, for non-Japanese, a nightmare.

The kanji signs have two pronunciations: mock Chinese, which, being more scholarly, has high status, and real Japanese. For example, a "mountain" in Chinese is written 山 and pronounced *shān*, the line over the *a* [\bar{a}] representing a level tone of voice, as opposed to a rising [á], falling [à] or falling-rising [ǎ] tone. In the Japanese version of the Chinese, that becomes *san*. But in proper Japanese, "mountain" is *yama*. The Japanese use both, with *san* as the higher status—hence Fuji-san for their most famous mountain, rather than Fuji-yama, which is favored by foreigners. One sign, two utterly different pronunciations.

The same system applies to the signs and words usually transcribed in English and many other languages as *ninja*. In

Chinese, the signs 忍者/ *rěn zhě* mean "one who endures or hides." Japanese uses the same signs. But in the Japanese pronunciation, the term is distorted into *nin sha*, usually transliterated as *ninja*. In spoken Japanese, the word for "one who endures or hides" is *shinobi mono* ("enduring or hiding person"), usually shortened to *shinobi*. The "nin" part of *ninja* consists of two elements, "blade" (刃) placed above "heart" (心) in the wide sense of intelligence, soul, life. By tradition, the two suggest a hidden meaning. Perhaps a ninja is someone who has a sword blade hanging over him, ready to end his life if anything goes wrong; perhaps he is someone who knows how to make his intelligence as sharp as a blade.

Until quite recently, Japanese were happy to use both terms indiscriminately, because they have the same signs and mean the same thing, except that the mock-Chinese version is higher status. Since early contacts between foreigners and Japanese were at a high social level, *ninja* became the preferred version in both foreign languages and Japan. ◠

Have You Read?
More by John Man

NINJA

1,000 Years of the Shadow Warrior
A New History
Out of the violent chaos of medieval Japan, a remarkable band of peasants from the mountainous Iga and Koga provinces rose to become some of the world's most feared warriors. These poor villagers trained to perfect the art of *ninjutsu* to defend themselves against far more powerful warlords, samurai, bandits, and warrior monks. By 1500, the ninja's extraordinary talents, from infiltrating cliff-top castles to carrying out daring strikes for the imperial shoguns, were in demand across Japan. In this revelatory book, acclaimed author John Man's thrilling historical account brings to life the world of the ninjas, the Japanese "shadow warriors" whose otherworldly skills as assassins and spies still seize our imaginations.

"An immensely entertaining history, packed with splendidly bloodthirsty tales of derring-do, feats of endurance and self-sacrifice." —*Guardian* (London)

THE GREAT WALL

The Extraordinary Story of China's Wonder of the World
The Great Wall of China is indeed a wonder of the world. Every
year, hundreds of thousands of tourists journey there, and myriad
photographs have made it familiar to millions more. Yet the Great
Wall remains mysterious and steeped in myth. In this riveting account,
John Man travels the entire length of the Great Wall and across two
millennia to find the truth behind the legend. Along the way, he delves
into the remarkable and complex history of China—from the country's
tribal past through its war with the Mongols to its present-day status as
a resurgent superpower.

"This engrossing and well-researched history of China's most famous
architectural project whets the reader's appetite to tread in Man's
footsteps." —*Publishers Weekly*

THE TERRA COTTA ARMY

China's First Emperor and the Birth of a Nation
The Terra Cotta Army is one of the greatest archaeological discoveries
ever made. Over seven thousand life-size figures of warriors and horses,
each individually carved, were interred in the mausoleum of the first
emperor of China. Weaving together history and a firsthand account
of his experiences in China, John Man tells the fascinating story of how
and why these astonishing figures were created in the third century BC,
and how they have become a symbol of China's history, culture, and
society.

"A virtuoso historical investigation." —*Kirkus Reviews*

ATTILA

The Barbarian King Who Challenged Rome
For a crucial twenty years in the early fifth century, Attila held the fate
of the Roman Empire and the future of all Europe in his hands. He
created the greatest of barbarian forces, and his empire briefly rivaled
Rome's. In numerous raids and three major campaigns against the
Roman Empire, he earned himself an instant and undying reputation
for savagery. But there was more to him than mere barbarism. Attila
was capricious, arrogant, brutal, and brilliant enough to win the loyalty
of millions. In the end, his ambitions ran away with him. He did not
live long enough to found a lasting empire, but did manage to jolt
Rome toward its final fall. In this riveting biography, masterful
storyteller John Man draws on his extensive travels through Attila's

heartland and his experience with the nomadic traditions of Central Asia to reveal the man behind the myth.

"*Attila* is superb, as compellingly readable as it is impressive in its scholarship." —Simon Sebag Montefiore, author of *Stalin*

GENGHIS KHAN

Life, Death, and Resurrection
Genghis Khan is one of history's immortals, alive in memory as a scourge, hero, military genius, and demigod. To some, he is a murderer of millions, a brutal oppressor. Yet in his homeland of Mongolia he is considered the revered father of the nation, and the Chinese honor him as the founder of a dynasty. In a supreme paradox, the world's most ruthless conqueror has become a force for peace and reconciliation. In *Genghis Khan*, John Man—the first writer to explore the hidden valley where Genghis is believed to have died—uses firsthand experiences in China and Mongolia to reveal the khan's enduring influence. This stunning narrative paints a vivid picture of the man himself, the places where he lived and fought, and the strong feelings that his name generates still.

"Absorbing and beautifully written. . . . A thrilling account." —*Guardian* (London)

THE GUTENBERG REVOLUTION

How Printing Changed the Course of History
In 1450, all of Europe's books were hand-copied and amounted to only a few thousand. By 1500, they were printed and numbered in the millions. Printing by movable type, the invention of Johannes Gutenberg, had caused a revolution. In this fascinating new history, author John Man tells Gutenberg's incredible story, from his birth in Mainz, Germany, in 1400 to his struggles to bring his remarkable invention to light against a background of plague and religious upheaval. His story is full of paradoxes: his ambition was to reunite all Christendom, but his invention shattered it; he aimed to make a fortune, but was cruelly denied the fruits of his life's work. Yet history remembers him as a visionary; indeed, his discovery marks the beginning of the modern world.

"At the heart of Man's enchanting narrative is Gutenberg's place as an early capitalist, an entrepreneur, deprived of patrician status by his mother's modest background, who set out to strike it rich in business."
—*New York Times Book Review*

"The best book about the origin of books you could read. . . . Clear, engaging, fast-paced, and authoritative." —Stephen Fry

ALPHA BETA

How 26 Letters Shaped the Western World
The idea behind the alphabet—that language with all its wealth of meaning can be recorded with a few symbols—is an extraordinary one. So extraordinary, in fact, that such an idea has taken root only once in human history: in Egypt about four thousand years ago. *Alpha Beta* follows the emergence of the Western alphabet as it evolved into its present form, contributing vital elements to our sense of identity along the way. The Israelites used it to define their God, the Greeks to capture their myths, the Romans to display their power. And today this same alphabet explodes with possibility once again through the Internet. Tracking the Western alphabet as it leaps from culture to culture, John Man weaves discoveries, mysteries, and controversies into a captivating story of fundamental historical significance.

"The story of how [the alphabet] came into being is a fascinating one and Man is the ideal writer to tell it. His scholarship seems boundless. . . . He also has a journalist's ear for a story. . . . Straight out of *Indiana Jones*." —*Times Educational Supplement* (London)

"Absorbing tale. . . . Many surprises on the way."
—*Sunday Telegraph* (London)

GOBI

Tracking the Desert
For seventy years the Gobi, one of the world's richest yet least explored wildernesses, was all but barred to outsiders. Mongolia's position as a buffer state between Russia and China meant that few modern English speakers had ever roamed its expanses and plumbed its many mysteries. With the collapse of communism, however, the glorious diversity of the Gobi desert can be examined at last. Traveling from west to east across the Gobi, intrepid author and historian John Man retraces the steps of

Have You Read? *(continued)*

early explorers, living with herdsmen and drawing on the most recent scientific work to deliver an accessible and comprehensive look at one of the world's richest deserts. Man's journeys reveal the extraordinary wildlife and pristine natural beauty of Central Asia's astonishing heartland.

"Vivid. . . . Enchanting." —*Publishers Weekly*

Don't miss the next book by your favorite author. Sign up now for AuthorTracker by visiting www.AuthorTracker.com.